How lovly is me
being as I am

JACOLBY SATTERWHITE

How lovly is me being as I am

Miller Institute For Contemporary Art

Carnegie Mellon University

Contents

Preface

ELIZABETH CHODOS

Director, Miller Institute for Contemporary Art

This book and its companion exhibition, *Spirits Roaming on the Earth*, are the most comprehensive surveys of Jacolby Satterwhite's prolific art practice to date. These twin projects premiered at the Miller Institute for Contemporary Art at Carnegie Mellon University in the Fall of 2021, after a year of being postponed because of COVID-19.

As disappointing as it was to wait an entire year for these projects to come to fruition, aspects of the postponement were a gift. Having an additional year to further trace Satterwhite's evolving practice offered more time to delve into the sensual and cerebral pleasures of his expansive and exuberant body of work, which abounds with play, conceptual intricacy, and technical virtuosity. This closer look into his 3-D animated films, electronic dance tracks, sculptures, performances, installations, and more, revealed something operating on a deeper register: an essential moral lesson on the healing properties of human creativity. For Satterwhite, the crucible of existential uncertainty has long been a generative engine of resilience, reinvention, and celebration. A characteristic that he shares with his late mother and muse, Patricia Satterwhite, who leveraged her own irrepressible creative energy to transform hardship into new worlds of possibility.

A world-builder himself, Satterwhite has developed a multiform gestalt that can be viewed in full for the first time in the exhibition at the Miller ICA and in this monograph. Taken together, this odyssey follows an extraordinary creative trajectory that cannot be fully appreciated only through its component parts. Mapping this holistic view of Satterwhite's singular ability to masterfully synthesize personal, theoretical, and pop-cultural influences across a wide range of materials and genres with unmatched skill and dexterity affirms his position as one of the preeminent makers and thinkers of our time.

Introduction

ANDREW DURBIN

Novelist and editor of *frieze* magazine

As Jacolby Satterwhite tells Kimberley Drew in an interview for this book, his artistic career began when he apprenticed as a draughtsman for his mother. An artist and songwriter, Patricia Satterwhite made tens of thousands of schematic pencil drawings of inventions she hoped to patent and sell on the Home Shopping Network. These objects were not often new things, but familiar ones, domestic kits many Americans would have already owned, like vacuum cleaners, shirts, and wardrobes, for which she often included language describing their use. "Jewelry for the ears," she wrote of earrings. Others are less instructive, more gnomic, as in a drawing of crystalline letters: "Diamonds are forever."

Much has been written about the enormous scale of Patricia's output, with the emphasis usually placed on her doomed hope of selling these products on television. While this makes for an interesting story, it skews her comprehensive practice away from the personal toward the practical and commercial. These drawings evince more than the private genius of a would-be inventor; they also embody the workings of a mind obsessed with how we remember our lives, as Jacolby makes clear. He tells Drew:

> When I would ask her about her drawings, I'd say: "Are you drawing a teacup?" She'd reply, "Yeah. Don't you see Diane's face in it?" Diane was her sister. She'd insist that there were figurative elements transcribed in the design of the cups, but I couldn't see it. In her schizophrenic condition, she would talk to herself for twelve hours a day while drawing. She would reminisce about real events, which she thought the objects contained. A time Diane betrayed her—perhaps something she found out over tea. The drawings stopped being about patents, which she only did for a year; they became an autonomous space for self-healing and the consolidation of her dark and positive memories.

Since I first began to think about Patricia and Jacolby's practice, the word *invention*—commonly used in writing about her—has come to strike me as an incomplete description of what the drawings do and did for Patricia. They also function as *inventories*, culling episodes from Patricia's life that she could only summarize, howbeit cryptically, in garbage pails, cock rings, and

teacups. And it was in the form of an inventory that Jacolby's first major work, *The Matriarch's Rhapsody* (2012), which is the basis of this book, began to incorporate his mother's practice into his own.

The Matriarch's Rhapsody was first shown at Monya Rowe Gallery in New York in 2013. The film is a forty-four minute animated slide show that pairs scans of Patricia's drawings with digital renderings of the objects it inventories, as well as photographs drawn from the Satterwhites' family albums. Movement—a major hallmark of Jacolby's later films and 3-D installations—is limited to the rotation of his animations on screen, which he executed using Maya, the program that has become integral to his world-building practice. Though *Rhapsody* is simpler than subsequent works, the slideshow contains within it the key elements of Jacolby's practice and can be viewed as a thesis, even a birthplace (a favorite metaphor of Jacolby's), for the works for which he is now most familiar. Hence, this book shouldn't be read as an intervention into an older piece in order to make it appear fresh, so much as an explication—even an excavation—of that place from which Jacolby arrived. This is the start. Or one of them.

After all, it was in this methodically paced slideshow that Jacolby first translated his mother's drawings into digital objects, objects (and attendant language) that would soon become the building blocks of the *Reifying Desire* series (2011–14), *Blessed Avenue* (2018), and *Birds in Paradise* (2019). And in the inclusion of family photographs, Jacolby emphasizes the importance of seeing his mother's drawings as more than the objects they purport to invent; they are a codex to her life—the life of a schizophrenic Black woman from Columbia, South Carolina—that calls up for her (and her son) faces, incidents, desires, betrayals, disappointments, and triumphs that would have otherwise been completely lost had Patricia not written them down in the form she did. Under pencil, the past. This is true of Jacolby's other films, too, where Patricia's schematics house moving images of his friends, lovers, and strangers, all of whom Jacolby filmed on green screens in his roving studio. Though a viewer cannot know what one object might have meant for her, whose face it would have recalled when she made the drawing, in *The Matriarch's Rhapsody*, Jacolby pairs each with a photograph to cast Patricia's process of association as his own. In this, Jacolby rectifies what he couldn't see in the teacup—back then,

Diane's face—by supplying the drawing with his own memories via the printed photograph.

From this first investigation into his mother's archive, Jacolby discovered a visual language that has proven immensely generative. Its grammar has formed the basis for sculpture, performance, film, and installation—all mediums this book addresses in contributions by Kimberley Drew, who interviewed Jacolby about making art as a queer Black man; Malik Gaines, who writes about his understudied performances of the early 2010s; Legacy Russell, who analyzes the way his films trouble the origins of modernity; and Jane Ursula Harris, who takes a broad view of the evolution of those same films, from *Rhapsody* to his most recent, *Birds in Paradise*. As each of these texts makes clear, the threads that weave together the present-day work can be traced to *The Matriarch's Rhapsody*.

Editing this book was not impersonal for me. It resulted from an intimate, close friendship with Jacolby, not just my professional commitment to his work, though there's that, too. We have both long admired the contributors who wrote for this catalogue, and the credit for inviting them belongs as much to him as it does to me. Though I am listed as an editor, Jacolby was my coeditor, the person whose ideas most influenced my own. That's the disclaimer. I'm just the guy who loves the guy.

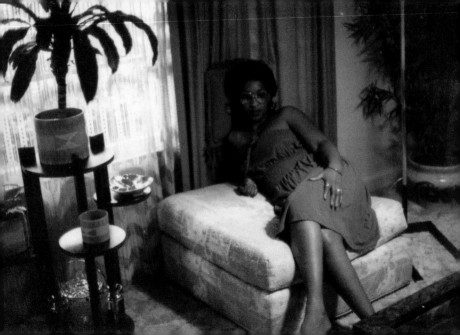

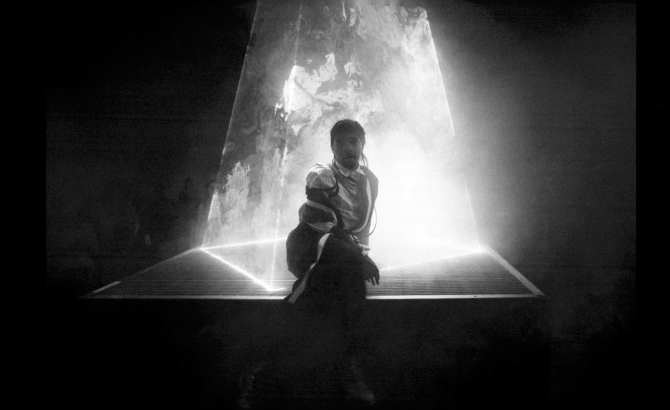

Matriarch's Rhapsody

Satterwhite began his deep exploration into his mother's drawings in 2010 when he started rotoscoping and tracing each frame for the film *Forest Nymph*. As an artist and inventor, his mother Patricia created products to pitch to organizations like the Home Shopping Network for development, although none of her inventions would ever be realized. Satterwhite inherited his mother's enormous collection of drawings and used them as a foundation for redering a three-dimensional collection of objects that he refers to as a toy box; a place for joy, a place for play, and most significantly, a place for discovery. For the film *Matriarch's Rhapsody*, Satterwhite took 230 of the drawings and morphed them into an architectural landscape, with scenes inspired by masters such as Hieronymus Bosch and Kerry James Marshall. This endeavor that reimagines his mother's interior world results in a forty-four minute film that features the thematic diagrams she created as he sat alongside her imagining other worlds in his South Carolina childhood home.

This codex provides Satterwhite access into his mother's psyche, as well as the ability to explore his early memories with his mother's expression from a post-idealized perspective. Satterwhite's introduction to artistic expression began with Patricia and now he collaborates with her still, by applying his own subjectivity to her drawings, through the addition of textures and colors to her sketches of household items that comprise the American Dream such as a pie dish, apron, and lemonade pitcher. These products exist beside family photographs taken by Jacolby's father Henry Satterwhite Jr., making Satterwhite interpret this particular project as being aligned with that of the Greek mythology of King Oedipus. Satterwhite uses this cache of drawings as schematic diagrams and a blueprint to accessing his mother's complex interiority as a diagnosed schizophrenic. She left for him an inheritance of boundlessness in this surrealist storyboard, a place for Satterwhite to play, explore, and breathe life into these two-dimensional drawings and conceptualize them as three-dimensional animations that disrupt the stagnancy of the mundane.

S.B.

Photograph of Patricia Satterwhite, c. 1989.
From the archive of Jacolby Satterwhite.

The American Dream;

A Lemon Aide Pitcher

A Table Lamp,

An Apron

A Grill

A Recorder Player Boom Box

A Pie Dish on a pie stand.

The Picket Fence w/a kickstand.

A Bell

A Coin Plate

Throne

Cases

Toe Nail
Cliiper

Extra large/extra sh

Throne

Cases

Toe Nail
Clipper
↓

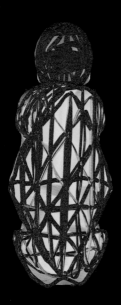

Extra large/extra shr

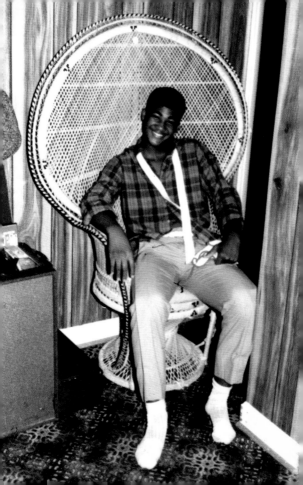

A
Cock's
House

the
whole
out
fit

For the
Fatbody

Hot Spots
Scented
Pad=So
in the Hot
spots
under
the
Breast
area and
under the
belly near
the cock, the
hot spots.

Waist
Cover →

The
whole
out
fit

Waist
Cover ➡

For the
Fatbody

Hot Spot.
Scented
Pads;so
in the Hot
spots
under
the
Breast
area and
under the
belly near
the cock, the
hot spots.

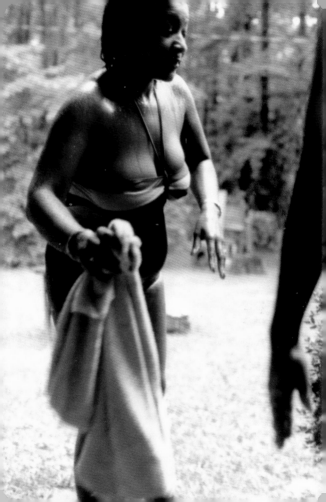

A Hats:

Money

Money

Paper

Money

for the

Queen,

me!!! money

to come to me

so I can see.

A Counter
Top mirror

A Martini
pitcher

A bottle
for
shaving
foam
lather

Sanitary
Nakins and
Pantiliners
wall con-
tainers

To get
one out
pull up the
front handle.
A
Knock
sound

Door
knocker

A Martini pilcher

w/ a bell sound. A mail Dor

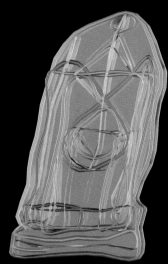

A Bottle for shaving foam lathor

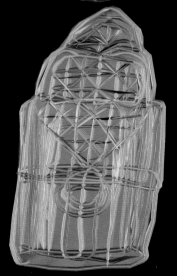

Sanitary nakins and Pantiliners wall containers

To get one out pull up the front handle.

A Knock sound

Door knocke

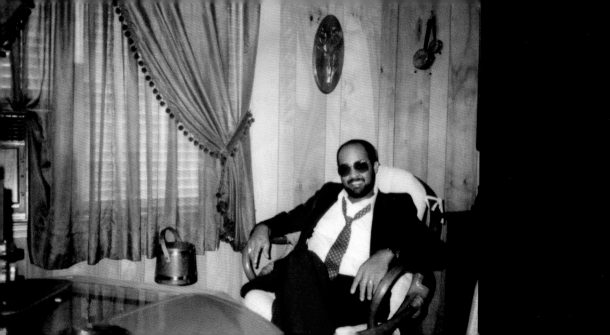

For
Fuel fuel
ofcu!

Dai

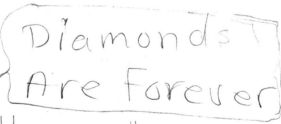

Diamonds
Are Forever

A Hanger Bag
for socks, etc.—

DIAMONDS

Forever

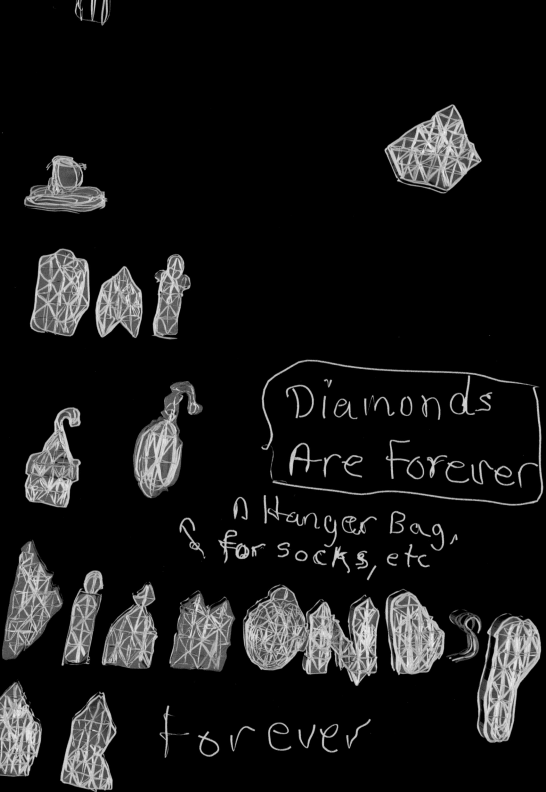

Diamonds
Are Forever

A Hanger Bag,
for socks, etc

DIAMONDS
forever

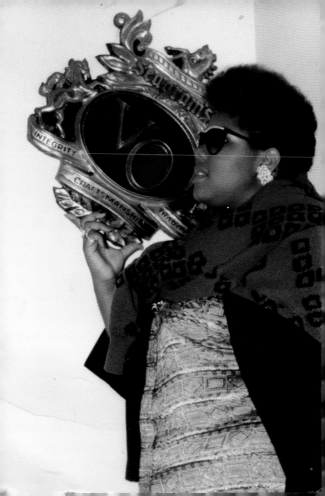

Forest Nymph

This three-channel performance film centers the protaganist Robin. An immune agent that blends Satterwhite and his mother, Robin is a feminine figure that defends against threatening orb-like viruses that are attacked by a swinging floor-length Kanekalon ponytail on two screens. The feminine appears in this work, and many others by Satterwhite, as a powerful energy resource to draw from, just as he does from his mother. Even when Patricia's work is not plainly visible, the spirit of her artistic influence looms. Another screen in the triptych offers more gender-neutral figures engaged in an erotic wrestling between the invading Robin and the body, surrounded by the thickets of wilderness, or what can be perceived as the unknown.

In this body of work, the viewer can see the beginning of Satterwhite's relationship with performance and animation. His body is physically pushed to its limits which allows for a control not often accessible when battling an internalized invisible illness. One is often at the mercy of health-care providers, but here, Satterwhite holds complete artistic authority. Although his practice began as a painter, Satterwhite explores performance as a means of interrogation and negotiation with the body that still trembles with the anxiety of illness as an invasion.

S.B.

Robin 3, 2009. C-print. 33 × 50 inches (83.8 × 127 cm).
Courtesy of the artist and Mitchell-Innes & Nash, New York.

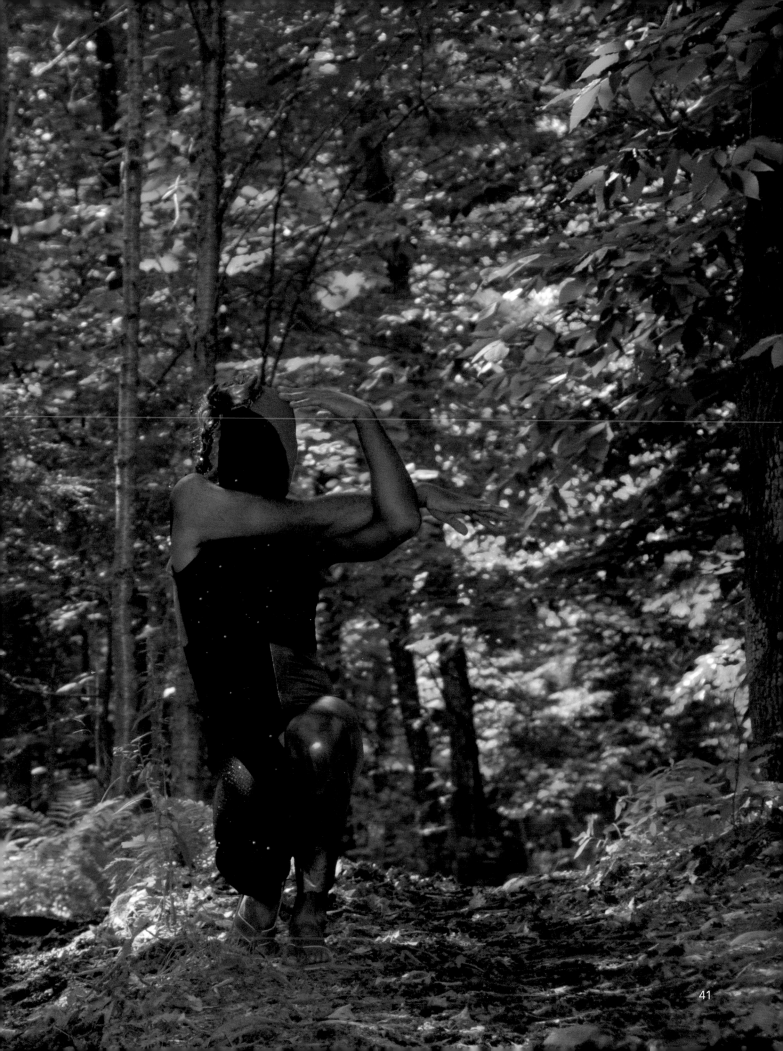

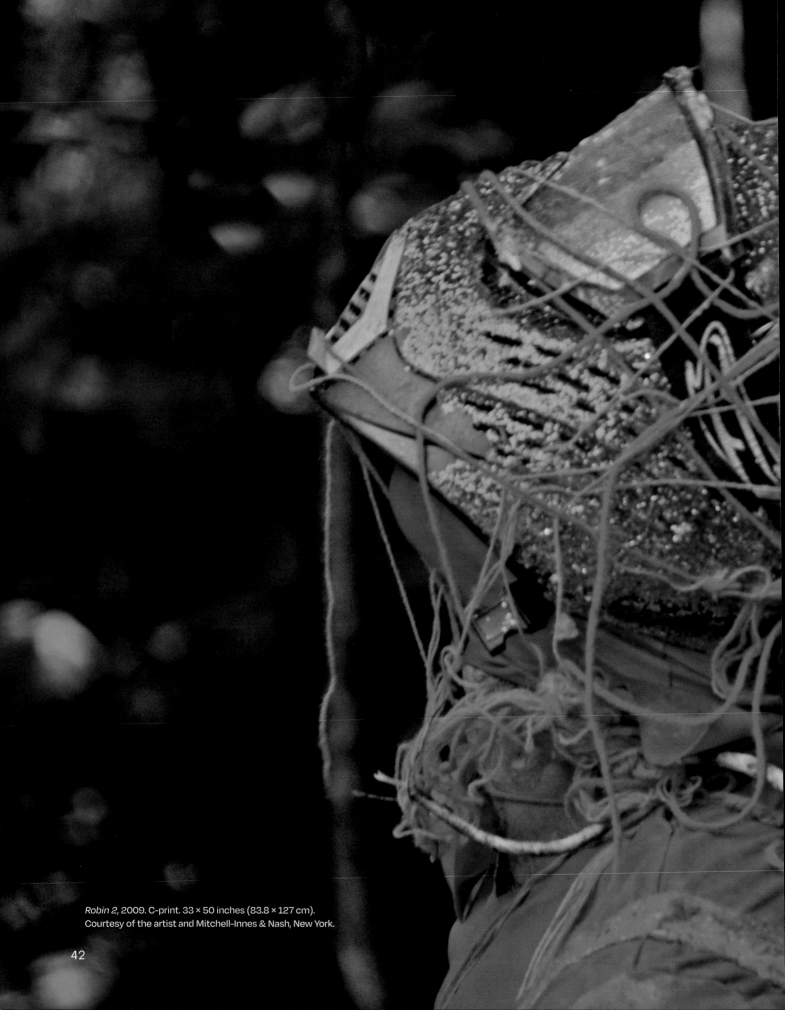

Robin 2, 2009. C-print. 33 × 50 inches (83.8 × 127 cm).
Courtesy of the artist and Mitchell-Innes & Nash, New York.

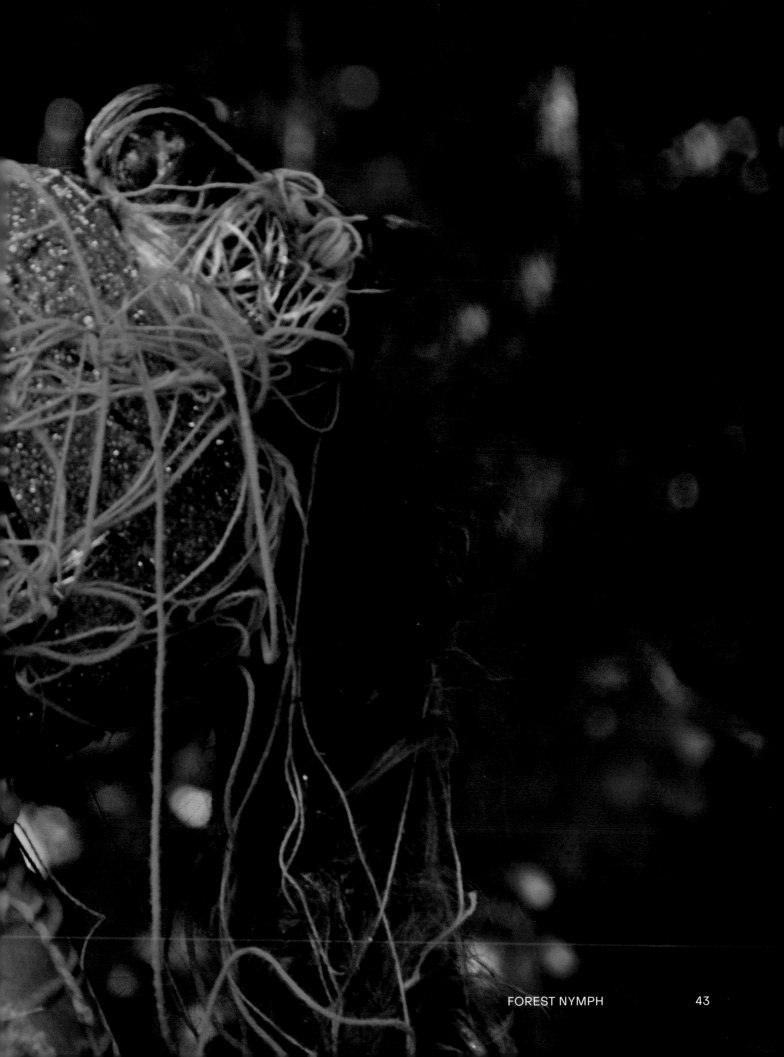

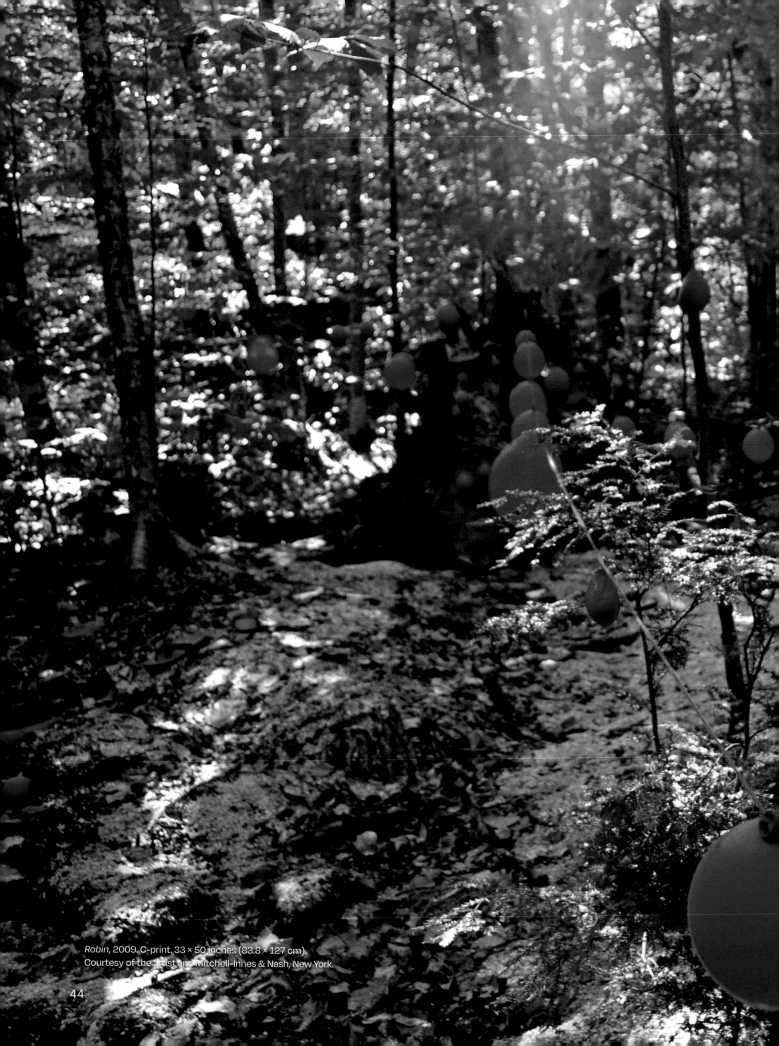

Robin, 2009. C-print. 33 × 50 inches (83.8 × 127 cm).
Courtesy of the artist and Mitchell-Innes & Nash, New York.

44

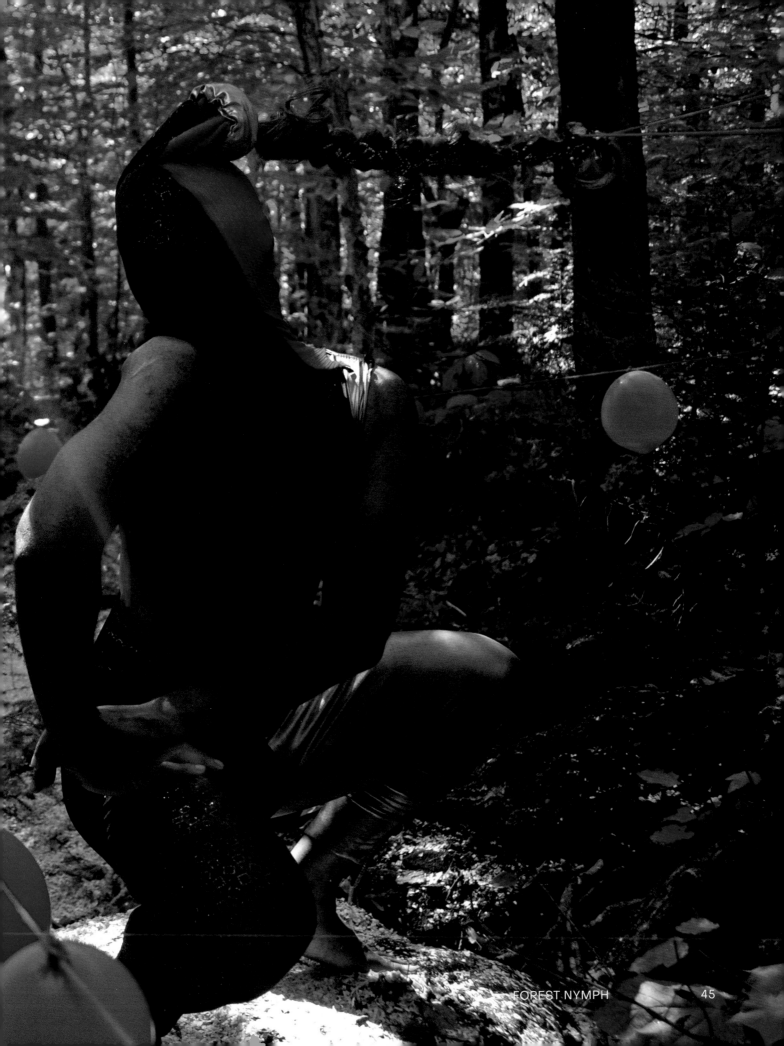

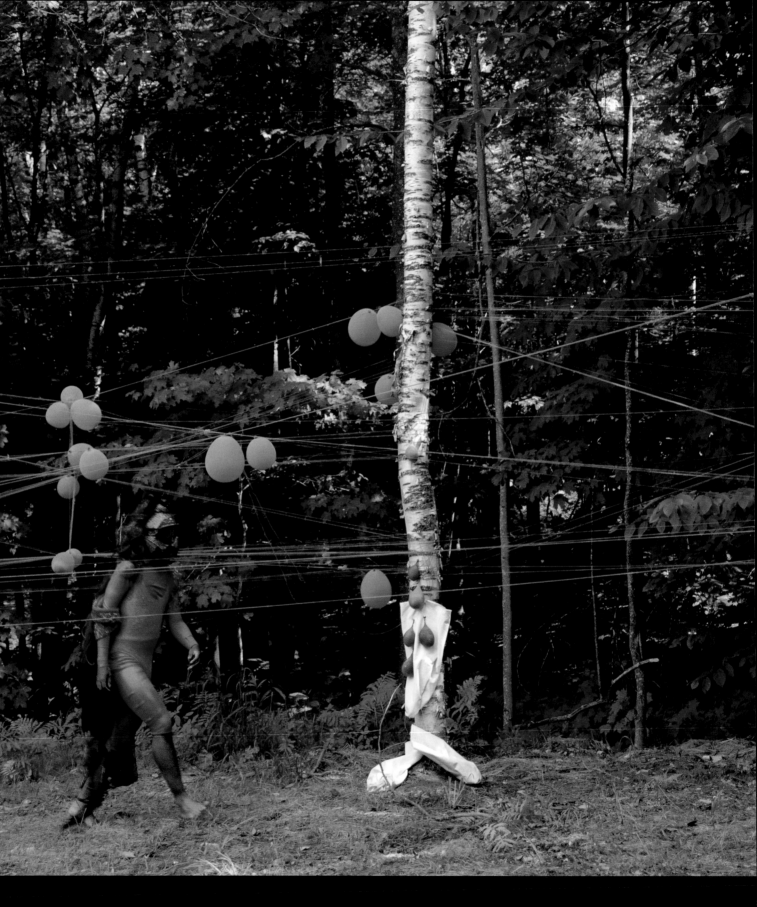

Stills of *Forest Nymph*, 2010. Three-channel 3-D animation and video with sound.
14:00 minutes. Courtesy of the artist; Lundgren Gallery, Palma de Mallorca, Spain;
Mitchell-Innes & Nash, New York and Morán Morán, Los Angeles.

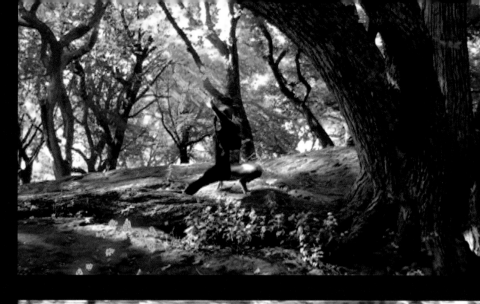
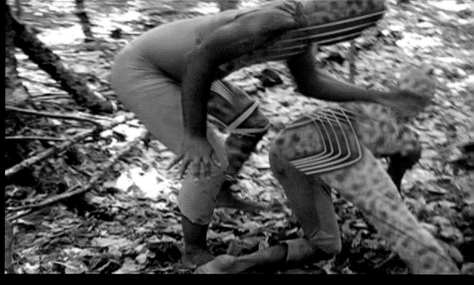
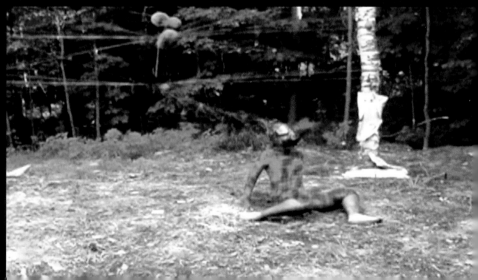

Country Ball

Country Ball's ideation began during Satterwhite's compilation of *Matriarch's Rhapsody* and took on many forms before its final presentation at The Studio Museum in Harlem in 2012. Satterwhite selected thirty objects from *Matriarch's Rhapsody* that spoke directly to recreational materials, such as tables, KFC buckets, slides, carousels, trampolines, and birthday cakes. These objects form a 3-D animated composite of the surrealist space of Black joy. Shown alongside thirty image sequences of Satterwhite's body, this two-channel film generates a narrative between Satterwhite's constructed worlds and a home video from 1989. This work is one example of how Satterwhite merges his mother's nostalgia with his own.

In the 1989 home video a young Satterwhite can be seen in green buoyantly queering the limitations of masculinity, yet again amongst the trees, which is a reoccurring setting of comfort in much of his work. Satterwhite's engagement with nature represents his own digital conception of Impressionism, akin to that of the painting practice of working *en plein air*. Perhaps nature shrouds, for just a moment, the barriers often placed around a young gay Black boy in the South, who desperately wants to transcend the limitations of flesh and gender.

S.B.

Still of *Country Ball 1989–2012*, 2012. 3-D animation and video with sound. 12:38 minutes. Courtesy of the artist; Lundgren Gallery, Palma de Mallorca, Spain; Mitchell-Innes & Nash, New York and Morán Morán, Los Angeles.

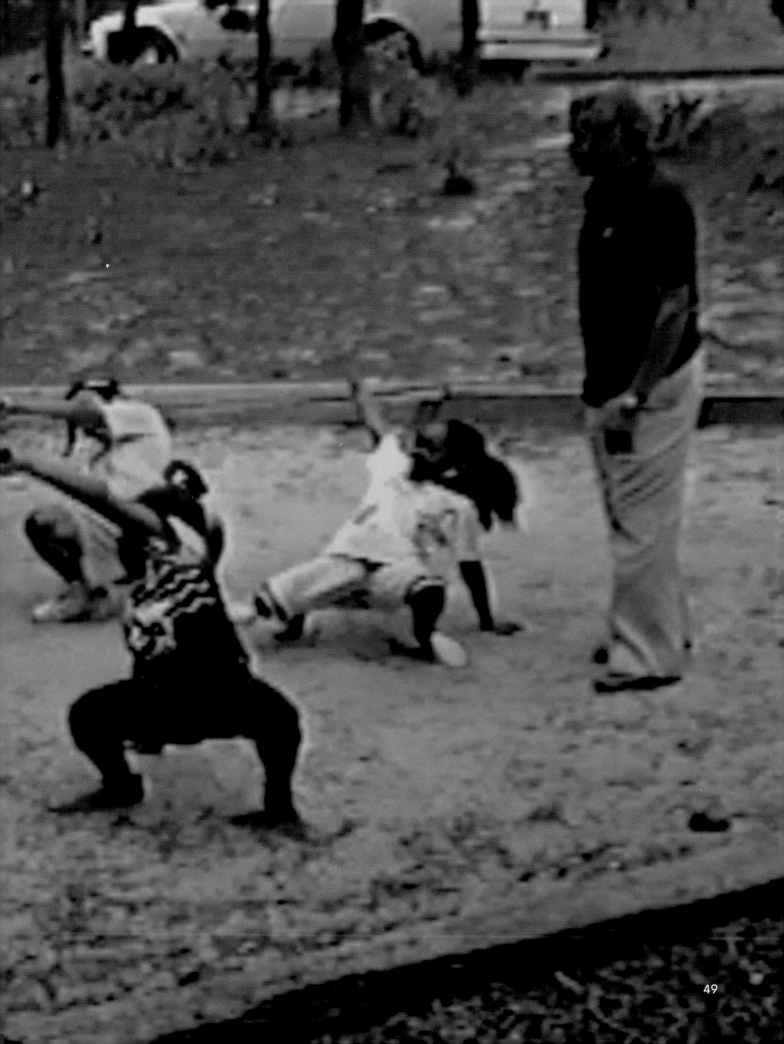

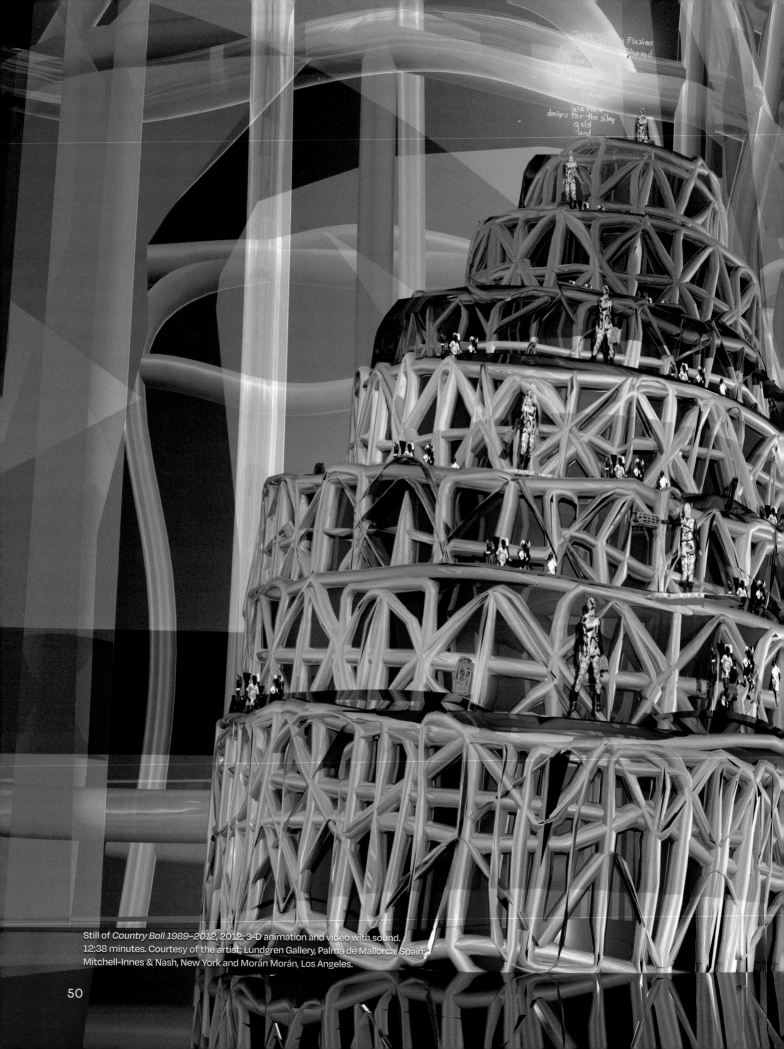

Still of *Country Ball 1989–2012*, 2012. 3-D animation and video with sound.
12:38 minutes. Courtesy of the artist; Lundgren Gallery, Palma de Mallorca, Spain;
Mitchell-Innes & Nash, New York and Morán Morán, Los Angeles.

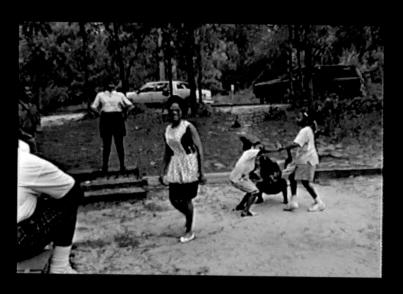
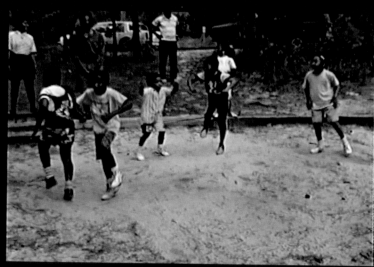
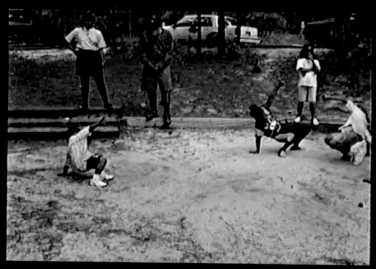
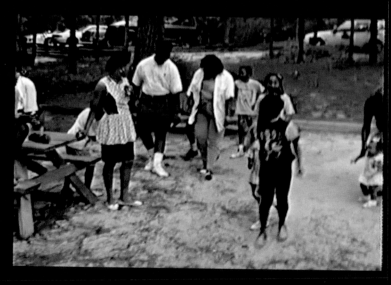

Stills of *Country Ball 1989–2012*, 2012. 3-D animation and video with sound.
12:38 minutes. Courtesy of the artist; Lundgren Gallery, Palma de Mallorca, Spain;
Mitchell-Innes & Nash, New York and Morán Morán, Los Angeles.

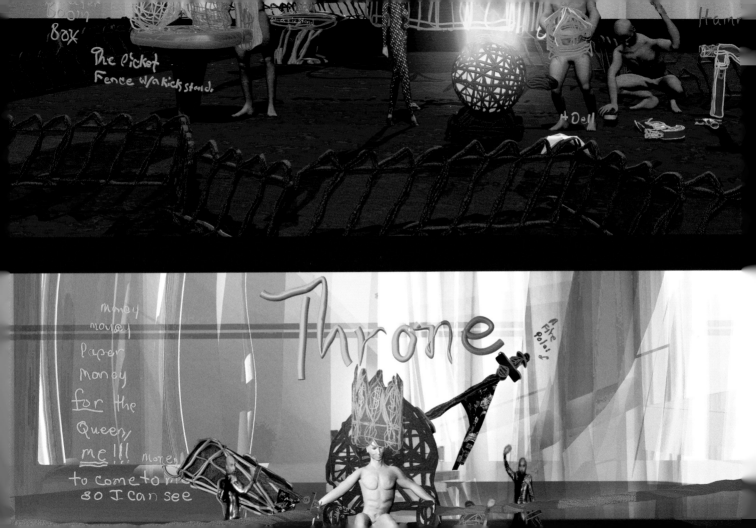

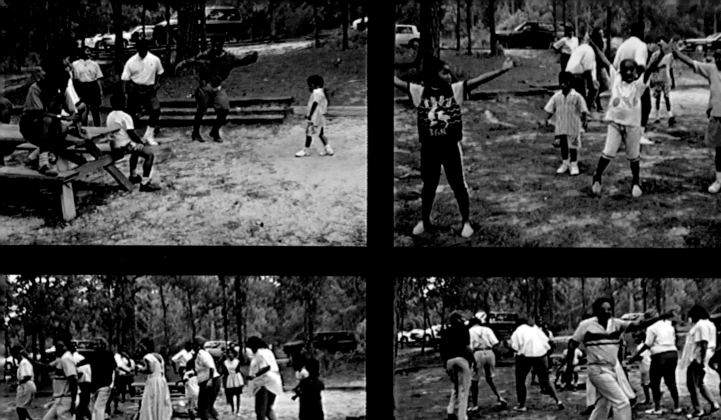
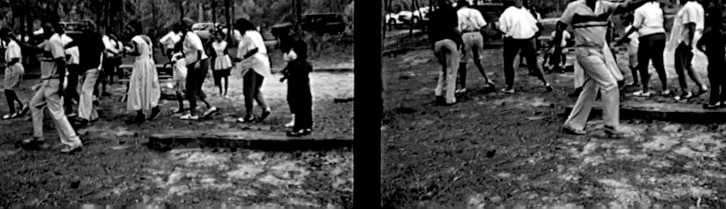

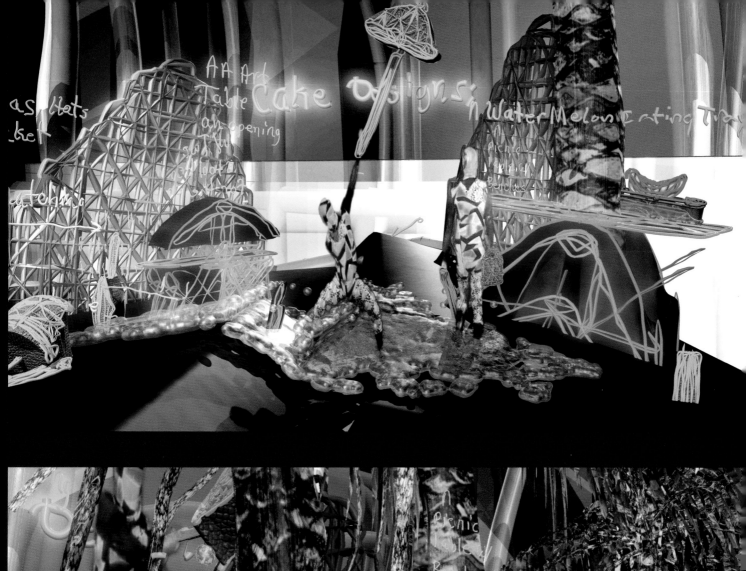
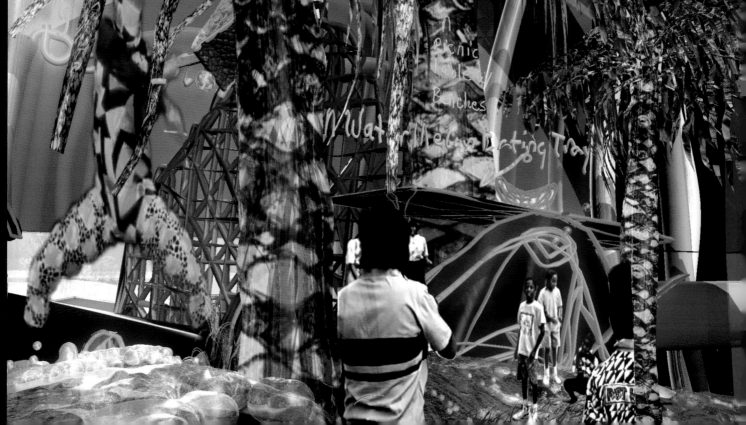

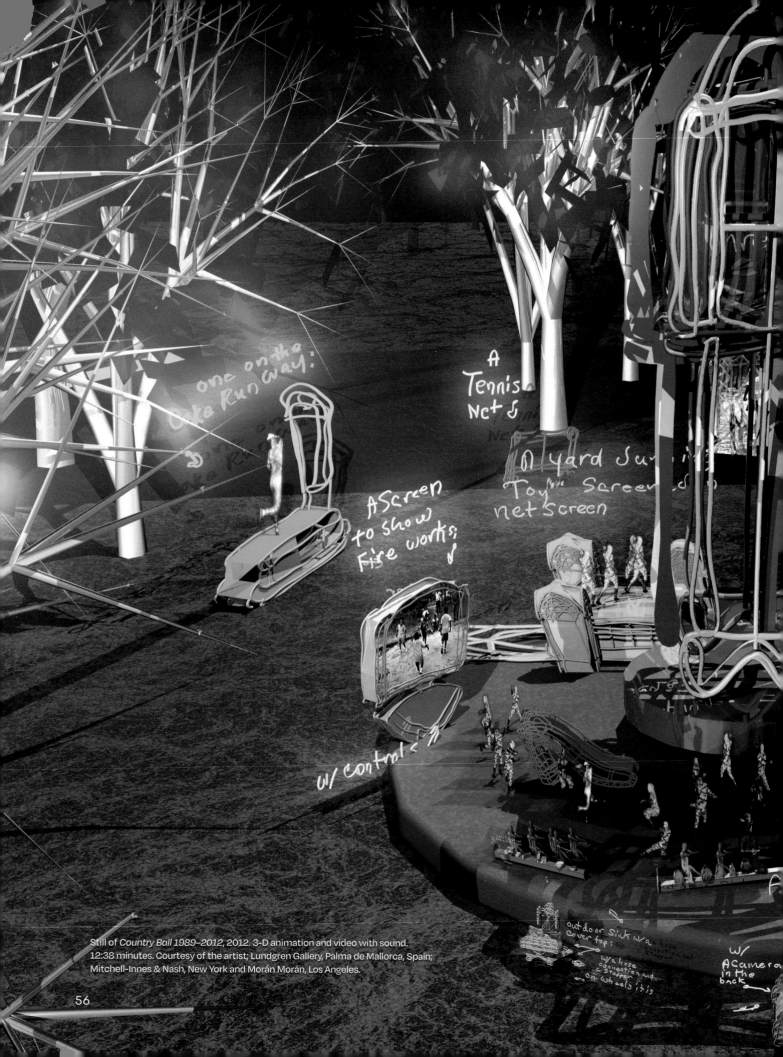

Still of *Country Ball 1989–2012*, 2012. 3-D animation and video with sound. 12:38 minutes. Courtesy of the artist; Lundgren Gallery, Palma de Mallorca, Spain; Mitchell-Innes & Nash, New York and Morán Morán, Los Angeles.

56

Picture frames

w/ felt
cleaning entrance
Mats!

A screen for show wall
fills

for parking

A Feeling of Healing: Jacolby Satterwhite's Kaleidoscopic Vision of Queer Self-Care

JANE URSULA HARRIS

For Jacolby Satterwhite, the mythic and the fantastic provide images of agency and resistance, especially for those living on the margins. "To survive as a queer person in this world," he said in a 2020 interview with *BOMB*, "you extrude a fantasy and commit to it, assimilating into structures where you don't necessarily belong. I create safe spaces to stay sane."[1]

It's a lesson Satterwhite first learned from his late mother Patricia, an artist, songwriter, and inventor whose music and schematic drawings of thousands of household objects—made using only pencil and 8 1/2 × 11 inch printer paper—are at the center of her son's work. Inspired by her love of home shopping channels and infomercials, and the hope for a better, more financially secure future, Patricia's inventions range from the banal to the ingenious: meat slicing trays, magnets for pain, a hot tub lounge chair, a picket fence with a kickstand, a levitating bed, a shoe-cum-water slide, and "cock covers," to name a few. Drawing and making objects, with their intriguing, handwritten instructions, functioned therapeutically, helping to alleviate her unemployment anxieties and growing battle with schizophrenia. In Satterwhite's immersive, multimedia practice, with its ongoing themes of self-care, metamorphosis, body trauma, and renewal, they form a codex for the signature world-building that has come to define his work.

An assignment at the Maryland Institute College of Art, where Satterwhite was an undergraduate student in painting, first led him back to his mother's drawings. Given the prompt by artist Derrick Adams, senior thesis instructor and mentor, to create a deeply personal work, Satterwhite dug them out of the attic, where they'd been stored in envelopes. Placing her schematics alongside family photos shot by his father, he created a video collage that became the basis for his first major multimedia work, *The Matriarch's Rhapsody* (2012). The forty-four minute-long video animation, which was first shown at New York's Monya Rowe Gallery in 2013, combines stills of Patricia's drawings with rotoscoped, neon-colored versions of her inventions, which rotate against a black background. Whenever relevant, family photos are also included: "A plant water ball to water the plants slowly," for example, appears beside a 1980s-era

1 https://bombmagazine.org/articles/jacolby-satterwhite/

snapshot of Patricia posing in a strapless terrycloth dress before a giant potted plant. "Bats as fighting weapons for the house and car" sits next to the artist's father's military portrait.

With the success of *The Matriarch's Rhapsody* and the unfettered, generative potential it opened in his work, Satterwhite abandoned painting for film. In the six-part *Reifying Desire* (2011–14) series that followed, Satterwhite made over two hundred 3-D models of his mother's drawings using the animation program Maya, treating them as scores to be activated by his body. Studio dance improvisations, vogue-like movements, and impromptu street actions were overlaid with his rotoscoped animations of Patricia's schematics, connecting and queering Patricia's disparate inventions in a process the artist describes as "object-perversion." Like Surrealism's Exquisite Corpse and the cut-up method of novelists William S. Burroughs and Brion Gysin, the resulting composites reveal hidden, alternate meanings both personal and unconscious. As Satterwhite explained in *Art Papers*: "The frequent paradox, hybridity, and double entendre in the drawings inspire a complex platform for me to perform and animate."[2] By transposing his mother's visions into his own dreamlike, floating universe—a glitchy, sci-fi world where pop music, art history, and mythology converge—Satterwhite gave them a new, digital life. With a shimmering electronic score, *Reifying Desire* also marks a key development in the use of sound that would influence his later films.

The chapters in *Reifying Desire* are largely organized around rituals of healing. *Reifying Desire 3: The Immaculate Conception of Doubting Thomas* (2012), for instance, merges Patricia's medical drawings—pill capsules, fire poles, "thongs to escape," and magnetic body bands for pain—with nude images of Satterwhite floating through a starry galaxy. Levitating amid luminous blue and purple triangles, one of Satterwhite's avatars dons a black harness that conflates Patricia's body band with BDSM attire. (Many depersonalized, digital figures appear in his films.) Another figure drifts on his back while his stomach expands, evoking the painful bloating known as "chemo belly"—a condition

2 http://monyarowegallery.com/files/ART_PAPERS_artistproject_p27_31_final%5B1%5D.pdf

painfully familiar to the artist, who was treated for cancer of the arm when he was a child growing up in South Carolina. The music is ethereal and dreamy.

Reifying Desire 3, also recreates—and tweaks—Caravaggio's iconic homo-erotic painting, *The Incredulity of Saint Thomas* (1601–2), which depicts the saint probing Jesus's wounds after the Resurrection. Satterwhite animates the Baroque painting, modeling the apostles after nude versions of himself, with a small video placed over Christ's injuries. Their close embrace highlights the eroticism in Caravaggio's painting while also emphasizing a kind of self-love, as multiple Satterwhite-saints hug one another while expressing disbelief in survival. Throughout the film, Satterwhite connects the Biblical parable, with its exploration of faith, doubt, and the metaphysics of bodily injury, to his own struggles with cancer and mortality, as the trio of descending MRI scans with their radiating beams of light makes clear.

Doubting Thomas appears throughout his films. In a recent work created for *Room for Living* at The Fabric Workshop and Museum in Philadelphia (2019–20), the configuration of saints from *Reifying Desire 3* were fabricated as a larger-than-life sculpture. Satterwhite has connected the Biblical story significance to his broader relationship to art, which affirms and grounds his own corporeal existence and sense of faith in himself: "During that period of time when I had cancer," he told T. Cole Rachel in *The Creative Independent* (2019), "I relied on art making and art processes and gaming as way to kind of channeling my energies in order to survive. Afterwards, I think I was just traumatized. I was thinking about my own mortality, so I made marks in order to leave something behind to prove that I am real."[3]

Like *Reifying Desire 3*, *Reifying Desire 5* (2012) invokes a canonical work to explore self-care and regeneration, by fusing his mom's drawings of bubble bath soaps with Pablo Picasso's *Les Demoiselles D'Avignon* (1907). Picasso's women are transposed into a tub designed by Patricia ("Water Tub Seat to soak in") while an avatar pours hot pink bath beads over them in a dance ritual that includes a death drop. Later, a hermaphroditic figure with breasts and a

3 https://thecreativeindependent.com/people/artist-jacolby-satterwhite-on-trusting-your-own-process/

giant penis ejaculates miniature, cat-suited iterations of Satterwhite into the cosmos, where they turn and pose in triangle frames.

Satterwhite's use of metamorphosis, mirroring, and self-replication—in this work and others—reflects the influence not just of surrealist strategies, but remix culture as well. Consider, for example, the architectural sources he stitches together to build his uncanny, capacious worlds, which bridge centuries and disciplines: Boschean hellscapes, shopping mall escalators, Roman coliseums, catwalks, go-go cages, spiderwebs, amusement parks, S&M dungeons, night clubs, merchandizing displays, crop circles, braided baskets, mutating cells, Fritz Lang's *Metropolis* (1927), B-movie spaceships, Akira Kurosawa's *Rashomon* (1950), early Renaissance polyptychs, and video games. Through this vast network of associations, Satterwhite infuses the mechanical with the sensual, destabilizing our sense of space and place while questioning the distinctions between real and unreal, digital body and breathing flesh.

In *Healing in My House* (2016), a man rides a shiny black pegasus—shaped like a balloon animal—high above a rugged seascape. Atop the mythic creature's head sits a female torso, her face a bulbous tumor framed by a long curly weave. They glide through the sky accompanied by a spaceship shaped like a treadmill, which transforms, over the course of the film, into a scaffold of triangles and gears. Two chained figures propel the contraption, ferrying passengers engaged in erotic play. Their leader, a white blonde woman (Egyptian trans activist and nightlife icon "Iman Le Caire") wearing a leather-studded harness, rises forth at the bow like a siren figurehead who casts spells with vogue-like hand gestures. The hallucinatory scene is intercut with images of the artist dancing at the Spectrum, an influential, artist-run nightclub in Brooklyn; dystopian cityscapes; figures performing repetitive factory-like motions; floating rocks; a merry-go-round under a bell jar; and diagrams of Patricia's drawings for toilets and bathroom fixtures. *Healing in My House* is one of the first instances where Satterwhite incorporates his mother's pop-inspired, home-recorded songs, which she made using a tape player. "When you come into my house," she sings against an electro-minimalist dance track, "there is no doubt, there's a feeling of healing in my house."

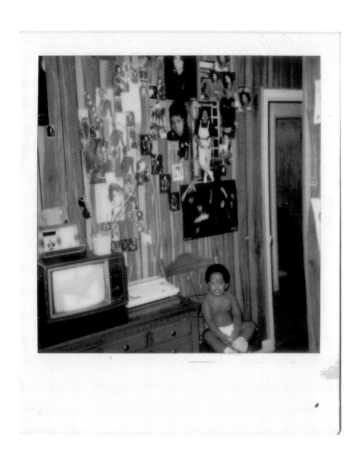

Photograph of Jacolby Satterwhite with Janet Jackson photos, c. 1987.
From the archive of Jacolby Satterwhite.

A leader of her church choir and a fan of nineties-era pop, R&B, and deep house, Patricia Satterwhite's love of music left an impression early on in her son. In a polaroid of the artist when he was a toddler—included in *The Matriarch's Rhapsody*—Satterwhite sits on a wooden chair in front of a wall of memorabilia and photos of Janet Jackson. Jackson's military-inflected choreography, avant-garde fashion, and utopian story arc mesmerized both Satterwhite and his mother; its serialized, multimedia structure and rhythmic pacing can be found in Satterwhite's own penchant for building atmospheric worlds across multiple chapters, and in his increasing reliance on music for his work, often built around his mother's songs.

With the film and installation *Blessed Avenue* at Gavin Brown's Enterprise in New York in 2018, the artist brought his bespoke virtual world (and his mother's music and inventions) into the physical space of a gallery. Part pop-up store, part underground club, it presented a new film alongside a boutique called "Pat's" (produced in collaboration with David Casavant) that sold mugs, notebooks, calendars, and pencils branded with Patricia's drawings, in addition to cloth dolls of Satterwhite wearing outfits based on performance costumes. During the course of the exhibition, while visitors shopped, Juliana Huxtable, Lourdes Leon Ciccone, and DeSe Escobar performed onscreen, transported from Satterwhite's green screen studio to a filmic landscape inspired by night clubs, hotels, and David Lynch's Red Room from *Twin Peaks* (1990–17). In one playful encounter, Huxtable brandishes a braided whip, flogging a collared Satterwhite. Dissolving boundaries between artwork and audience, the giant, double-sided projection, with its pulsing kaleidoscope of fantasy and commerce, induced a trance-like state redolent of raves. *Blessed Avenue* was made in the aftermath of his mother's death in 2016. Despite the work's exuberant theater, Satterwhite's profound grief can be heard in the driving soundtrack of Patricia Satterwhite's songs, now enhanced with swelling electronic and orchestral music made in collaboration with the musician Nick Weiss.

Satterwhite and Weiss followed *Blessed Avenue* with a full album, *Love Will Find A Way Home* (2019), transforming his mother's lo-fi music into a more somber, dancier soundtrack. As a requiem, replete with orchestral strings and techno beats, the record enacts an otherworldly call-and-response between mother and son. Released under the name PAT, the fourteen-track, hour-and-a-half-long album includes an impressive roster of collaborators including Kindness, Lawfawndah, Brody Blomqvist, and cellist Patrick Belaga. Nick Weiss, evoking its dark yet celestial sound, conveys the maternal inscription throughout as a "mixture and journey between nihilistic loss and spiritual arrival [that] felt timely and close to us," as he told *Live Eye TV* in 2019.[4]

4 https://www.liveeyetv.org/2019/10/music-news-pat-releases-blessed-ave-ft-brody-blomqvist-single-with-video-from-jacolby-satterwhite/

Love Will Find A Way Home served as a score for the six-part video installation series, *Birds in Paradise* (2018–20), a two-channel animation juxtaposing a virtual coliseum with West African matriarchal rites. The circular motif of the former is echoed by crop circles, disco balls, drone footage of war zones, and performances that turn Satterwhite's body into a maypole. In one particularly memorable scene, Satterwhite is baptized by a Black mermaid. Created over a three-year period, the first half of the *Birds in Paradise* series was installed at Pioneer Works in late 2019. The retail component of *Blessed Avenue* reappeared in the Brooklyn-based institution, now as a music store, with posters, t-shirts, and records—a gesture both nostalgic and functional. Resurrecting the listening stations that Satterwhite spent hours glued to in the 1990s, the store offered its customers a similar experience before buying the record. "You don't think about music with CDs and vinyl and 8-tracks anymore," Satterwhite told *Art News* in 2019. "What relationship in this contemporary [digital] medium can the listening experience have with an object? That's virtual reality and VR-headsets. It brings a re-entry back to the music as well, because in order to consume the sound and the visuals, you have to look up, look down, look left, look right to listen to the album. For me, it's more of an experiment in intersecting mediums."[5]

Satterwhite's remix of old images and the new, like the repurposing of his mother's songs and lyrics, similarly yokes the past to the future. Hypnotic and magical, *Birds in Paradise* summons the utopian promise of his mother's practice through the prism of his own queer desires. As such, it is neither swan song nor eulogy, but a posthumous collaboration where mother and son perform in filmic perpetuity, and agency is renewed through loss.

5 https://moranmorangallery.com/my-palette-is-a-40-gigabyte-hard-drive/

Reifying Desire

This collection of films began as an investigation into performance, an abstract artistic form free from the constriants of biography, which allowed for an expansive immersion into the digital realms of Afro-futurism. In the three years spent creating this sextet series, one can feel that Satterwhite establishes his confidence as a three-dimensional pioneer. Testing boundaries and limits in his practice, Satterwhite demonstrates an incessant need to comprehend and dissect multiplicity within himself and the environments from which he has derived. This includes the queer Black experience and the shadows in which we gather and rejoice through movement, his mother Patricia and her objects, as well as pop-cultural references that are both critical and empathetic to the hopeless contradictory norms of America.

The origins of body control, restraint and performance as a means of survival was established during the creation of the United States of America. Enslaved Africans used movement as means of communication and resistance. Satterwhite acknowledges this history by continuing the practice of nonverbal communication as a vehicle for human intimacy and understanding. The sequence can be viewed as a birth cycle of developmental expansion and evolution, as it was created during Satterwhite's own Saturn return—an astrological marker when Saturn makes it first return to the place in the sky it was at the time of a person's birth. Satterwhite's ability to build worlds by combining the analog with the digital is another form of queering—a natural inheritence of the diasporic Black experience. Satterwhite performed and filmed all of the digital avatars' body movements himself, then uploaded the footage into animation software; the aesthetic evokes a fantastical video game. Each film progressively begs the question with higher frequency: How many ways can one contort without breaking?

S.B.

Still of *Reifying Desire 5*, 2012. 3-D animation and video with sound. 8:47 minutes. Courtesy of the artist; Lundgren Gallery, Palma de Mallorca, Spain; Mitchell-Innes & Nash, New York and Morán Morán, Los Angeles.

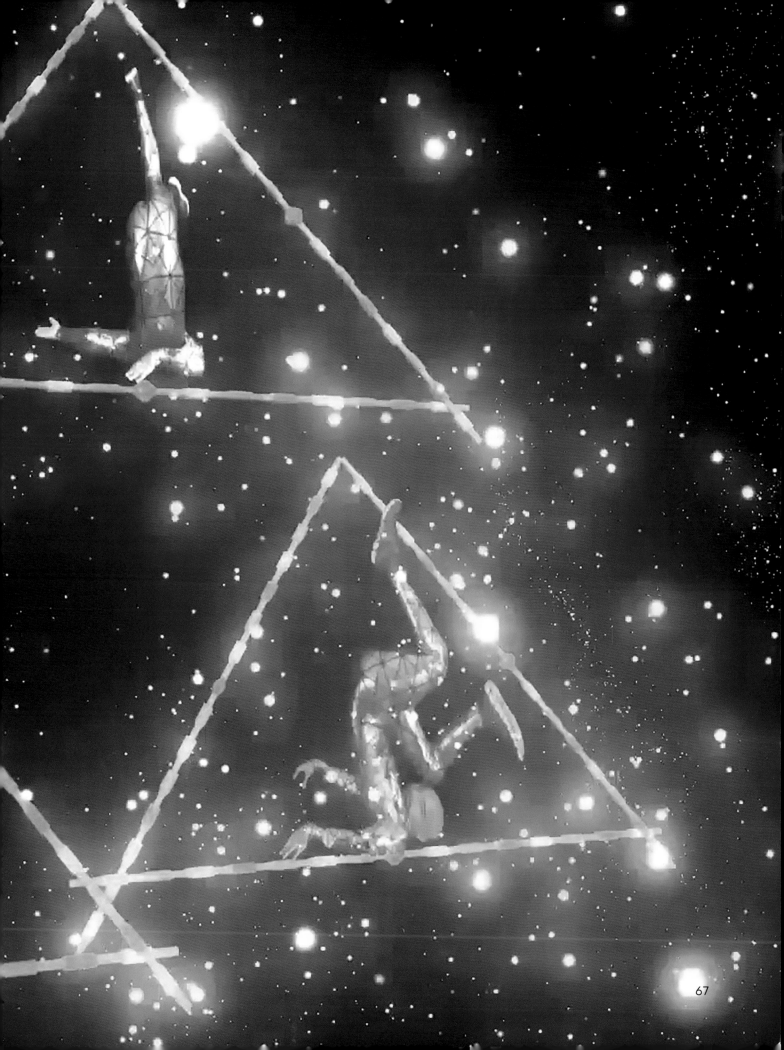

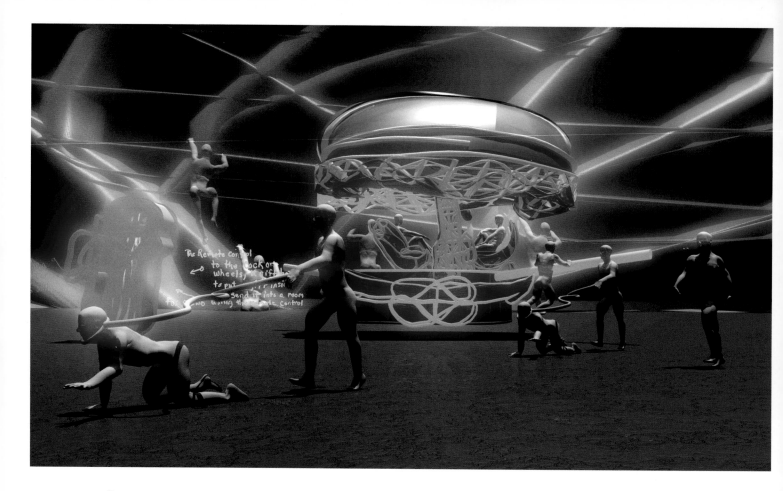

Reifying Desire 1

Stills of *Reifying Desire 1*, 2011. 3-D animation and video with sound. 4:02 minutes. Courtesy of the artist; Lundgren Gallery, Palma de Mallorca, Spain; Mitchell-Innes & Nash, New York and Morán Morán, Los Angeles.

Reifying Desire 1 begins with cyborg figures moving inside a phallus-shaped structure that was drawn by his mother as a remote control cock. Satterwhite reimagines this figure as an origin space. A place of commencement for this series. One can see that Satterwhite is beginning his relationship with animation here, and like all new relationships, they can be beautifully experimental in form and brightly refreshing as they follow no established paths of progression. Using hybridized objects and figures practicing S&M openly in the neon-colored world of toy cocks that read in Patricia's handwriting, "like a toy car" as if the only way that one can control a phallus is with a remote control. Satterwhite is able to transform abstract concepts that pull from a wide range of influences into a storyline of comprehension. Text that reads numerator and denominator questions the hierarchy of society and capitalism's need to dominate for order to be maintained. A carousel of masculine cyborg figures move synchronously on the backs of other cyborgs, questioning if sex and intimacy can ever be independent of capitalism and the established norms of religion.

S.B.

A Carocell

w/ music
to play

Still of *Reifying Desire 1*, 2011. 3-D animation and video with sound.
4:02 minutes. Courtesy of the artist; Lundgren Gallery, Palma de Mallorca,
Spain; Mitchell-Innes & Nash, New York and Morán Morán, Los Angeles.

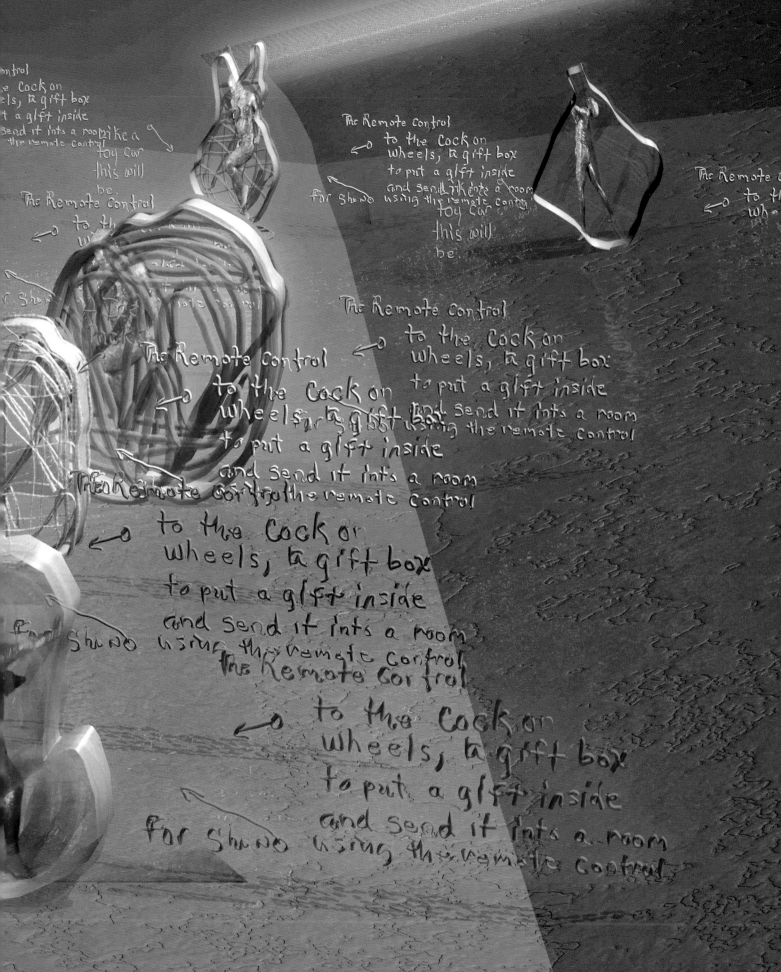

The Remote control
to the Cock on
wheels, a gift box
to put a gift inside
and send it into a room
using the remote control
toy car
this will
be.

The Remote Control
to the Cock on
wheels, a gift box
to put a gift inside
and send it into a room
using the remote control

The Remote Control
to the Cock on
wheels, a gift box
to put a gift inside
and send it into a room
using the remote control
the Remote Control

to the Cock on
wheels, a gift box
to put a gift inside
and send it into a room
using the remote control
the Remote Control

for shino to the Cock on
wheels, a gift box
to put a gift inside
and send it into a room
for shino using the remote control

A Level-
foting
Bed: t

Still of *Reifying Desire 1*, 2011. 3-D animation and video with sound.
4:02 minutes. Courtesy of the artist; Lundgren Gallery, Palma de Mallorca,
Spain; Mitchell-Innes & Nash, New York and Morán Morán, Los Angeles.

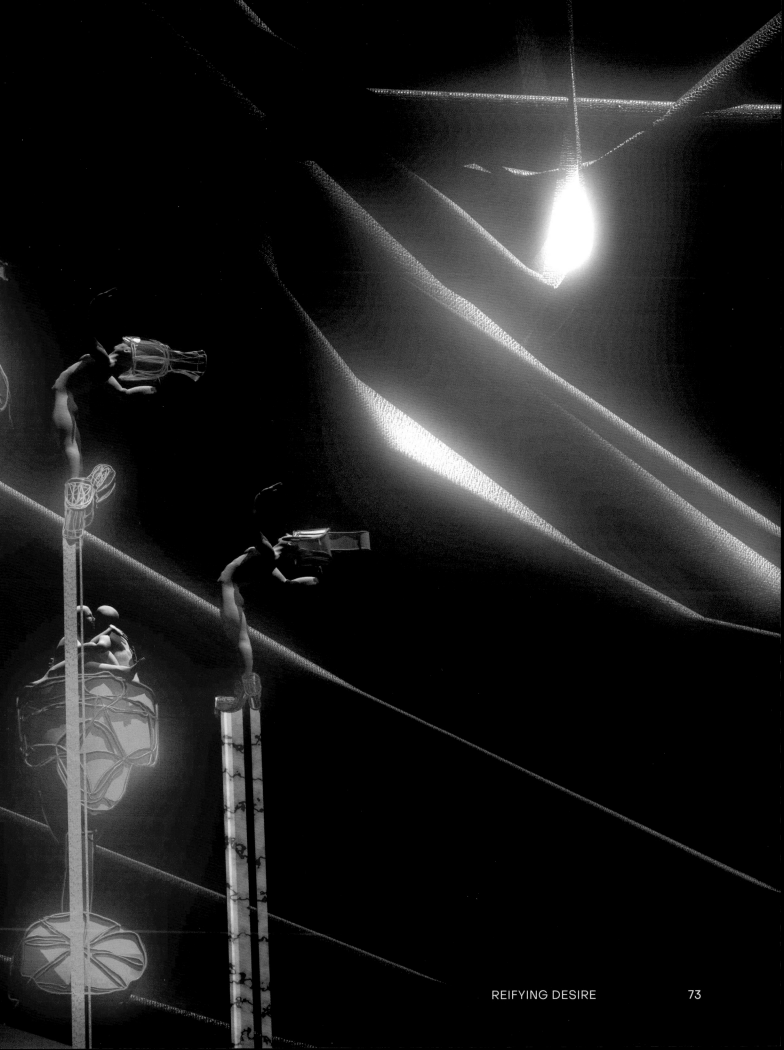

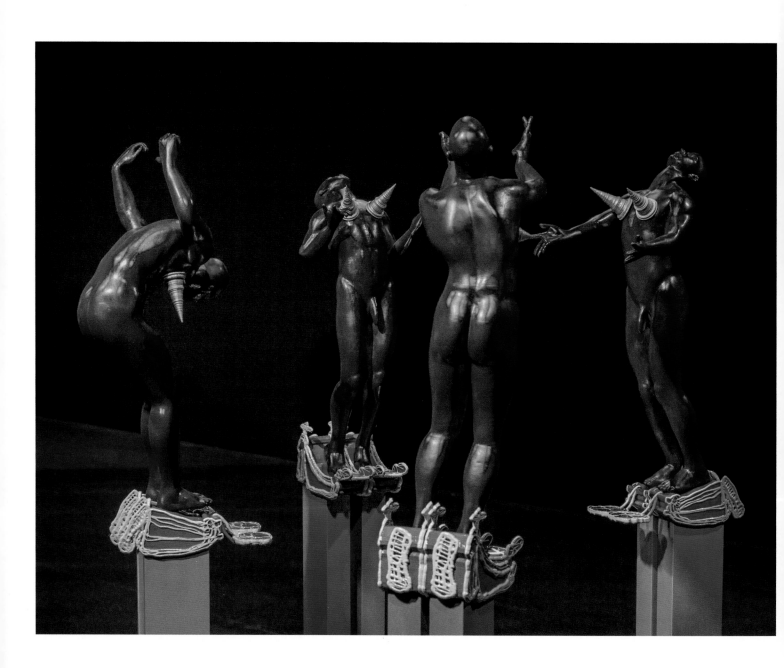

Installation views of *Reifying Desire 1* with related sculpture.
Jacolby Satterwhite, in collaboration with The Fabric Workshop and Museum,
Philadelphia. *Room for Ascension*, 2019. Mirrored acrylic, HD color video,
televisions, aluminum, enamel, plywood, PLA filament, epoxy, epoxy resin
and wood. 120 × 72 × 72 inches (304.8 × 182.9 × 182.9 cm). Installation view
of *Room for Living* at The Fabric Workshop and Museum, Philadelphia, 2019.
Courtesy of the artist and The Fabric Workshop and Museum, Philadelphia.
Photo: Carlos Avendaño.

74

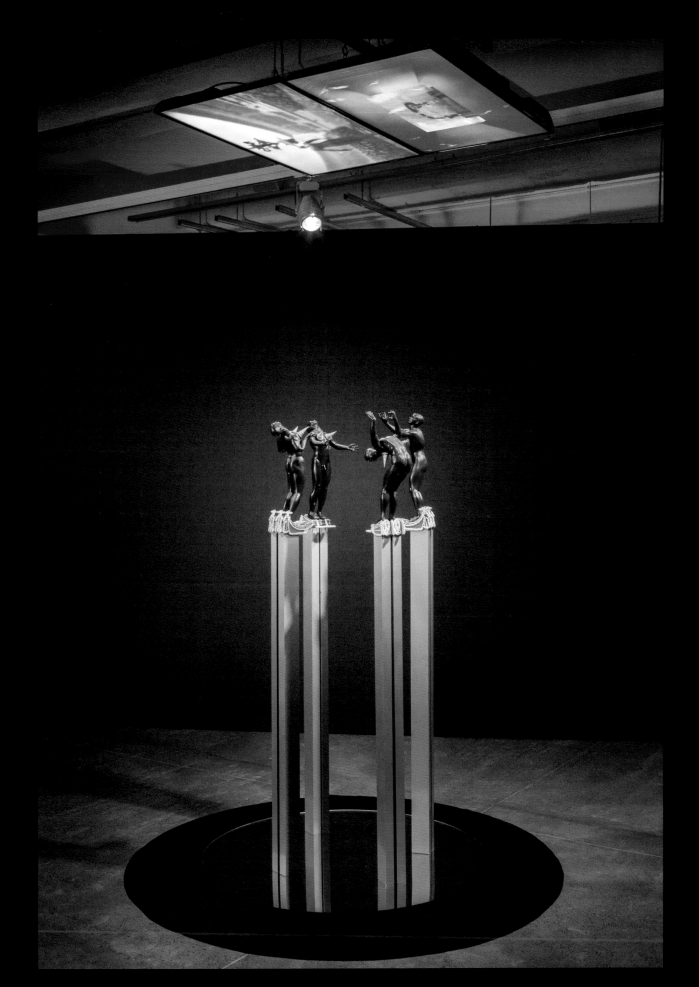

Reifying Desire 2

Stills of *Reifying Desire 2*, 2011. 3-D animation and video with sound. 8:23 minutes. Courtesy of the artist; Lundgren Gallery, Palma de Mallorca, Spain; Mitchell-Innes & Nash, New York and Morán Morán, Los Angeles.

Water is centrally positioned in *Reifying Desire 2* as the conductor of all movement and connection, both human and natural. The commencement of the film immerses the viewer into a sonic trance allowing for a calming atmosphere that fluidly blends the analog with the digital. Satterwhite positions himself as a genderless water bearer as he dances along a shoreline, gathering and spreading water from his cone shaped breasts to the futuristic world that he has built. In this world we see masculine cyborg figures in a lip-locked embrace in which their translucent bodies show that they are transferring fluids of life to one another through intimacy and physical touch. The transference of energy and life is also spread through the phallus of other cyborgs amongst an orgy of other concrete-colored figures, spraying fluids towards Patricia's *level-tating bed*, that is positioned as the central and most elevated point of the utopic environment. This element of the series focuses the viewer on mutation and evolution through both the natural and supernatural, allowing for a reimagined understanding of birth and reproduction.

S.B.

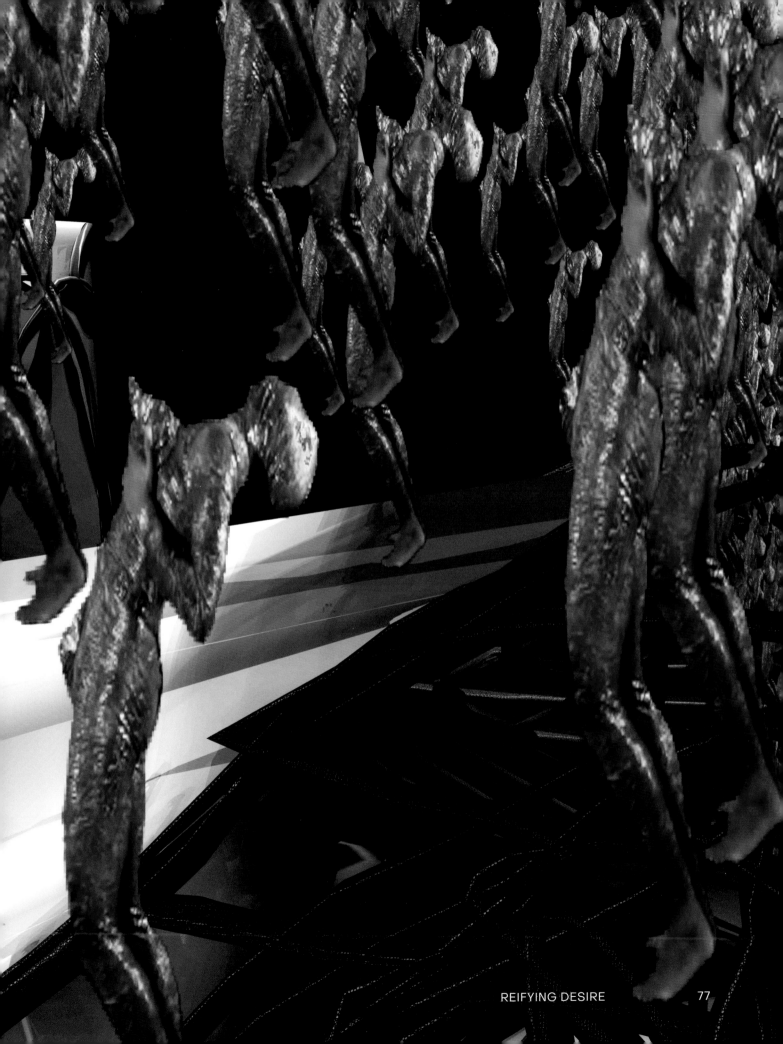

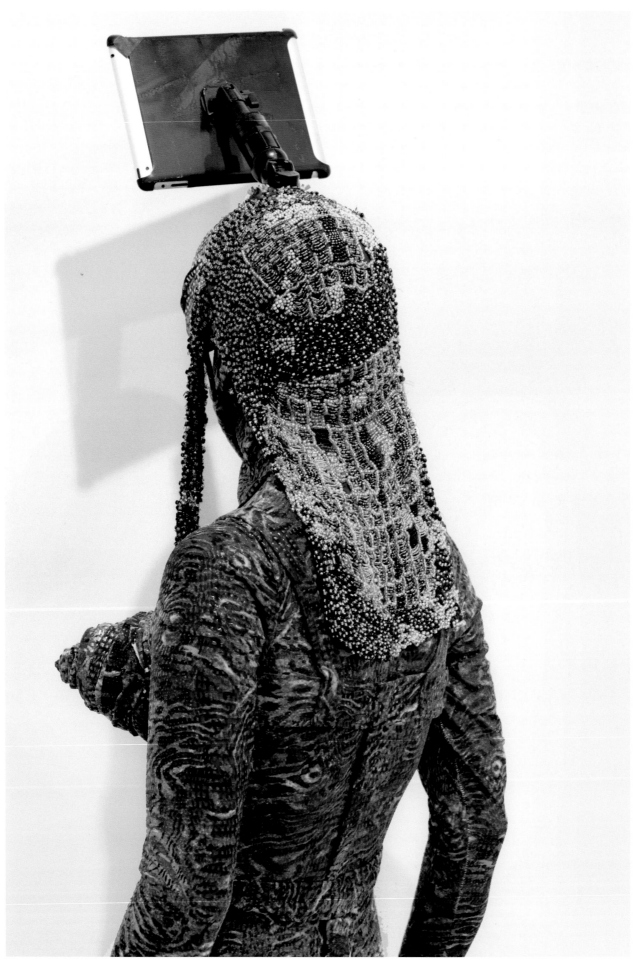

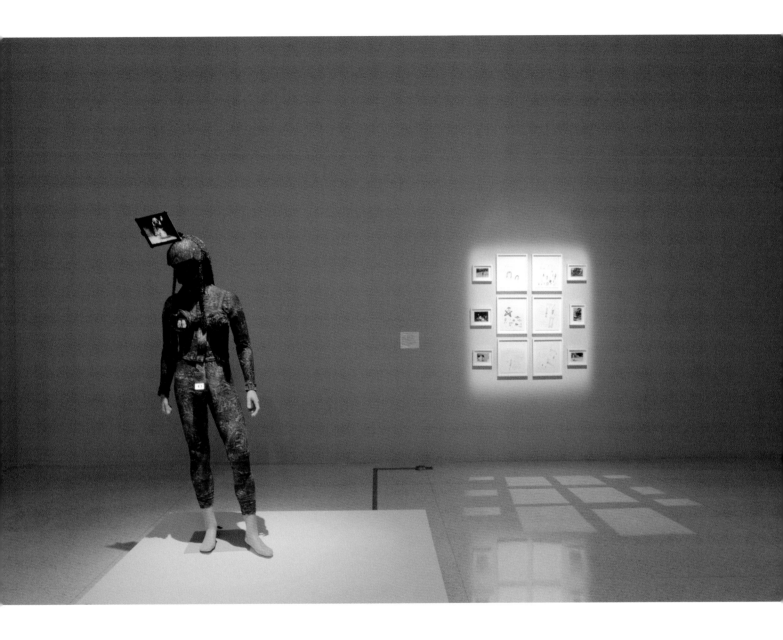

Above: *Orifice I*, 2010–12. Hand-sewn bodysuit, hand-beaded helmet, iPad, iPods, speaker, and mannequin. 84 × 38 × 24 inches (213 × 96.5 × 61 cm). Installation view of *Radical Presence: Black Performance in Contemporary Art* at Walker Art Center, Minneapolis, 2014. Courtesy of the artist and Walker Art Center, Minneapolis. Photo: Gene Pittman.

Opposite: Detail of *Orifice I*, 2010–12. Courtesy of the artist and Morán Morán, Los Angeles.

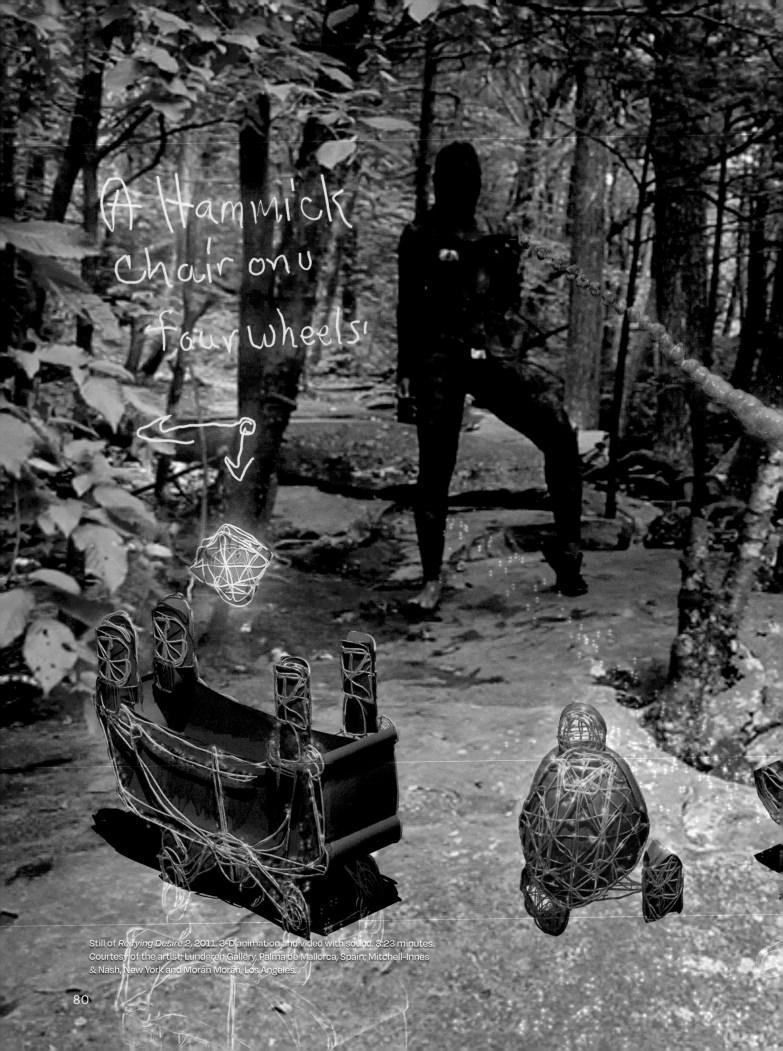

A Hammick chair on four wheels

Still of *Reifying Desire 2*, 2011. 3-D animation and video with sound. 8:23 minutes. Courtesy of the artist; Lundgren Gallery, Palma de Mallorca, Spain; Mitchell-Innes & Nash, New York and Morán Morán, Los Angeles.

80

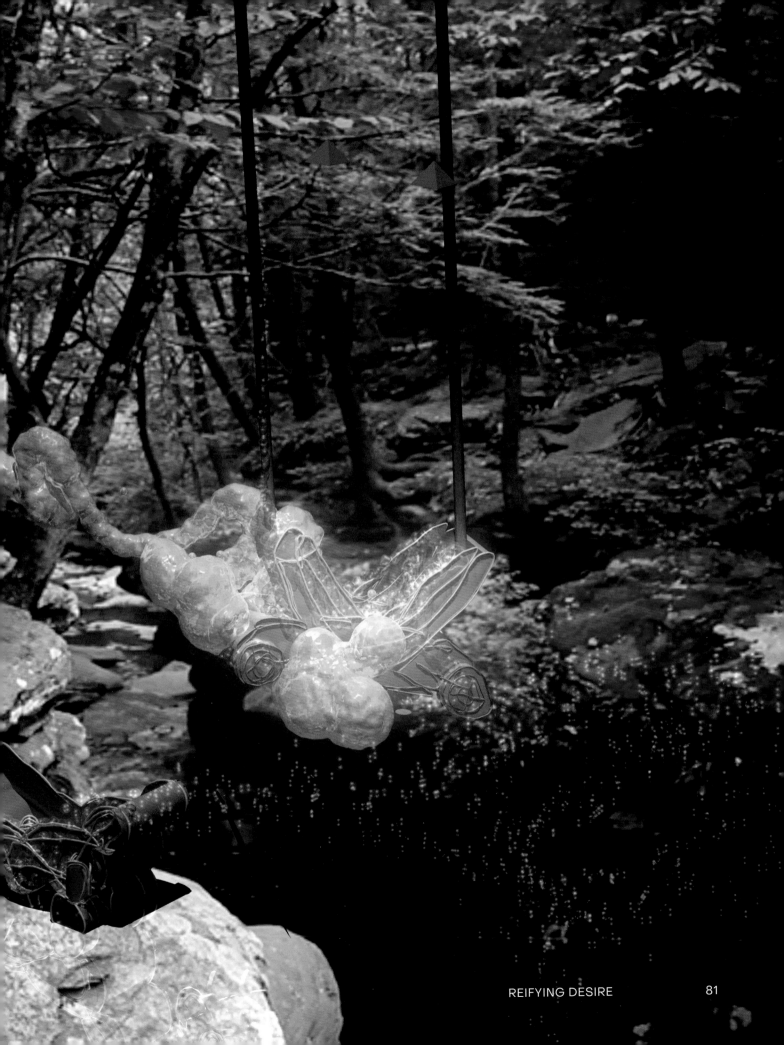

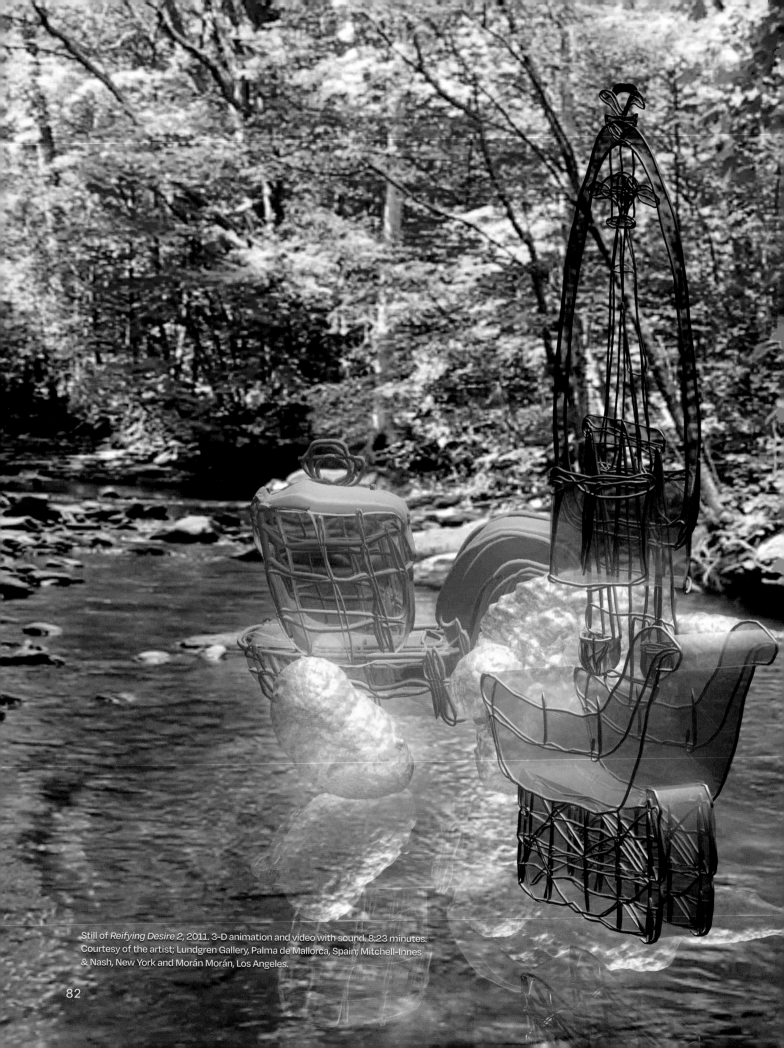

Still of *Reifying Desire 2*, 2011. 3-D animation and video with sound. 8:23 minutes.
Courtesy of the artist; Lundgren Gallery, Palma de Mallorca, Spain; Mitchell-Innes
& Nash, New York and Morán Morán, Los Angeles.

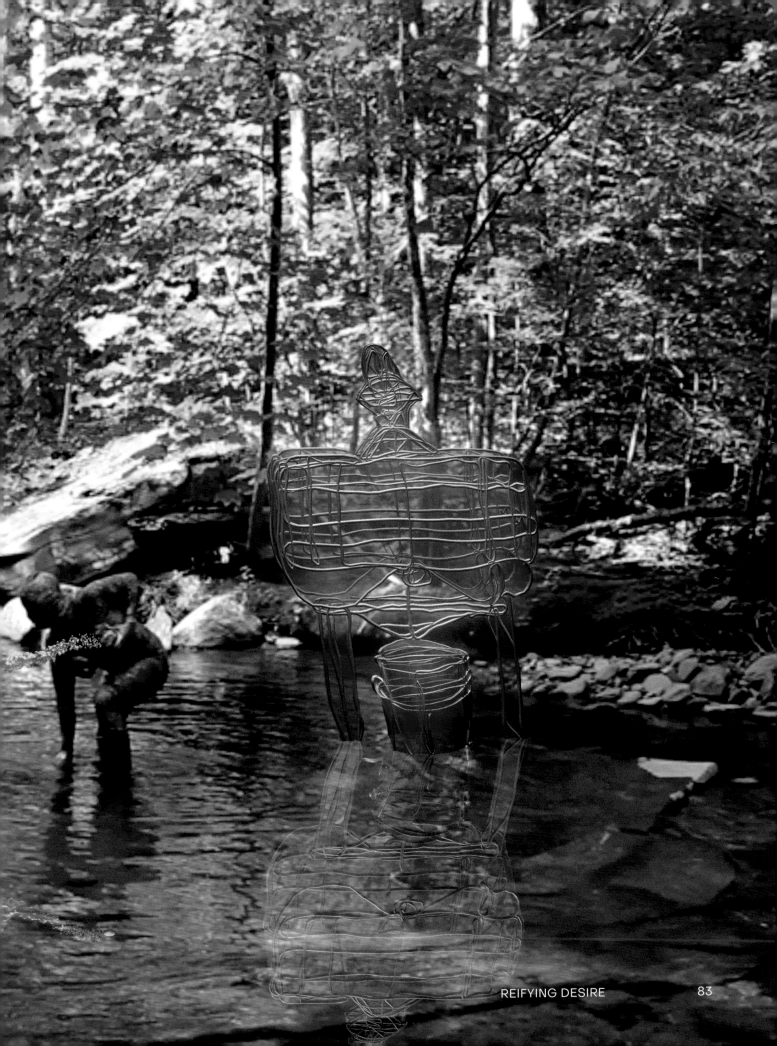

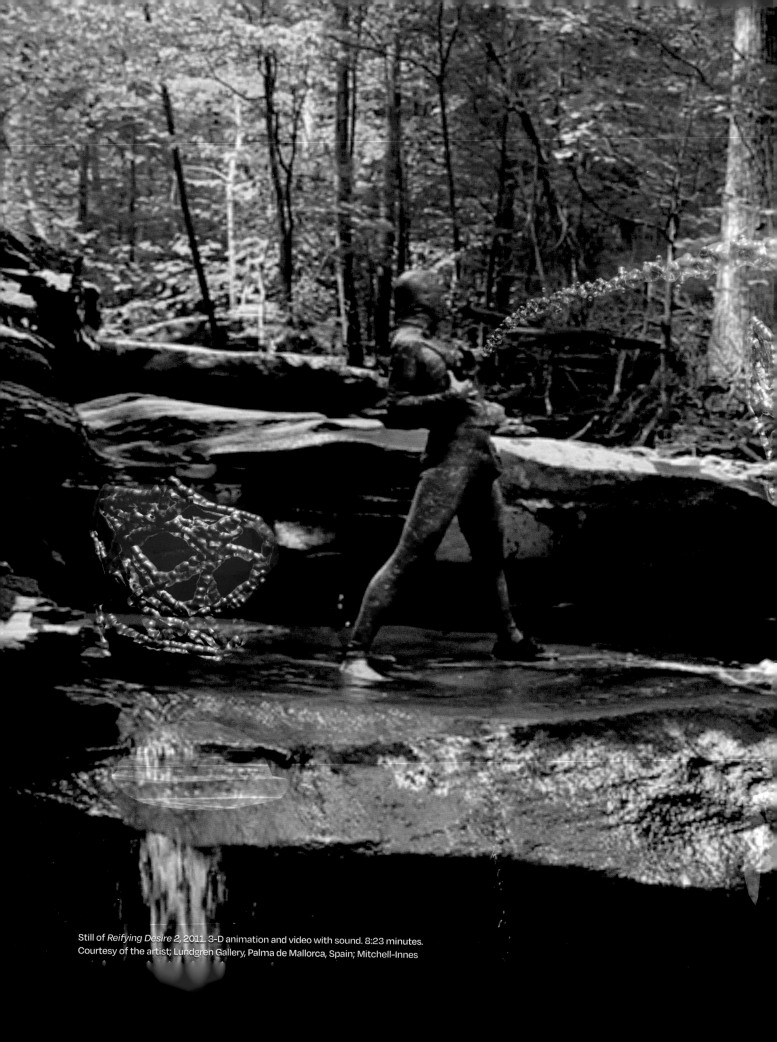

Still of *Reifying Desire 2*, 2011. 3-D animation and video with sound. 8:23 minutes.
Courtesy of the artist; Lundgren Gallery, Palma de Mallorca, Spain; Mitchell-Innes

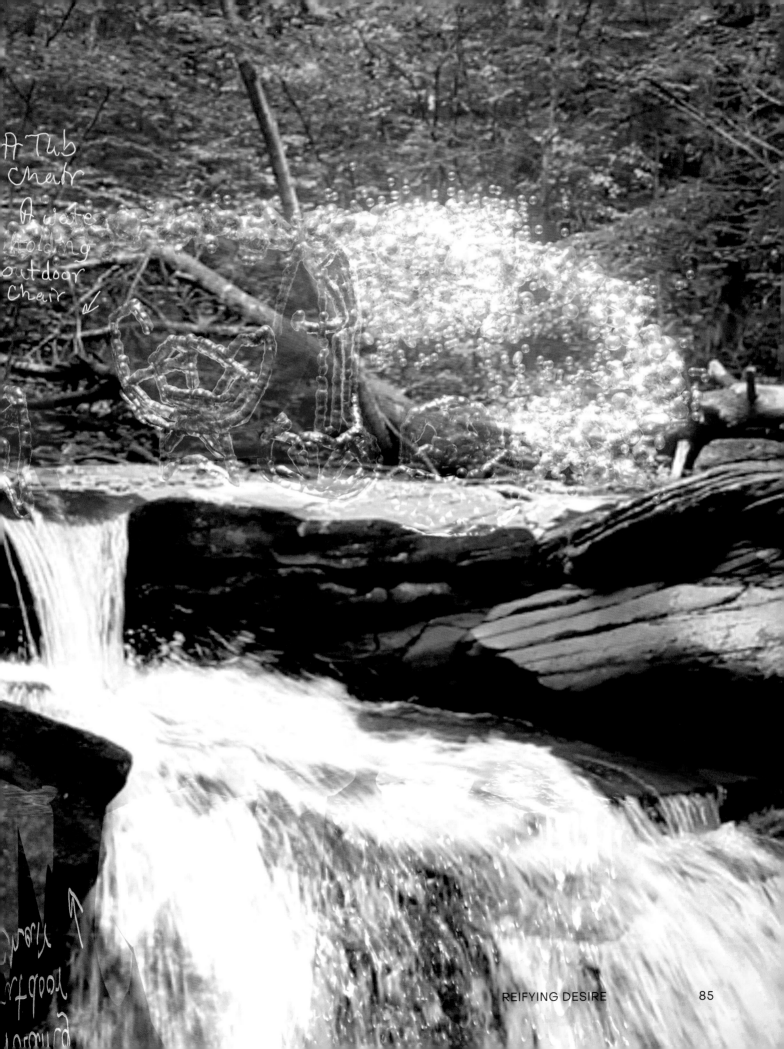

A Tub
Chair
A water
Holding
outdoor
Chair

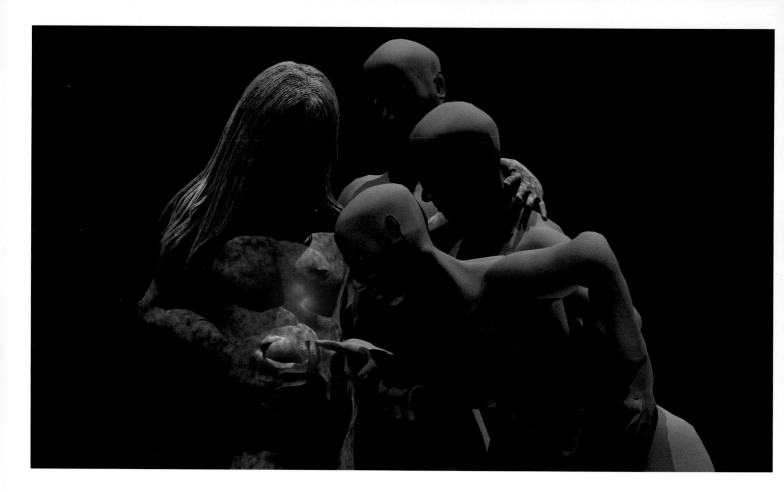

Reifying Desire 3

Stills of *Reifying Desire 3*, 2012. 3-D animation and video with sound. 8:25 minutes. Courtesy of the artist; Lundgren Gallery, Palma de Mallorca, Spain; Mitchell-Innes & Nash, New York and Morán Morán, Los Angeles.

The Doubting Thomas allegory depicted in Carravagio's painting is the central force of momentum in *Reifying Desire 3*. Saint Doubting Thomas could only verify his right to existence through physicality, a trait that Satterwhite shares. The allegory of skepticism plays a critical part in Satterwhite's practice as he considers the contemporary reality of our current world. Doubt becomes a recurring marker in his lexicon, showing up in many video works as well as his neons and prints. Through anthropomorphic biological creatures and cellular structures that float through what seems to be a dark underworld, Satterwhite produces evidence of the unseen. The viewer is submerged in a world made of darkness where neon glows like gaslights. The immensity of the darkness often contributes to feelings of stagnation and isolation, but it is here, in the dark, that evolution dwells. The cells move fluidly through the underbelly as Satterwhite vogues in a centralized stage that seems to be kinetically powering the energy of the cellular structures that mutate and cycle through phases that give birth to new forms. Within the darkness, we thrive. The darkness is not the absence of light, but the complete absorption of it. It is here that new life emerges.

S.B.

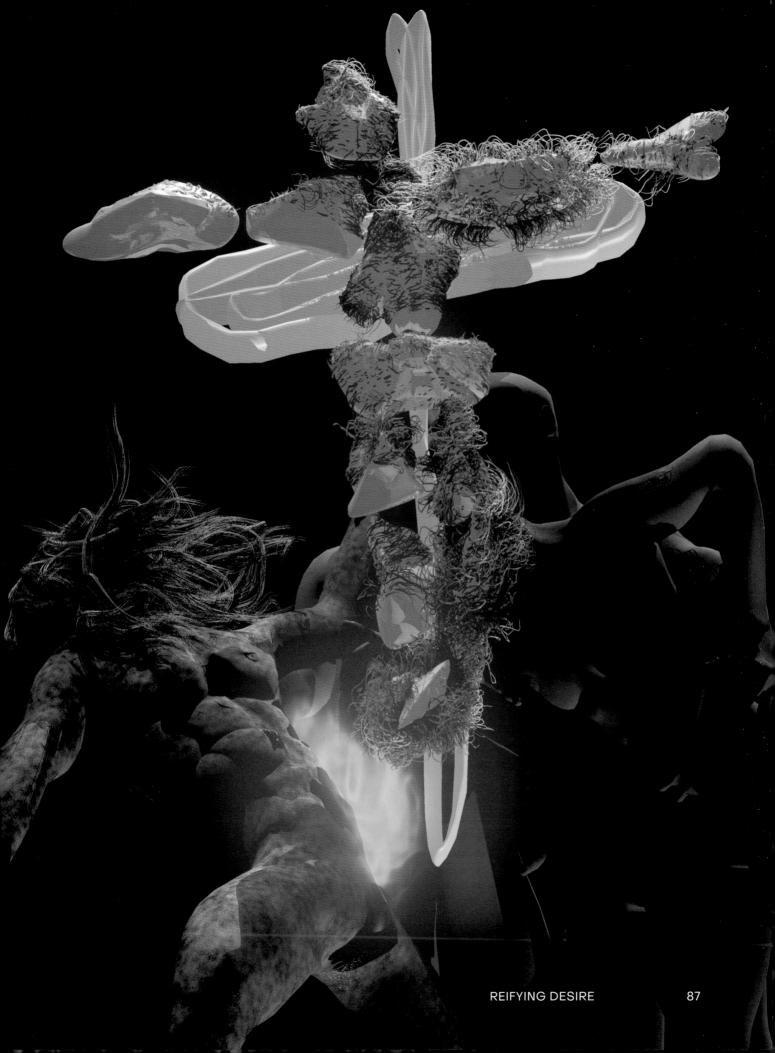

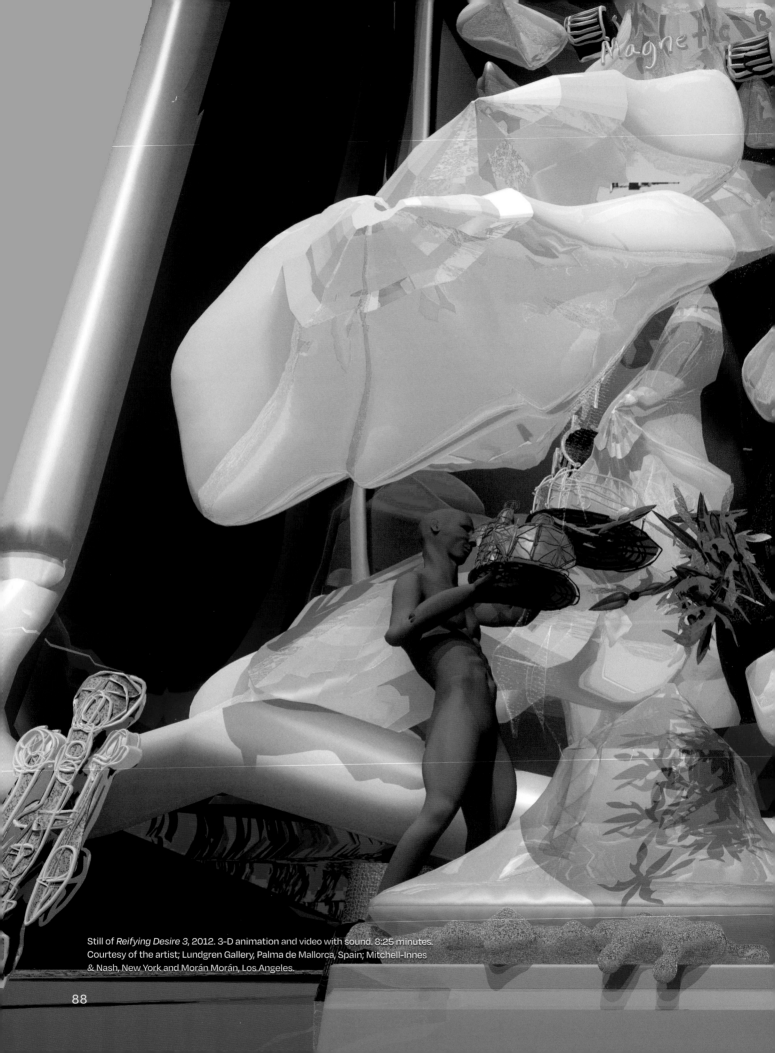

Still of *Reifying Desire 3*, 2012. 3-D animation and video with sound. 8:25 minutes. Courtesy of the artist; Lundgren Gallery, Palma de Mallorca, Spain; Mitchell-Innes & Nash, New York and Morán Morán, Los Angeles.

pain in the body
Body Bands!
e bands on the paini

Bonds are the way to
ear the
sitive m
tive ma
e neg
bec
raci
th
he '
the
e ar
the Positi
Bands,

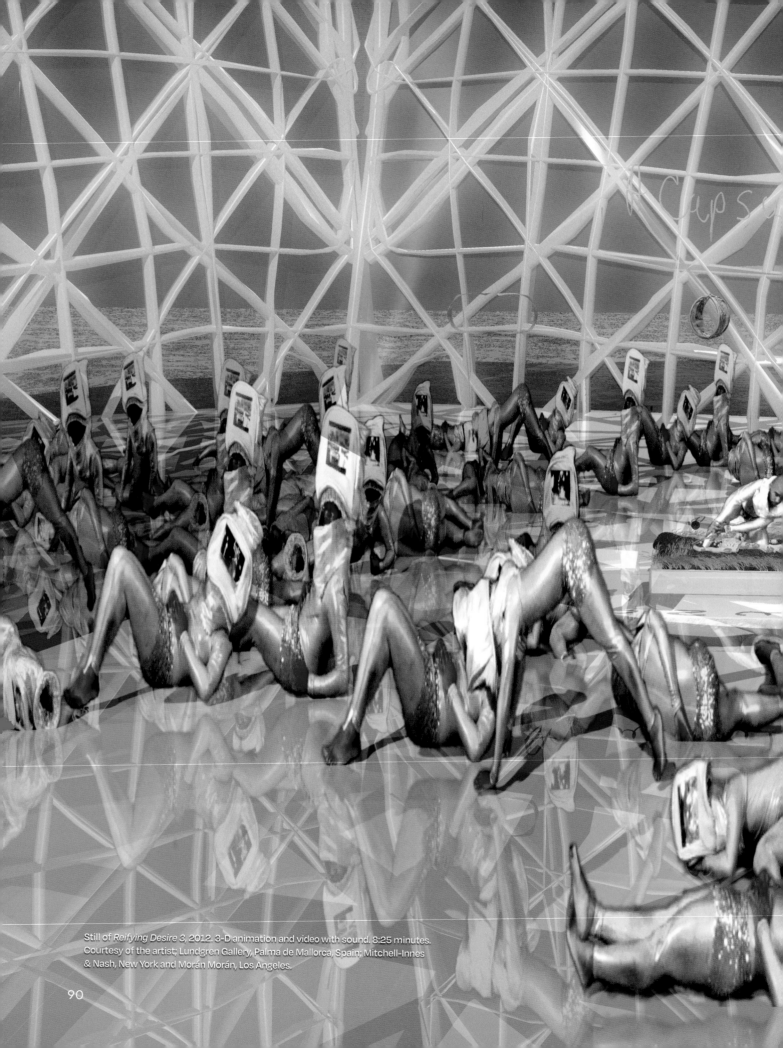

Still of *Reifying Desire 3*, 2012. 3-D animation and video with sound. 8:25 minutes.
Courtesy of the artist; Lundgren Gallery, Palma de Mallorca, Spain; Mitchell-Innes
& Nash, New York and Morán Morán, Los Angeles.

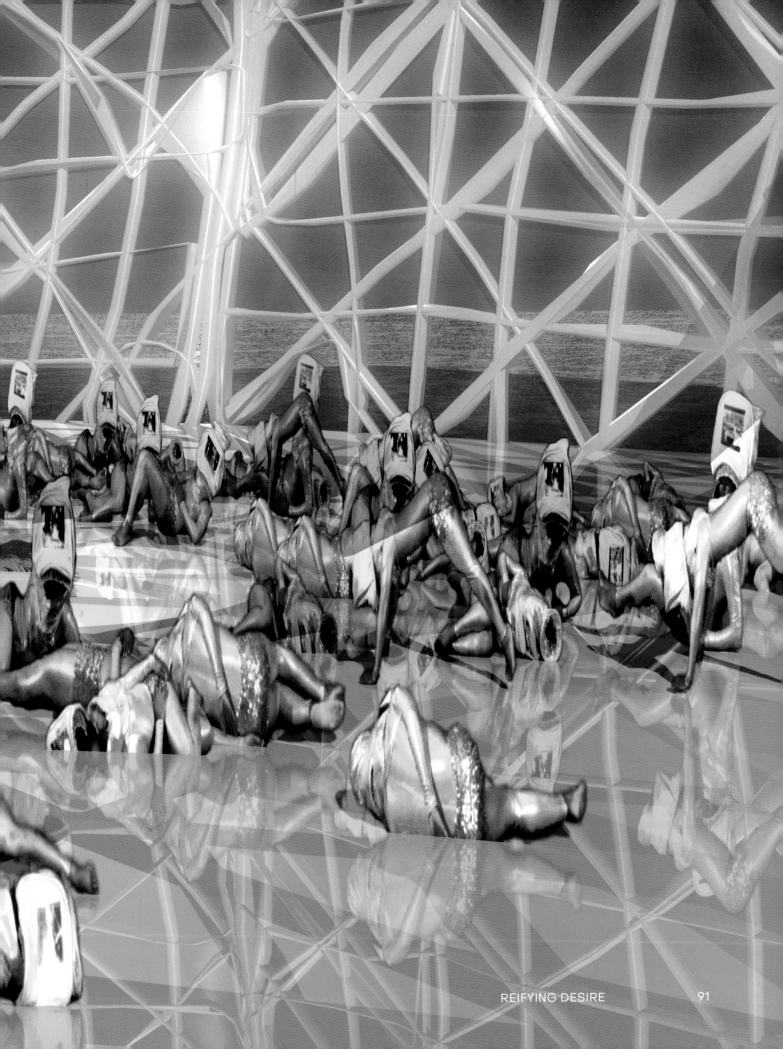

Reifying Desire 4 – Model It

Stills of *Reifying Desire 4 – Model It*, 2012.
Two-channel video installation exhibited on
a perpendicular wall with performance by
Satterwhite. 10:36 minutes. Courtesy of the
artist; Lundgren Gallery, Palma de Mallorca, Spain;
Mitchell-Innes & Nash, New York and Morán Morán,
Los Angeles.

Reifying Desire 4 is a two-channel video of nature v. urbanity. When exhibited, this diptych is displayed on a perpendicular wall, allowing for the viewer to understand the intersections that exist when moving between worlds. Patricia sings in a raspy and comforting voice that resembles an embrace as Satterwhite vogues through New York City's Upper East Side. She encourages him to never stop. Taxis and people and pets traverse across the screen as if Satterwhite is invisible, but he continues still. The X-men army base is also featured in this film, furthering the concept of mutant othering. In this diptych, Satterwhite's weaponizing of the ponytail occurs again; as a combat agent, the ponytail protects the body from invaders as Satterwhite performs amongst the trees. The sequence of the *Reifying Desire* films shifts and turns throughout the narrative, existing as a body of its own.

S.B.

92

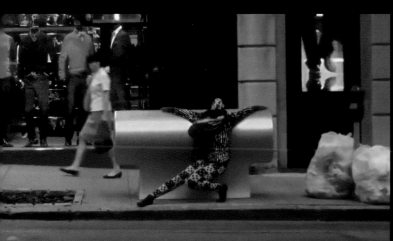
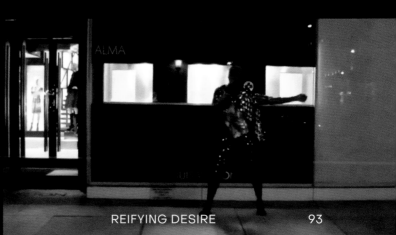

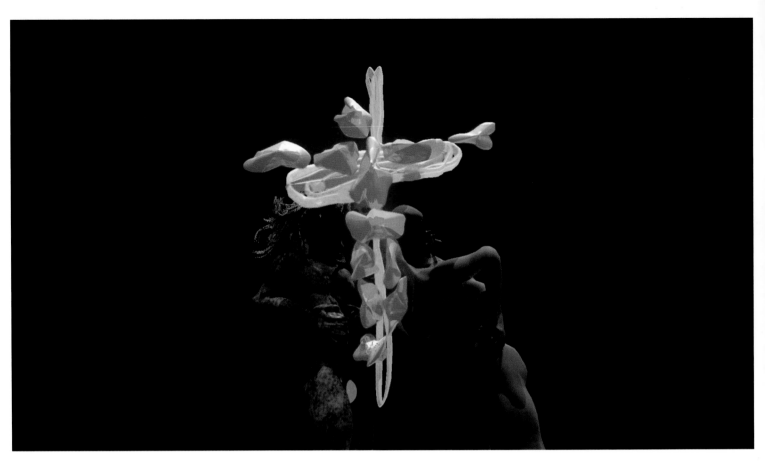

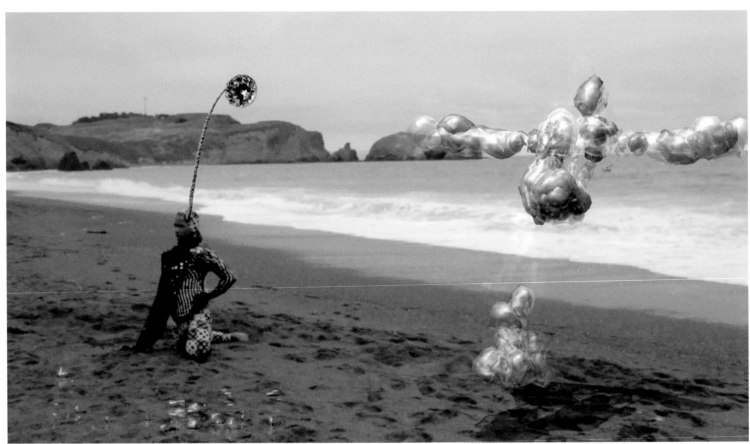

Stills of *Reifying Desire 4 – Model It*, 2012. Two-channel video installation exhibited on a perpendicular wall with performance by Satterwhite. 10:36 minutes. Courtesy of the artist; Lundgren Gallery, Palma de Mallorca, Spain; Mitchell-Innes & Nash, New York and Morán Morán, Los Angeles.

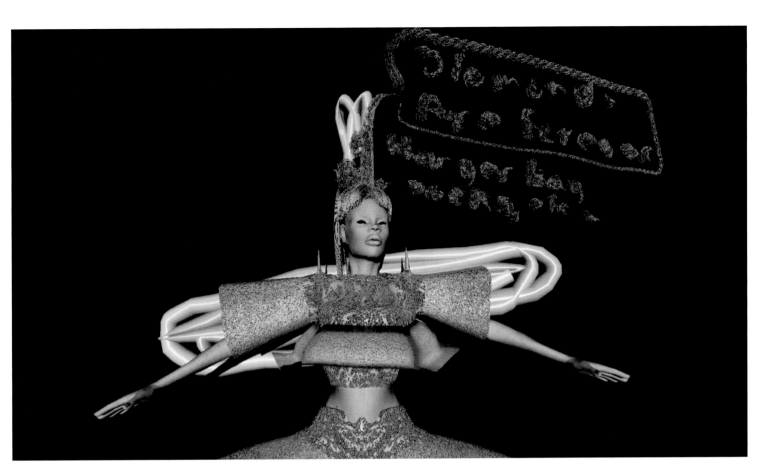

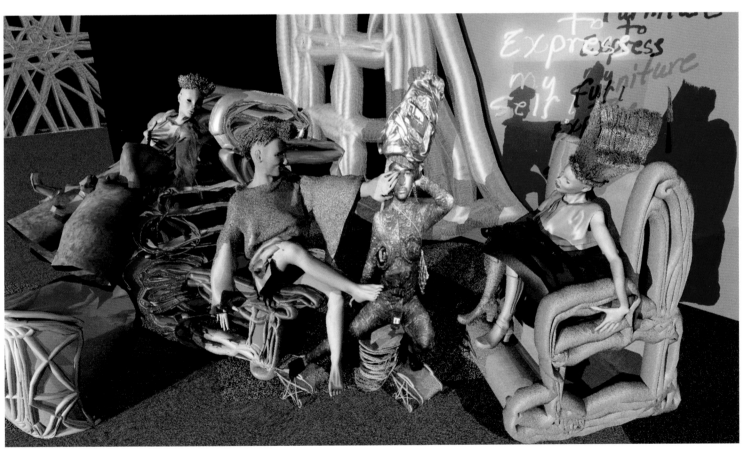

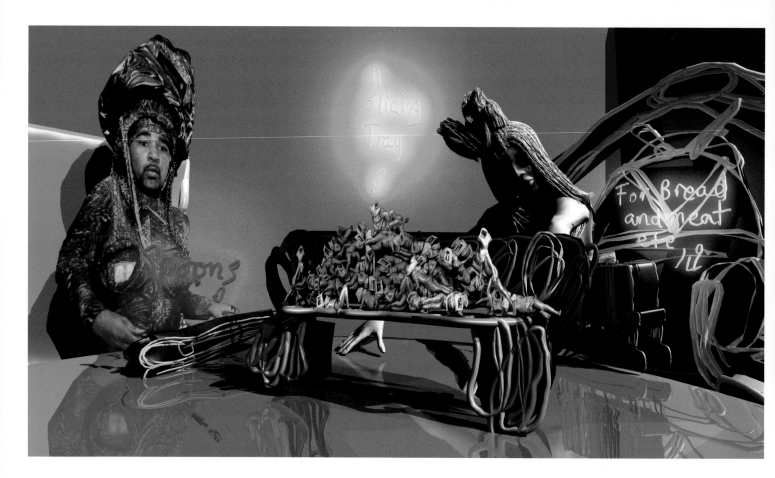

Reifying Desire 5

Stills of *Reifying Desire 5*, 2012. 3-D animation and
video with sound. 8:47 minutes. Courtesy of the
artist; Lundgren Gallery, Palma de Mallorca, Spain;
Mitchell-Innes & Nash, New York and Morán Morán,
Los Angeles.

Patricia writes, "For Pussy Power pour bub-
ble bath into the bathtub, into the water and
soak for a while to turn the smell of pussy off."
A bath is a place of healing and retreat. The clos-
est we come to reentering the womb in our daily
lives. It's warm and we submerge into a struc-
ture that holds us close. A place to have some
moments. A place for solitude. A 3-D version of
this instructional note from Patricia about Pussy
Power circulates reimagined in neon as *Reifying
Desire 5* opens and Satterwhite appears, covered
in chrome dancing and watering the women.
The women are concrete-colored femme bots
who rest beneath him resembling Picasso's *Les
Demoiselles d'Avignon*, 1907, and their pubics
are replaced by brown bushes on fire that he
waters with a thick pink viscous secretion. One
of the femme bots is sacrificed on a crucifix.
Images of Satterwhite's mother Patricia float
through this world as if she is there to bear wit-
ness. A femme bot then grows a phallus that

shoots out miniature Jacolbys, a creation of
both the masculine and the feminine. In Greek
mythology, the poet Orpheus could entrance
beasts with the beauty of his singing and went to
the underworld after the death of his wife Eury-
dice to secure her release, but lost her because
he failed to obey the condition that he must not
look back at her until they had reached the living
world. Within Satterwhite's figurative sculpture
one can locate this same desire for resurrec-
tion and the artist's yearning for his mother. In
this fantasy world, the artist extinguishes the
flames of pain that attached themselves to her,
and as such, he repairs an inevitable condition
of the Black femme experience. Satterwhite's
preoccupation with matriarchy and mythology
merges here to form a world of reification of
femme power.

S.B.

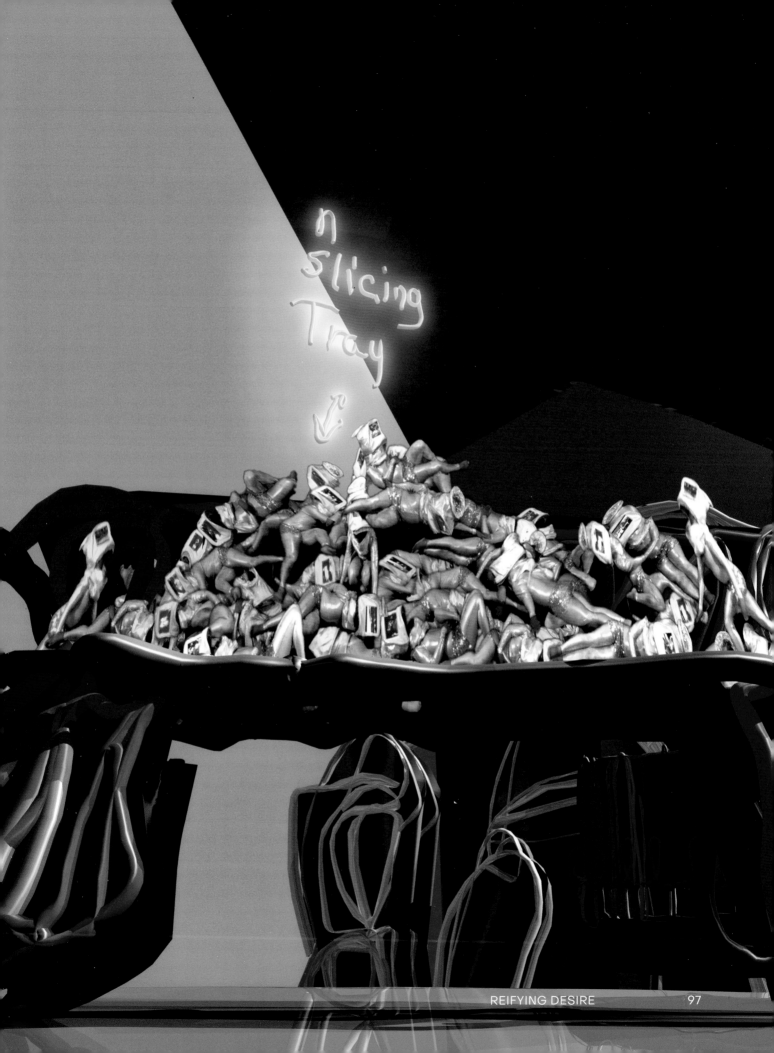

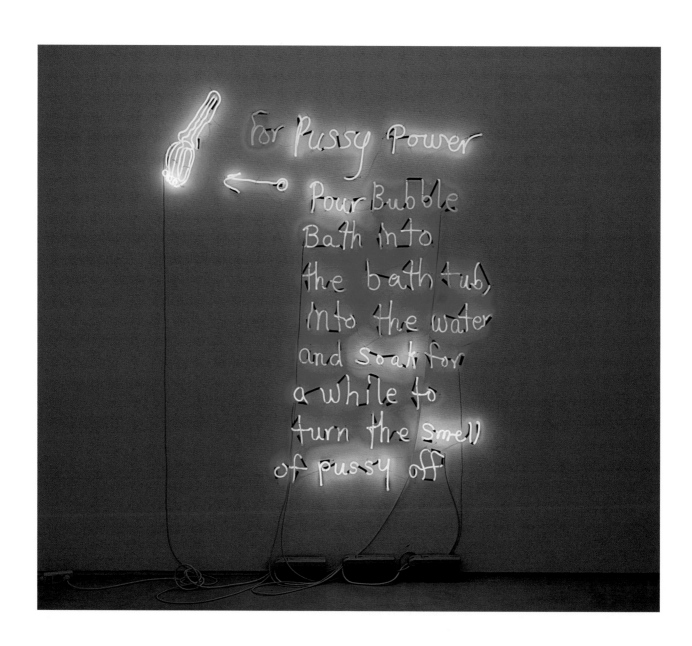

Neon rendered from Patricia Satterwhite's drawings.
Pussy Power, 2017. Neon. 94 1/2 × 75 inches (240 × 190 cm). Courtesy of
the artist and Lundgren Gallery, Palma de Mallorca.

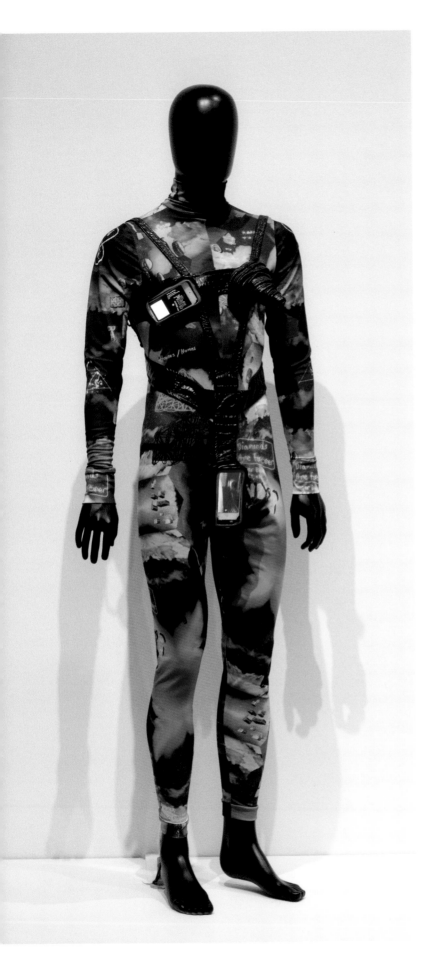

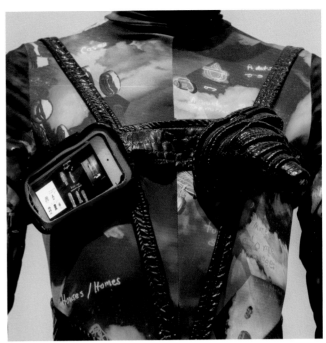

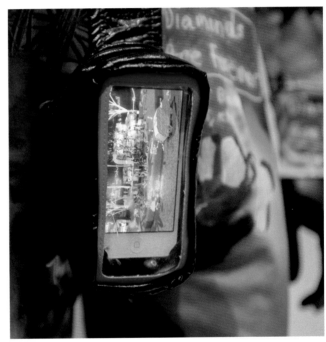

Orifice Xeon, 2013. Custom digital print spandex, vinyl, buckram, boning, iTouch and mannequin. 71 × 15 3/4 × 23 1/2 inches (180 × 40 × 60 cm). Installation view of *Speculative Bodies* at the Minneapolis Institute of Art, Minneapolis, 2019. Courtesy of the artist and Minneapolis Institute of Art. Photo: Minneapolis Institute of Art.

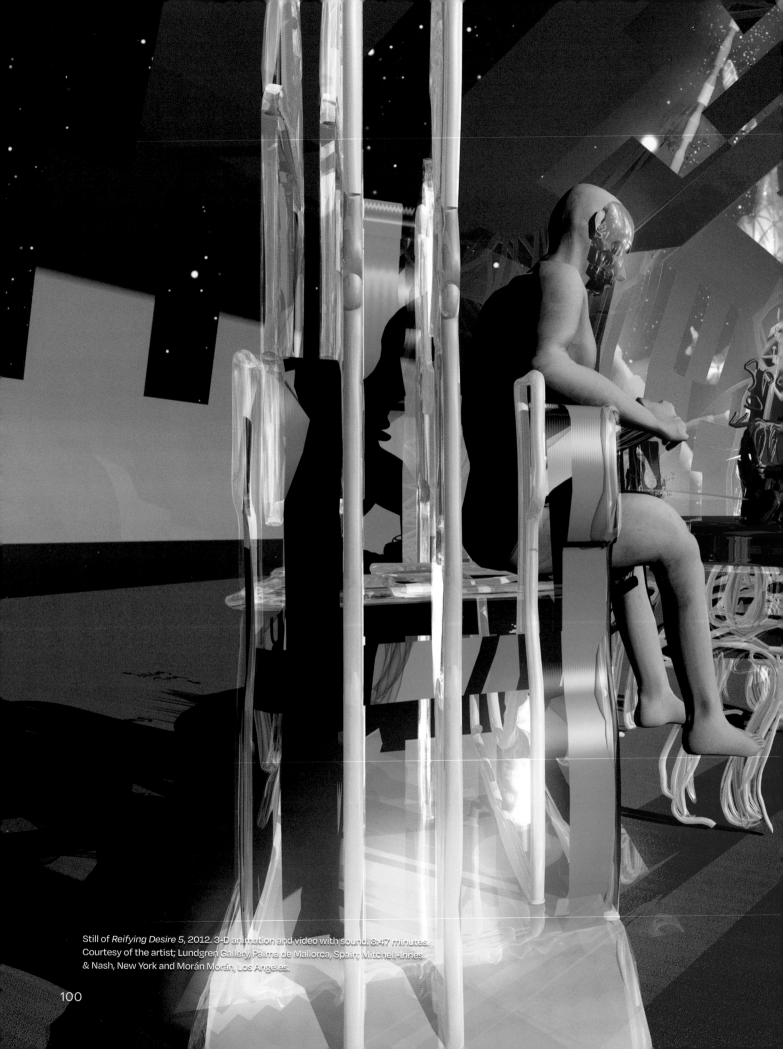

Still of *Reifying Desire 5*, 2012. 3-D animation and video with sound. 8:47 minutes.
Courtesy of the artist; Lundgren Gallery, Palma de Mallorca, Spain; Mitchell-Innes
& Nash, New York and Morán Morán, Los Angeles.

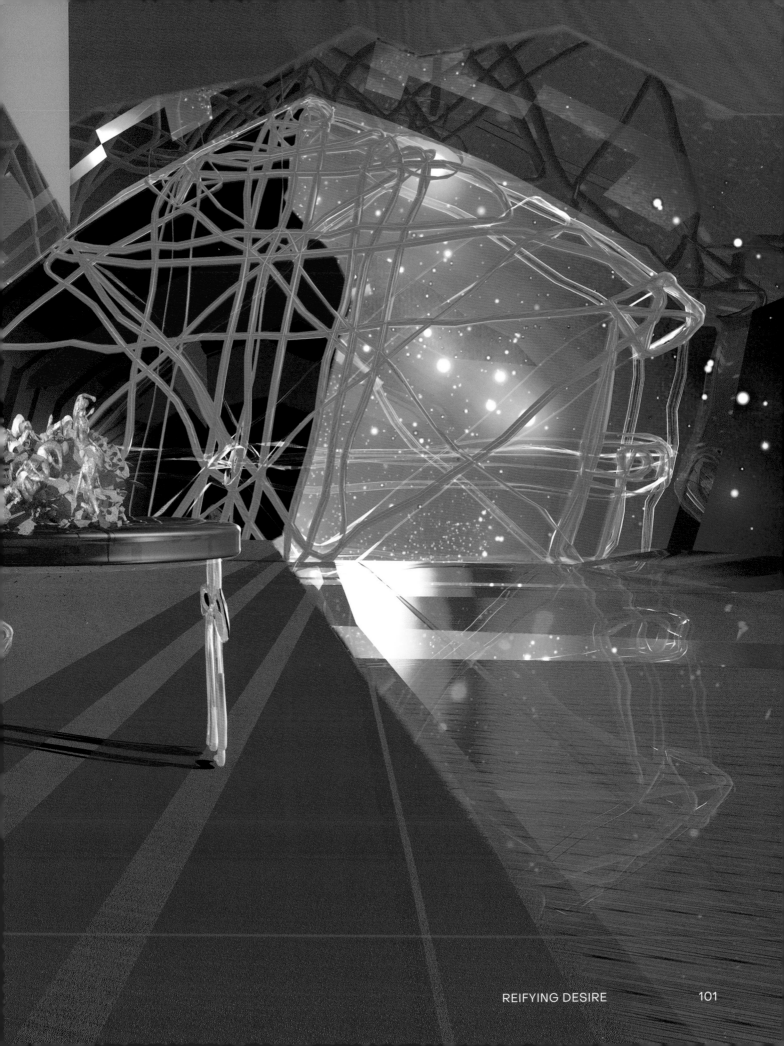

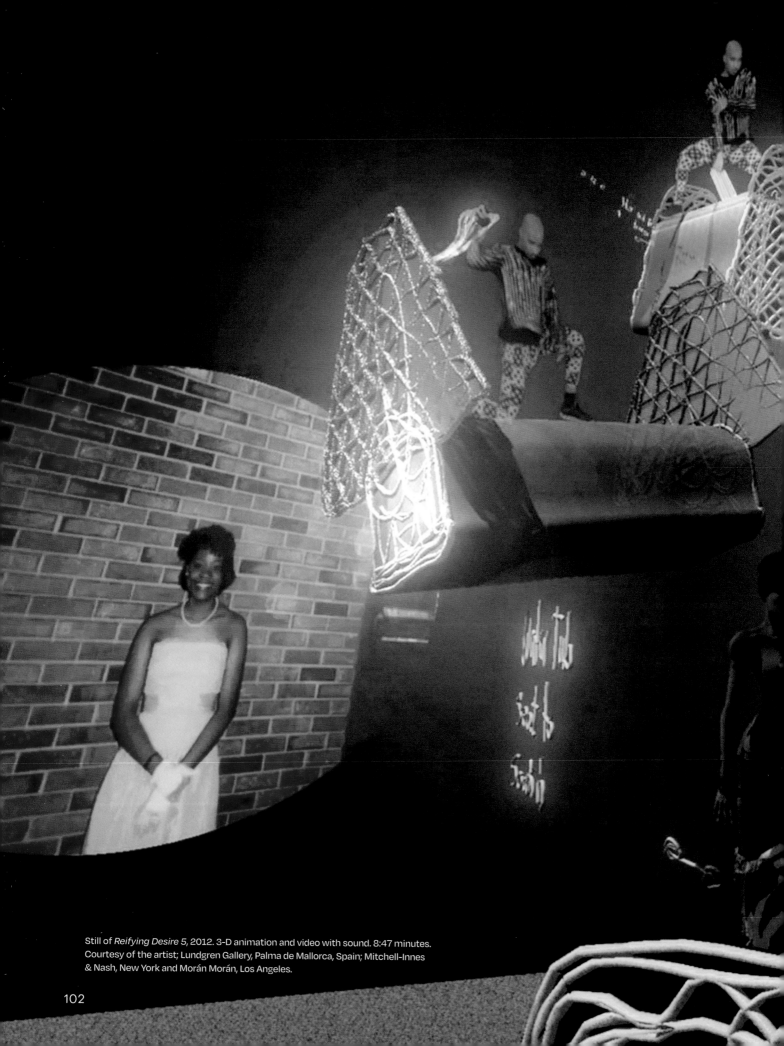

Still of *Reifying Desire 5*, 2012. 3-D animation and video with sound. 8:47 minutes. Courtesy of the artist; Lundgren Gallery, Palma de Mallorca, Spain; Mitchell-Innes & Nash, New York and Morán Morán, Los Angeles.

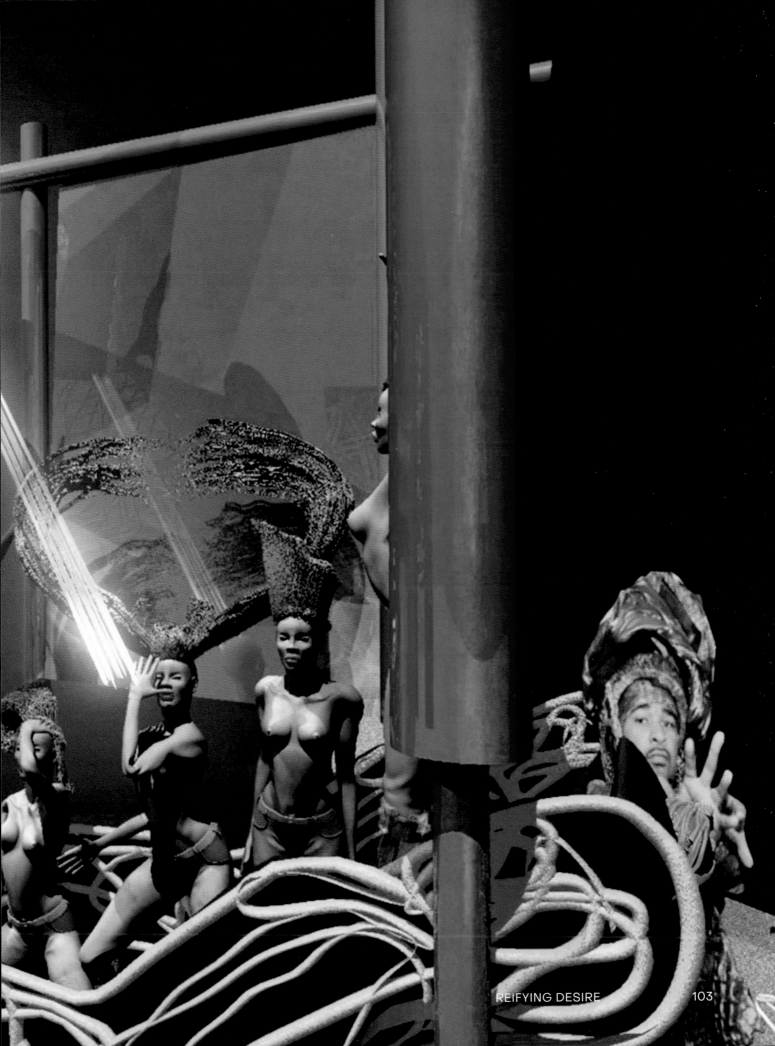

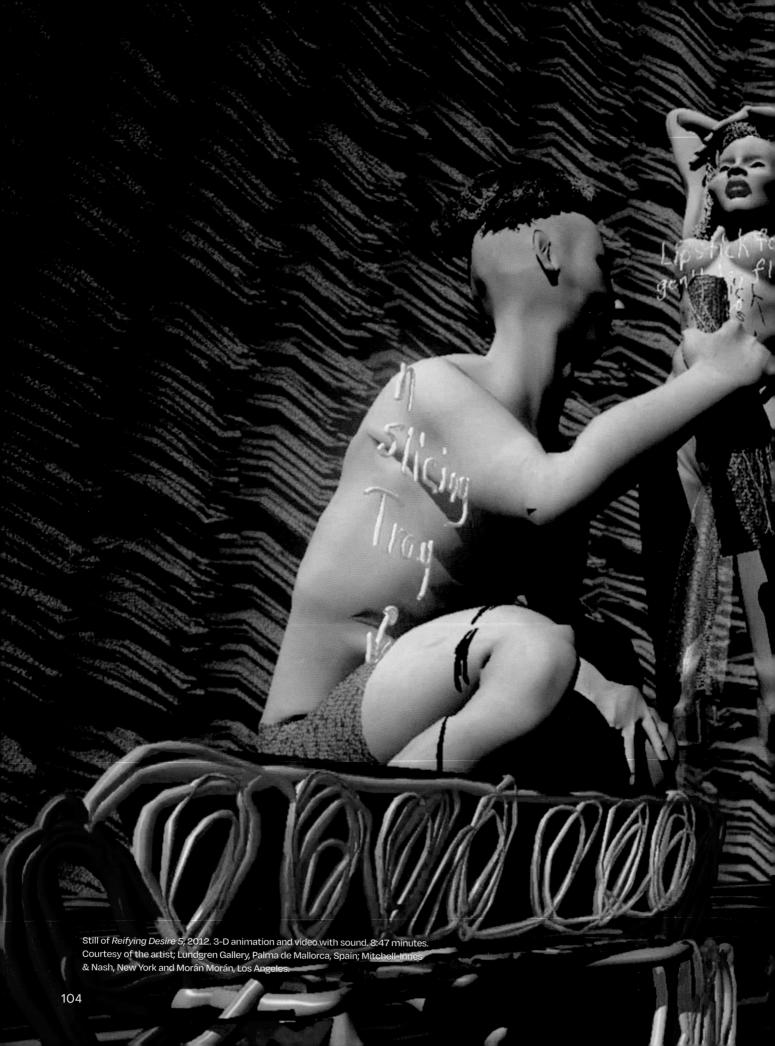

Still of *Reifying Desire 5*, 2012. 3-D animation and video with sound. 8:47 minutes.
Courtesy of the artist; Lundgren Gallery, Palma de Mallorca, Spain; Mitchell-Innes
& Nash, New York and Morán Morán, Los Angeles.

between the legs, the
scented,

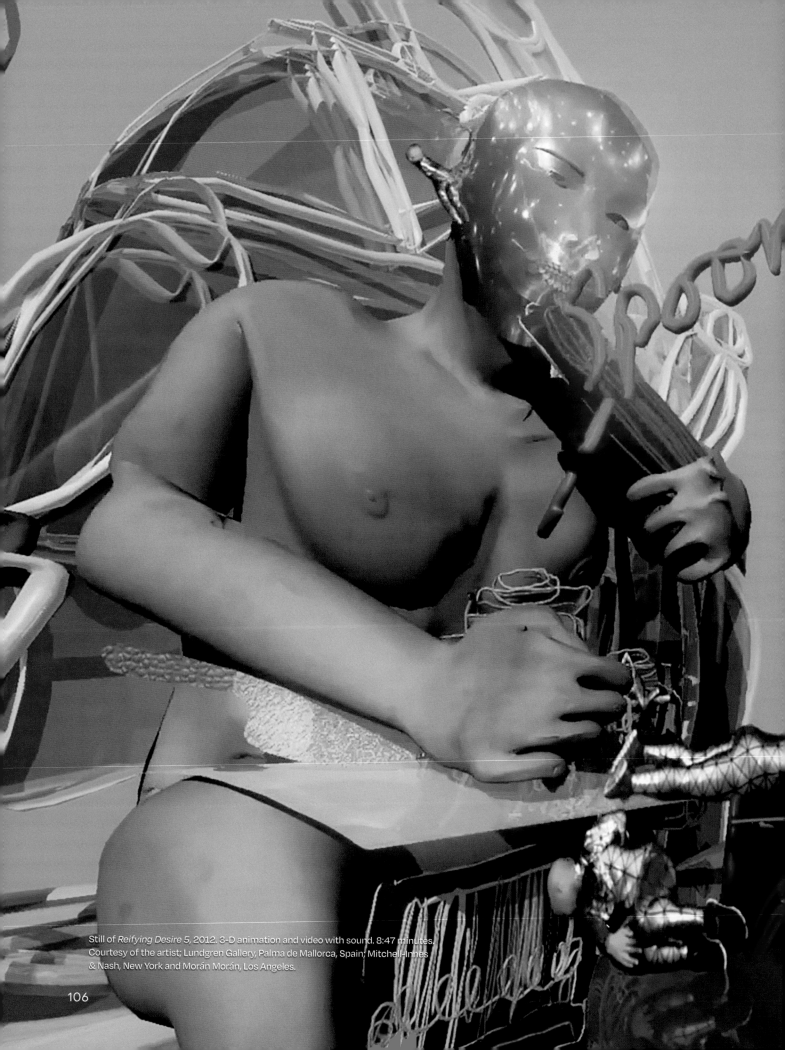

Still of *Reifying Desire 5*, 2012. 3-D animation and video with sound. 8:47 minutes.
Courtesy of the artist; Lundgren Gallery, Palma de Mallorca, Spain; Mitchell-Innes
& Nash, New York and Morán Morán, Los Angeles.

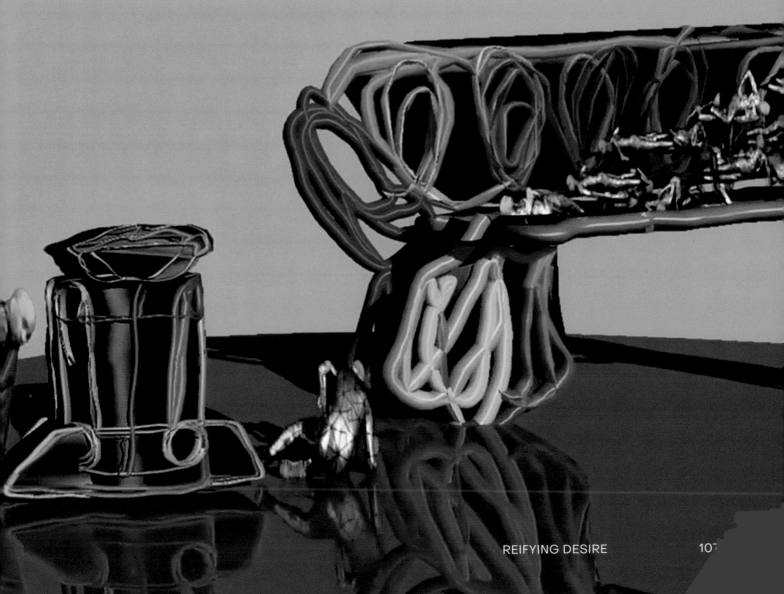

A
Slicing
Tray
↓

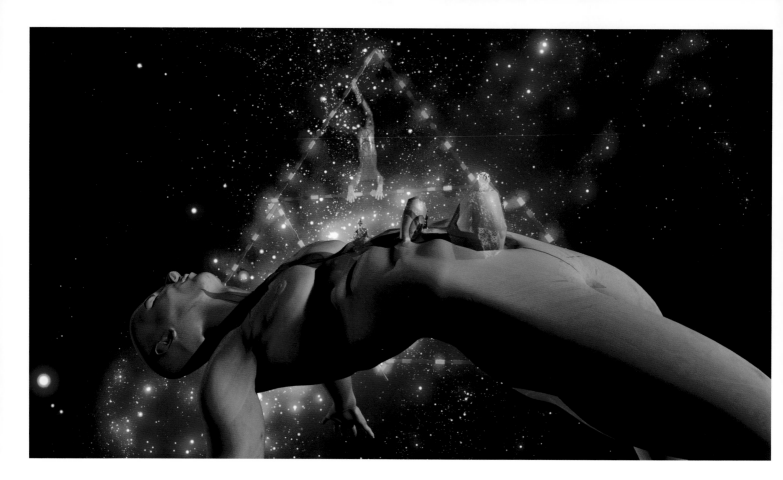

Reifying Desire 6

Stills of *Reifying Desire 6*, 2014. HD digital video and color 3-D animation with sound. 24:08 minutes. Courtesy of the artist; Lundgren Gallery, Palma de Mallorca, Spain; Mitchell-Innes & Nash, New York and Morán Morán, Los Angeles.

In the final film of the *Reifying Desire* sequence, Jacolby Satterwhite is impregnated by bareback gay porn star Antonio Biaggi. It is significant that this film was created the same year that Truvada, the HIV preventative medication, became available on the pharmaceutical market. Bringing Biaggi into the film charges this last chapter of *Reifying Desire* with the politics of its time. The film ends with Satterwhite laying an egg that hatches into a new human language that metastasizes until it can no longer function. *Reifying Desire 6* creates a realm of infinite genders where the multiplicity of being becomes the norm and sexuality and queerness live within us all openly. When Satterwhite vogues and falls into the death drop he emulates the daily deaths that occur when you live in a body that won't allow you to be seen while also making you a complete spectacle. Satterwhite's work reclaims space by building his own stage and creating the world in which it is housed. Informed by his mother's ability to hybridize objects, Satterwhite is seen in this film wearing a studded harness with smartphone screens installed that include other videos, making him a fleshy computer-generated cyborg. "I wanted my body to no longer be human, to become a punctuation mark or some kind of musical note, a kind of pivot that facilitates narrative," Satterwhite explains to Evan Moffitt for *frieze* magazine.[1] Satterwhite's bent body becomes a narrative vehicle throughout the series as sex moves beyond the realm of existing purely as intimacy and power, and into a form of nonverbal communication.

S.B.

1 https://www.frieze.com/article/body-talk-0

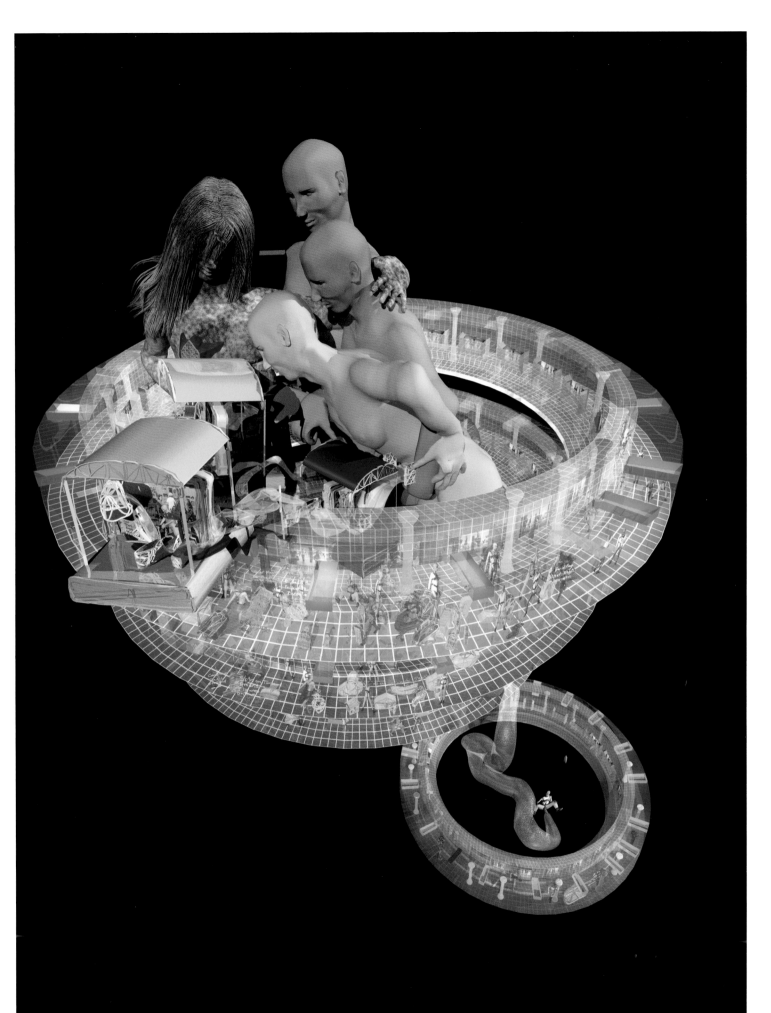

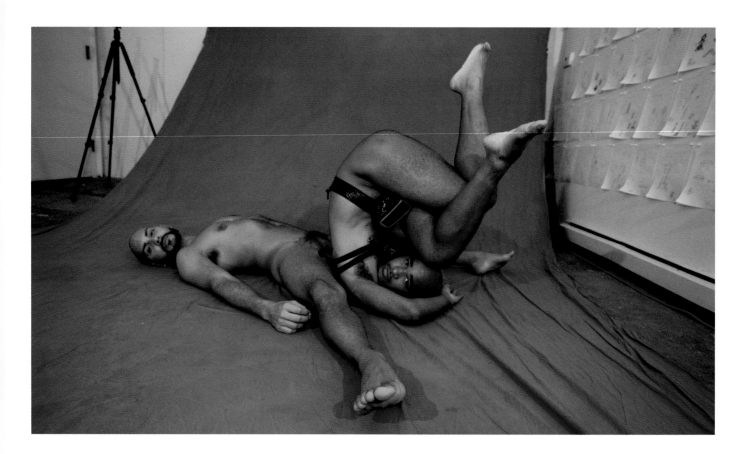

Above: Preproduction documentation for *Reifying Desire 6*.
Photograph of Jacolby Satterwhite with Antonio Biaggi, 2013.

Right: Source material for *Reifying Desire 6*.
Patricia Satterwhite. *A level-tating Bed*, 1998–2008.
Graphite on paper. 11 × 8 1/2 inches (27.9 × 21.6 cm).
Courtesy of Jacolby Satterwhite and Mitchell-Innes & Nash, New York.

Opposite, top: Installation view of *Reifying Desire 6* with related sculpture.
Jacolby Satterwhite, in collaboration with The Fabric Workshop and Museum, Philadelphia. *Room for Levitating Beds*, 2019. PLA filament, epoxy, epoxy resin, spray mount, aluminized glass beads, HD color video, steel, velour, plywood, vinyl, hot glue, foam tubing, wire and poly-fil. 48 × 120 × 48 inches (121.9 × 304.8 × 121.9 cm). Installation view of *Room for Living* at The Fabric Workshop and Museum, Philadelphia, 2019. Courtesy of the artist and The Fabric Workshop and Museum, Philadelphia. Photo: Carlos Avendaño.

Opposite, bottom: Print derived from *Reifying Desire 6* animations.
Island of Treasure, 2013. C-print. 30 × 53 inches (76.2 × 134.62 cm). Courtesy of the artist and Morán Morán, Los Angeles.

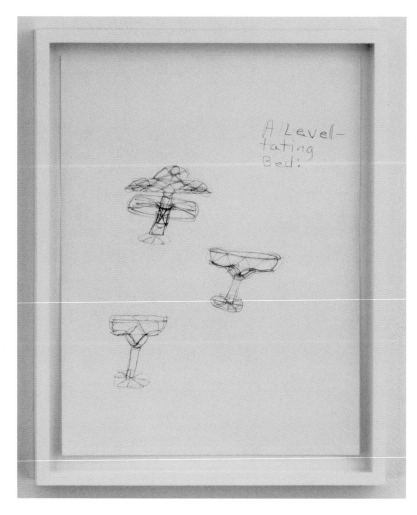

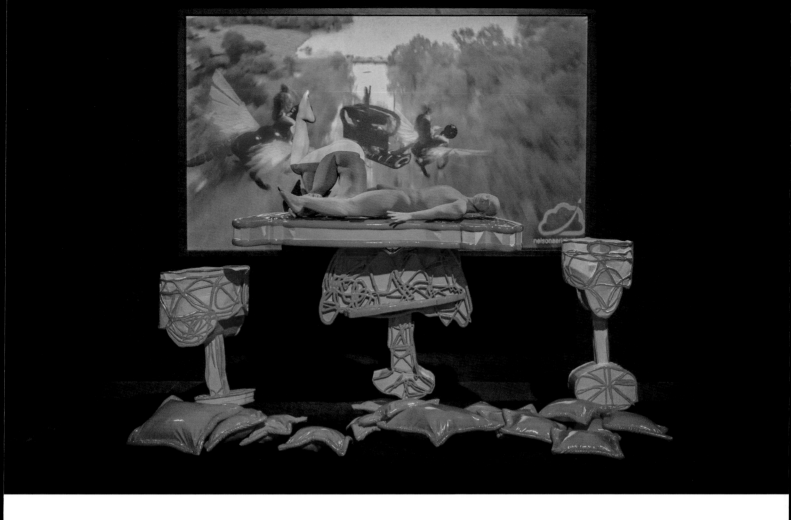

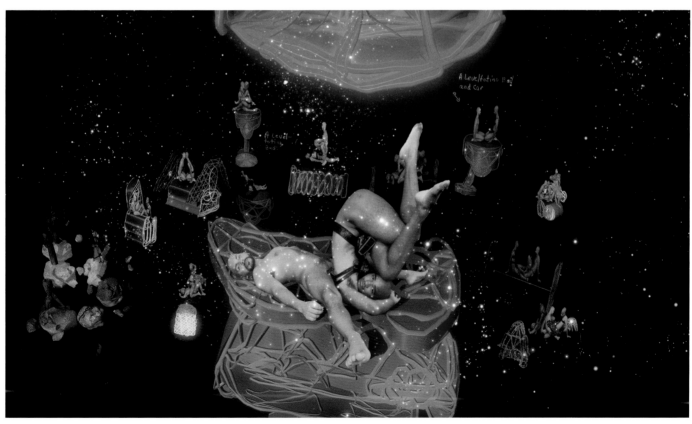

Print derived from *Reifying Desire 6* animations.
Infinite, 2013. C-print. 30 × 53 inches (76.2 × 134.62 cm).
Courtesy of the artist and Lundgren Gallery, Palma de Mallorca.

Print derived from *Reifying Desire 6* animations.
Resource Body, 2013. C-print. 30 × 53 inches (76.2 × 134.62 cm).
Courtesy of the artist and Lundgren Gallery, Palma de Mallorca.

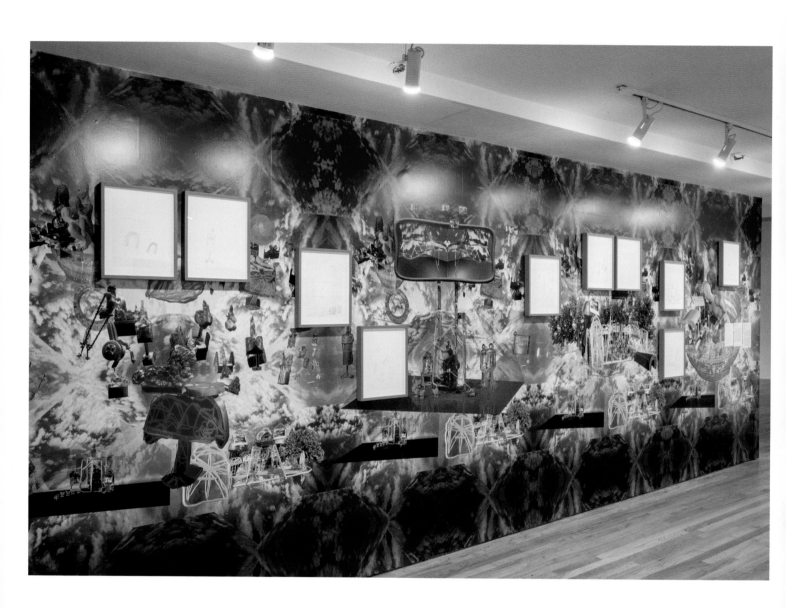

Above: Wallpaper derived from *Reifying Desire 6* with framed drawings by Patricia Satterwhite.
Satellites, 2014. Installation view of *When the Stars Begin to Fall: Imagination and the American South* at The Studio Museum in Harlem, New York, 2014. Courtesy of the artist and The Studio Museum in Harlem Archives, New York. Photo: Adam Reich.

Opposite: *Satellites (morph),* 2014. C-print in artist's frame. 85 × 58 × 3 inches (215.9 × 147.3 × 7.6 cm). Courtesy of the artist and Morán Morán, Los Angeles.

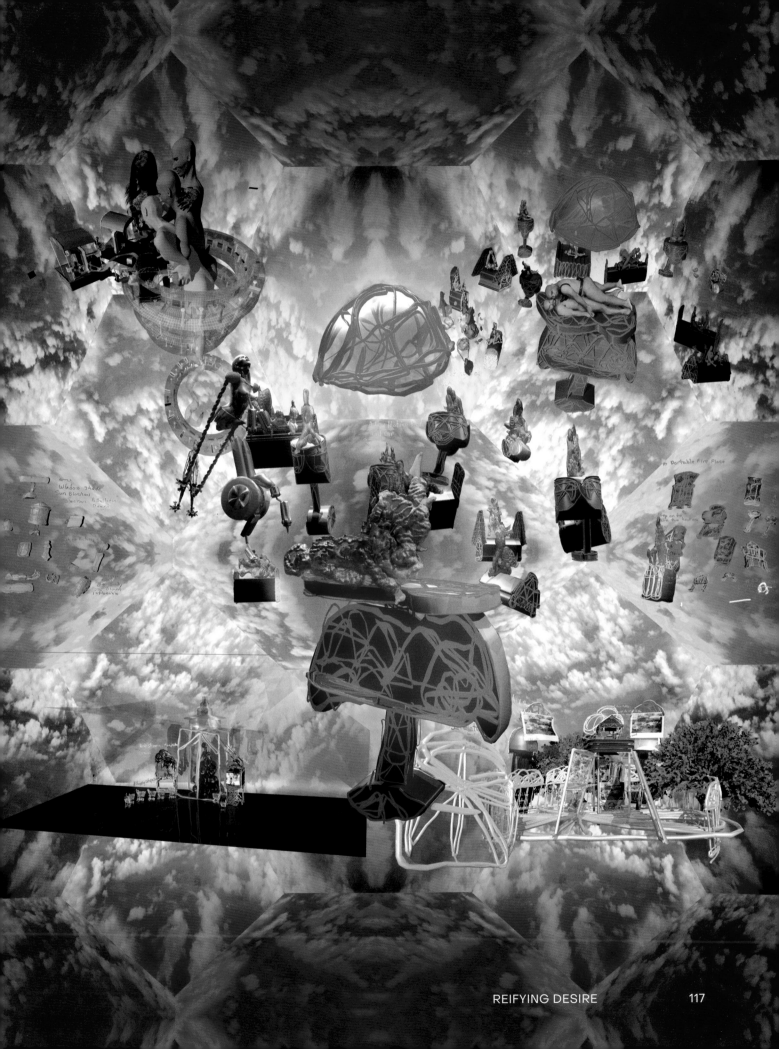

Healing in My House

This collection serves as an artistic connective tissue between Satterwhite's *Reifying Desire* and *Birds in Paradise* series. This transition pushed Satterwhite beyond the confines of his visual practice and into the discovery of how to create a sonic portal of transformation. This progression would begin with the creation of C-prints for *En Plein Air* and *Interstate 75* as a form of visual surrealist mood boarding that would aid the artist in conceptualizing future 3-D animations.

How lovly is me being as I am began as a sketch of Patricia's featuring the title hand-written in a two-line stanza, and grew into an exhibition at Morán Morán Gallery in Los Angeles in 2014. The title is a revelation posed as a question that necessitates no response, resting above a collection of phallus-shaped sketches of floating objects, and serves as denotation marking the birth of a new way of moving through the world. *How lovly* is a moment of chrysalis in Satterwhite's career; therefore it is fitting that his survey, *Spirits Roaming on the Earth* at the Miller ICA at Carnegie Mellon University, is accompanied by the monograph titled in honor of this evolutionary moment.

This transformative bridge would prove pivotal in the artist's career. Satterwhite took the conceptual structures his mother created and pushed them forward into his own realm of subjectivity by incorporating animation and sound to create digital conceptual impressionism that led to the creation of the films *Healing in My House* and *Domestika*. Through this explorative collection Satterwhite anatomized the ways that color manipulated mood and employed these discoveries to establish the frequency and objectives of what would become the audio album, *Love Will Find A Way Home* (2019), produced in collaboration with Nick Weiss from the electronic music duo, Teengirl Fantasy. In his dissections of color theory, Satterwhite explores the ways that color and light sculpt atmospheres and environments, resulting in the viewer's submergence into a macrocosm of his creation. This practice is present in much of his work, but particularly in *Throne*, where the gentle yellow neon softens and beckons. In Black Panther Party co-founder, Dr. Huey P. Newton's iconic portrait by Blair Stapp, the rattan peacock chair is a symbol of regality and power. Satterwhite identifies the chair throughout his work as a throne, a visual identification with a radical Black tradition. *Throne* is written in the font of Satterwhite's late mother, Patricia, who introduced him to the process of art making as a form of escape and recollection. Satterwhite encourages recollection as a form of inheritance and assigns value to memories. In a world where the global Black diaspora are deliberately denied access to their history, Satterwhite turns memory into a form of power and currency. Because the history is written by the victors, or more specifically, the oppressors, Satterwhite asserts his own power by taking up his mother's pen where she left off, allowing for the act of memory and immortalization to work in tandem.

S.B.

Still of *Domestika*, 2017. Virtual reality video with sound. 15:24 minutes. Courtesy of the artist; Lundgren Gallery, Palma de Mallorca, Spain; Mitchell-Innes & Nash, New York and Morán Morán, Los Angeles.

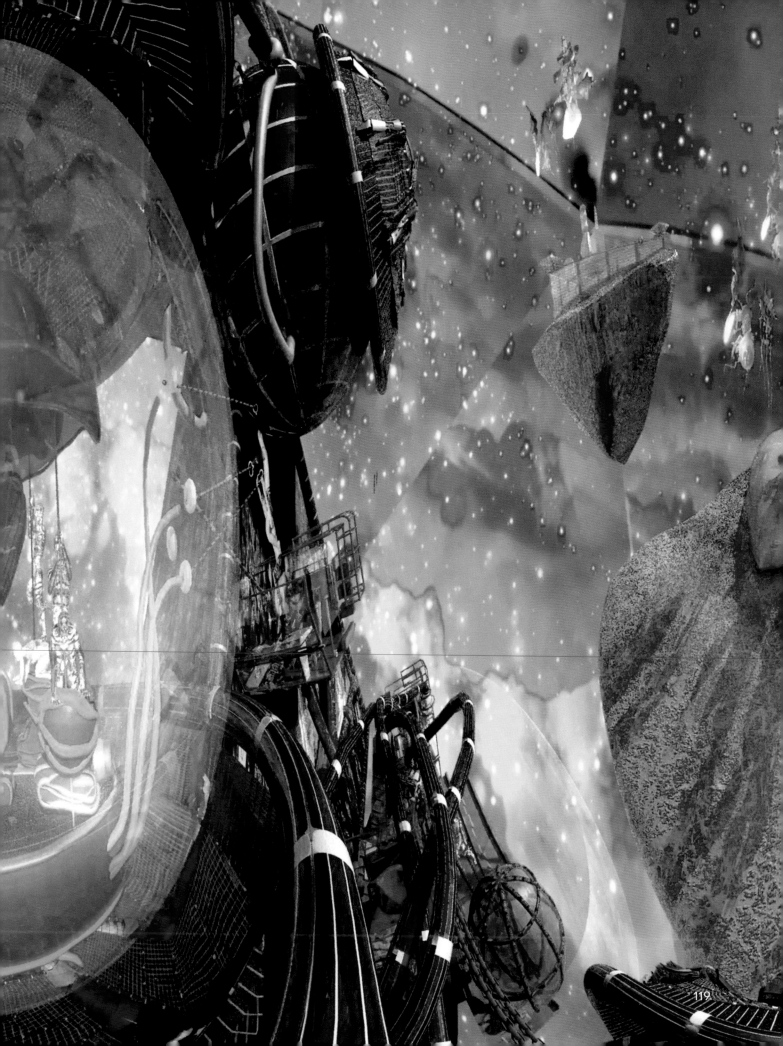

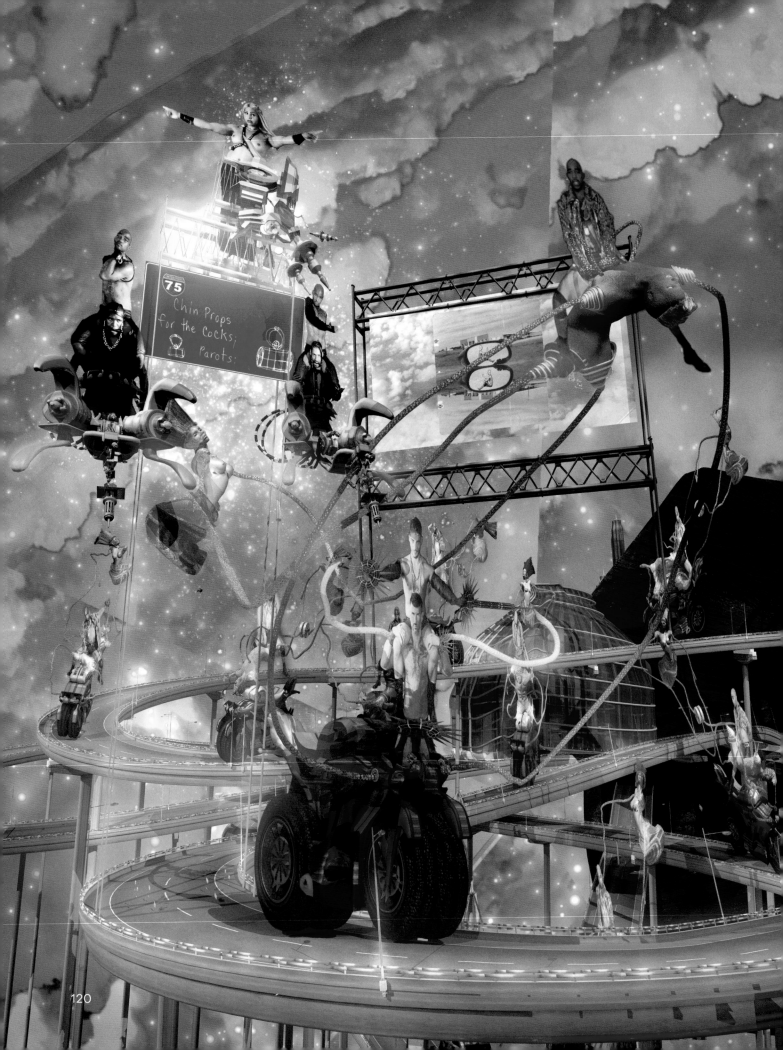

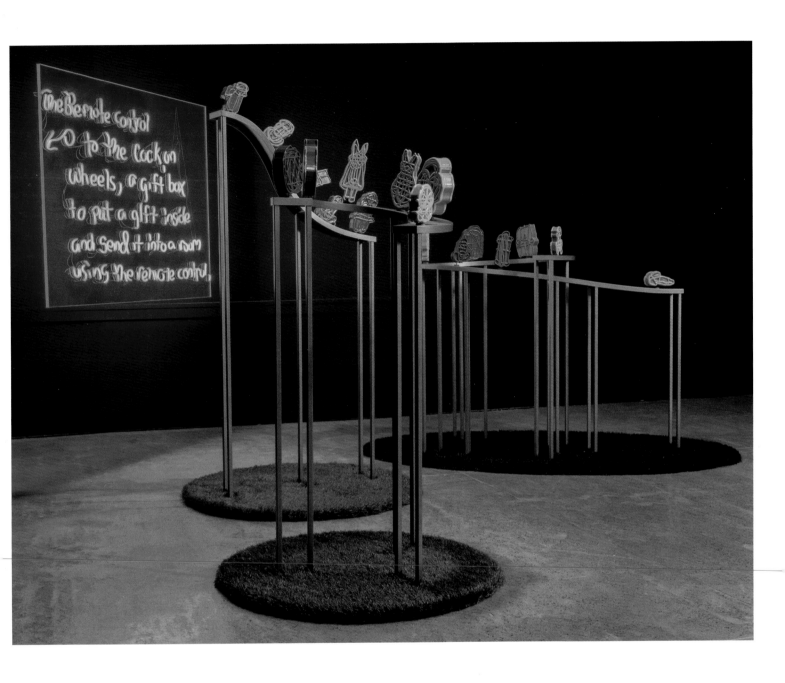

Above: Installation view of sculpture derived from *Reifying Desire 1*, *Interstate 75*, and Patricia Satterwhite's drawings.
Jacolby Satterwhite, in collaboration with The Fabric Workshop and Museum, Philadelphia. *The Remote Control for Cocks on Wheels*, 2019. Powder-coated steel, plywood, artificial turf, magnets, PLA filament, epoxy resin, enamel, baking soda, superglue, bond filler, plexiglass, LED and silicone. Neon: 48 × 59 inches (121.92 × 149.86 cm). Three sculptures with track stands (diameter): 62 × 44 inches (157.48 × 111.76 cm), 78 × 44 inches (198.12 × 111.76 cm), 54 × 70 inches (137.16 × 177.8 cm). Installation view of *Room for Living* at The Fabric Workshop and Museum, Philadelphia, 2019. Courtesy of the artist and The Fabric Workshop and Museum, Philadelphia. Photo: Carlos Avendaño.

Opposite: *Interstate 75*, 2015. C-print. 78 × 60 inches (198.1 × 152.4 cm). Courtesy of the artist and Lundgren Gallery, Palma de Mallorca.

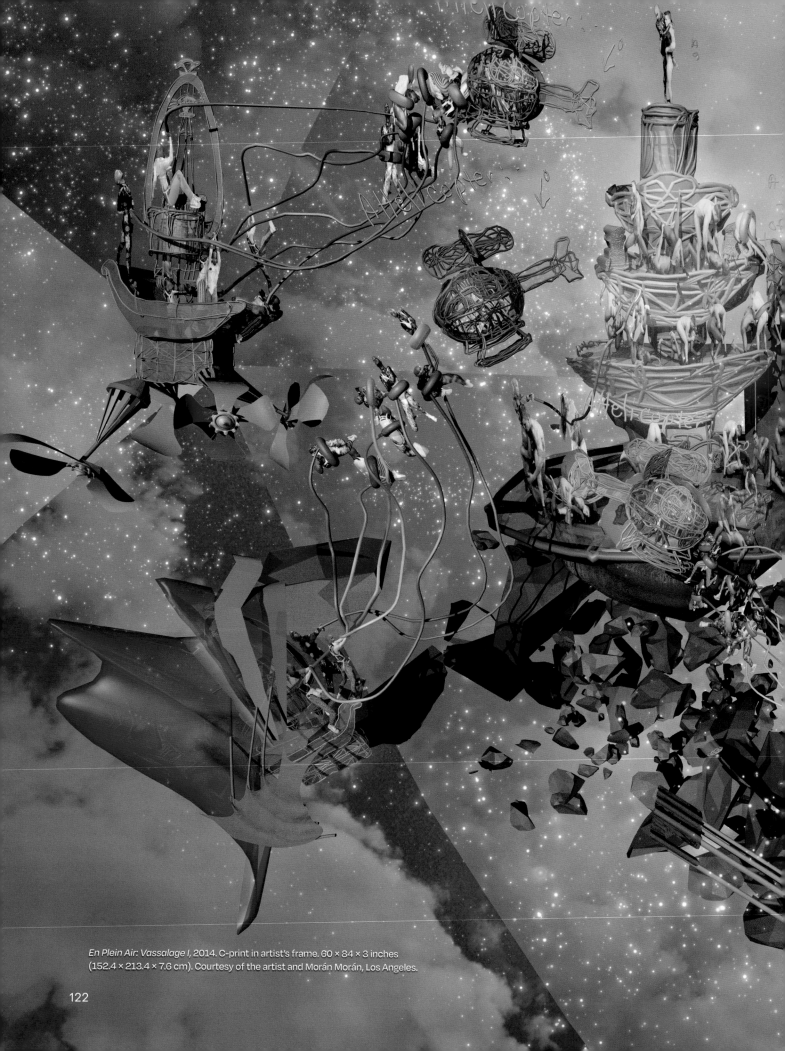

En Plein Air: Vassalage I, 2014. C-print in artist's frame. 60 × 84 × 3 inches (152.4 × 213.4 × 7.6 cm). Courtesy of the artist and Morán Morán, Los Angeles.

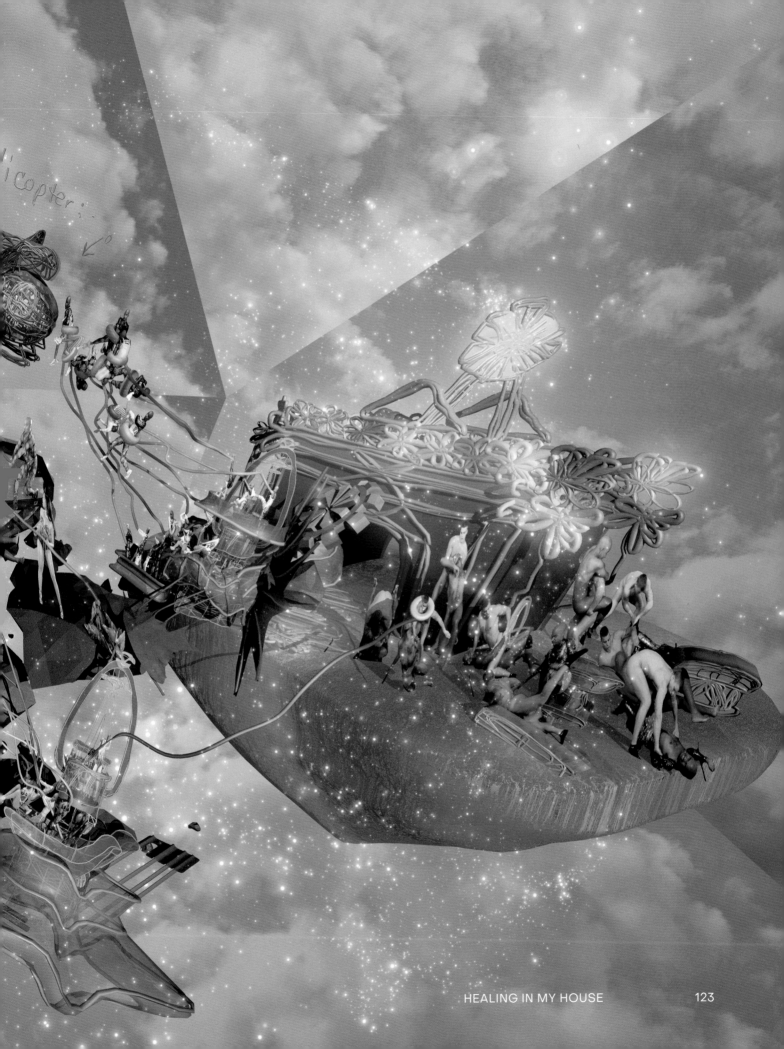

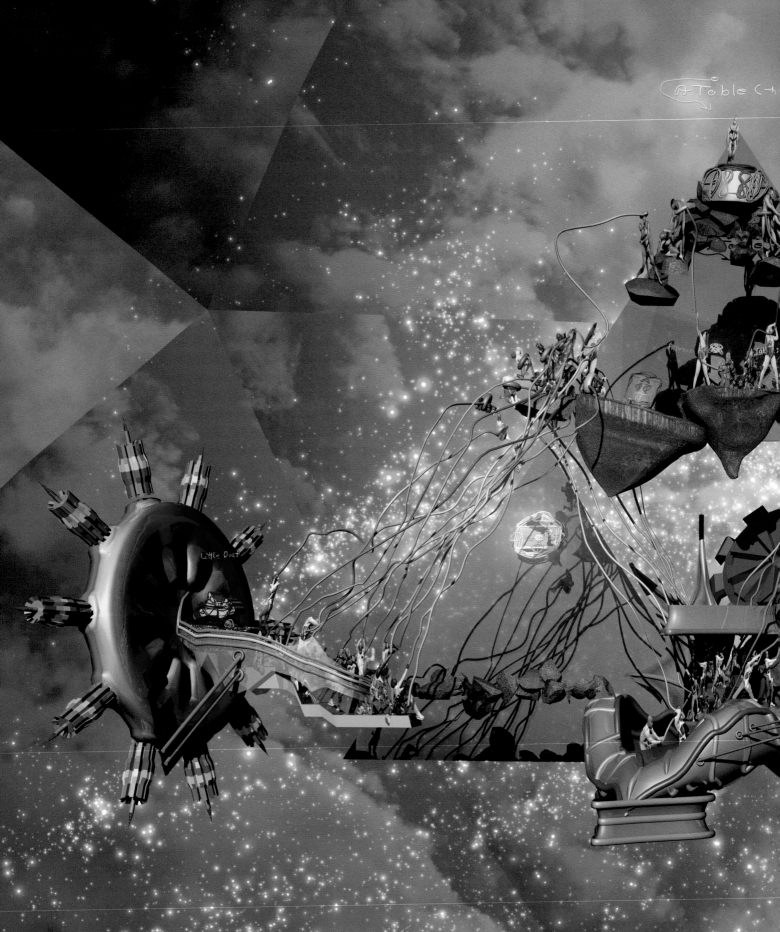

En Plein Air: Vassalage III, 2014. C-print in artist's frame. 60 × 84 × 8 inches (152.4 × 213.4 × 7.6 cm). Courtesy of the artist and Morán Morán, Los Angeles.

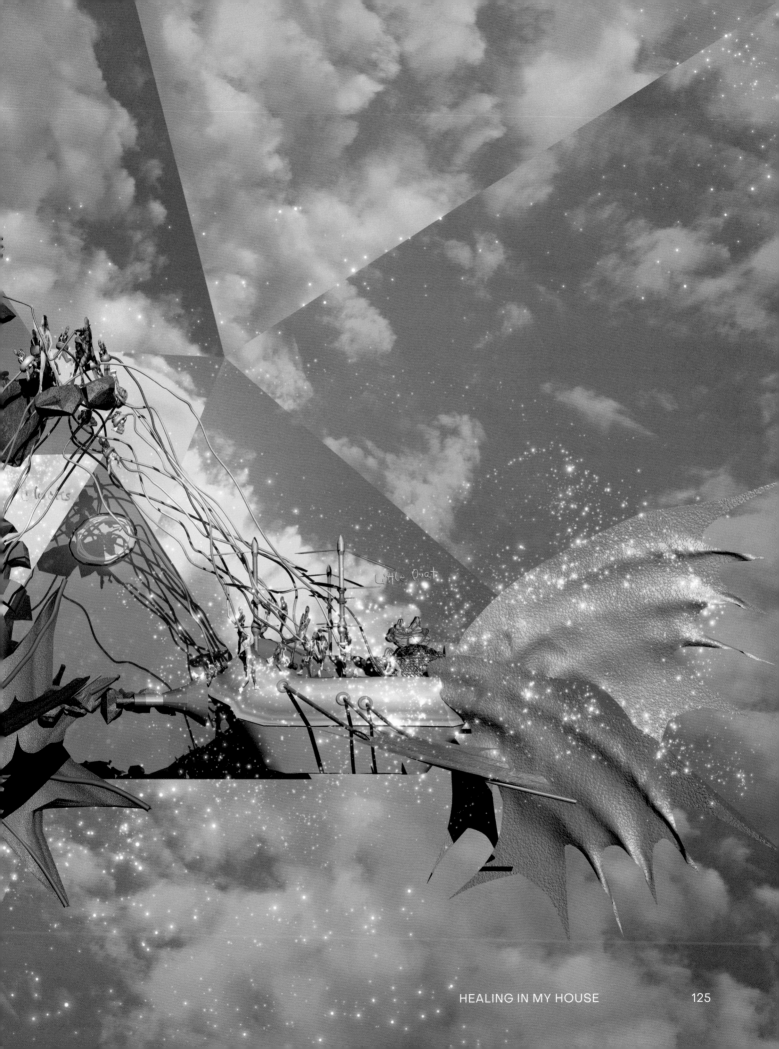

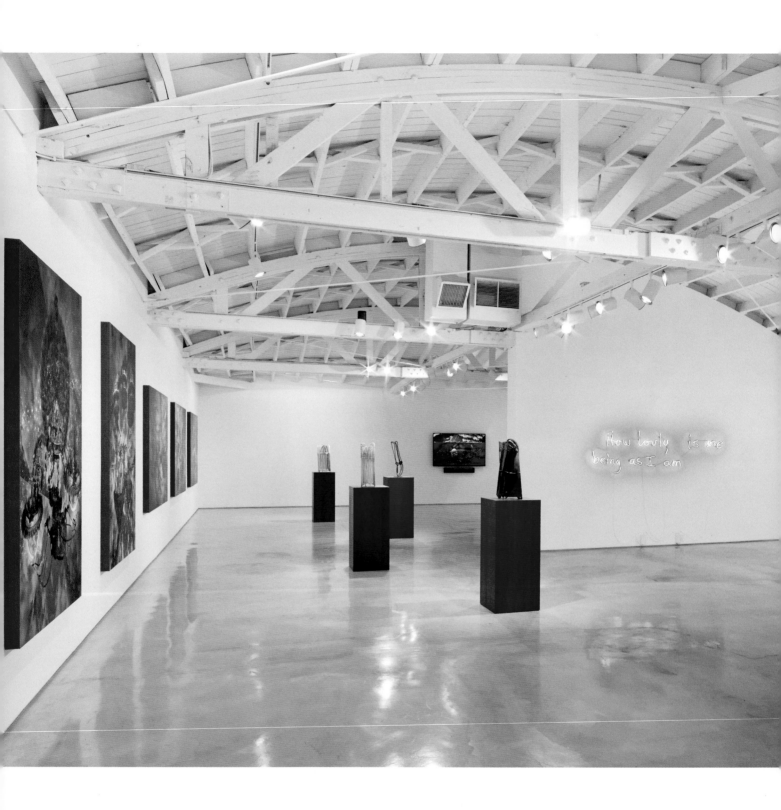

Installation view of *How Lovely Is Me Being As I Am* at Morán
Morán, Los Angeles, 2014. Courtesy of the artist and Morán
Morán, Los Angeles. Photo: Joshua White.

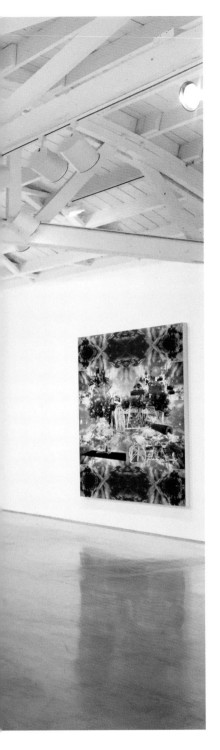

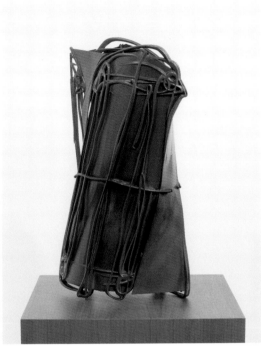

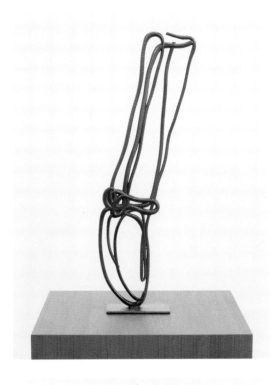

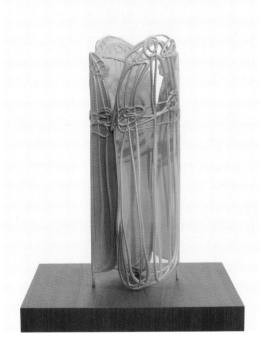

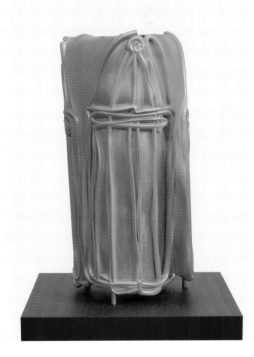

Sculptures rendered from Patricia Satterwhite's drawings.

Metonym I (Chameleon), 2014. Nylon, enamel, and artist's pedestal. Sculpture: 22 1/4 × 12 × 7 inches (56.52 × 30.48 × 17.78 cm). Pedestal: 40 × 18 × 18 inches (101.6 × 45.72 × 45.72 cm). Courtesy of the artist and Morán Morán, Los Angeles.

Metonym III (Gold), 2014. Nylon, enamel, and artist's pedestal. 21 1/2 × 8 1/2 × 7 inches (54.5 × 21.5 × 17.78 cm). Pedestal: 40 × 18 × 18 inches (101.6 × 45.72 × 45.72 cm). Courtesy of the artist and Morán Morán, Los Angeles.

Metonym II, 2014. Nylon, enamel, and artist's pedestal. Sculpture: 22 1/4 × 12 × 7 inches (56.52 × 30.48 × 17.78 cm). Pedestal: 40 × 18 × 18 inches (101.6 × 45.72 × 45.72 cm). Courtesy of the artist and Morán Morán, Los Angeles.

Metonym IV (Gold), 2014. Nylon, enamel, and artist's pedestal. Sculpture: 22 1/4 × 11 × 11 inches (56.5 × 27.9 × 27.9 cm). Pedestal: 40 × 18 × 18 inches (101.6 × 45.72 × 45.72 cm). Courtesy of the artist and Morán Morán, Los Angeles.

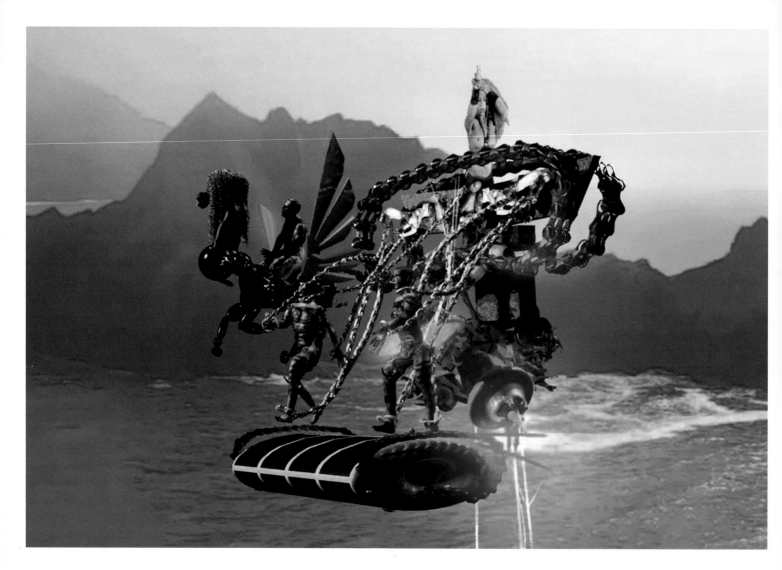

Healing in My House

Stills of *Healing in My House*, 2016. 3-D animation and video with sound. 9:26 minutes. Courtesy of the artist; Lundgren Gallery, Palma de Mallorca, Spain; Mitchell-Innes & Nash, New York and Morán Morán, Los Angeles.

Originally commissioned by The San Francisco Museum of Modern Art, while creating *Healing in My House* Satterwhite made the artistic decision to move away from Patricia's drawings and into her vocal archive. In collaboration with Nick Weiss, Satterwhite digitized 150 of his mother's a capella recordings, and *Healing in My House* was the first song they created out of this archive. Satterwhite would go on to create a music video to accompany this introductory single. In this video Satterwhite explores the democratic ways of viewing space with the accompaniment of sound. The sound component allows for a reentry into the work that his mother Patricia left behind while weaving in new influences and narratives. As a studied painter, Satterwhite is constantly grasping at ways to enter the painterly space through alternative mediums in an effort to interrogate his concepts and propel them forward with momentum.

S.B.

128

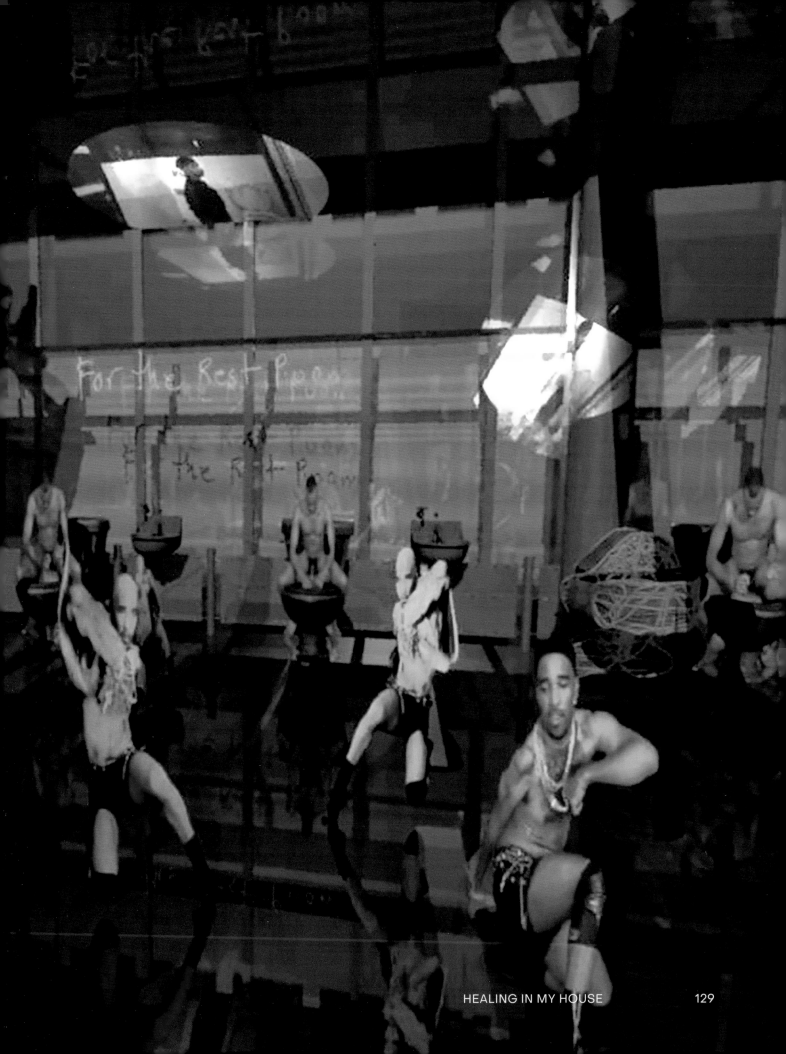

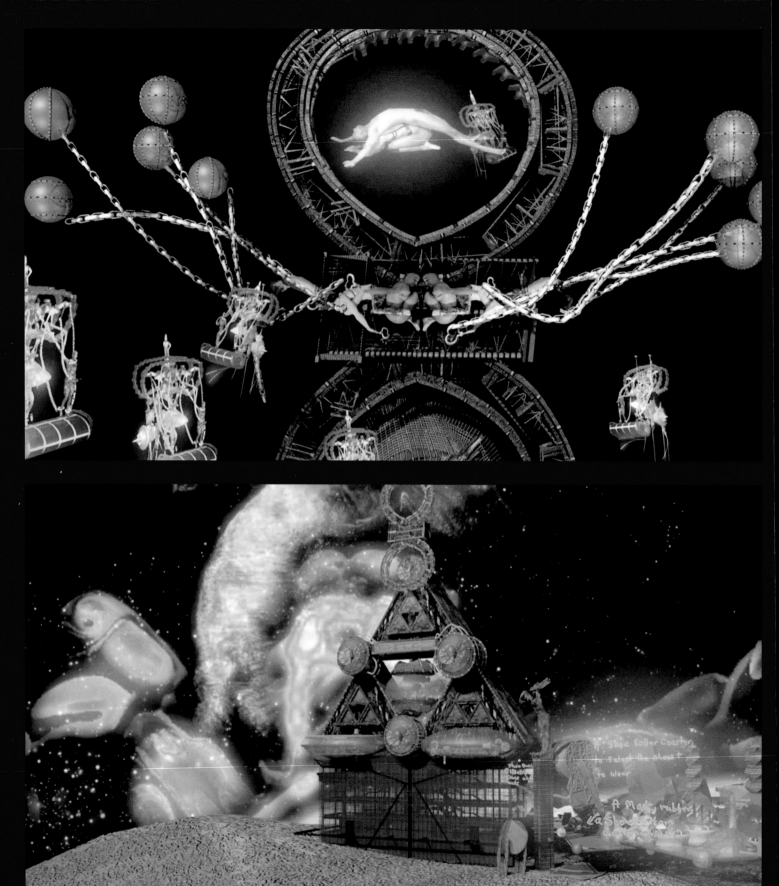

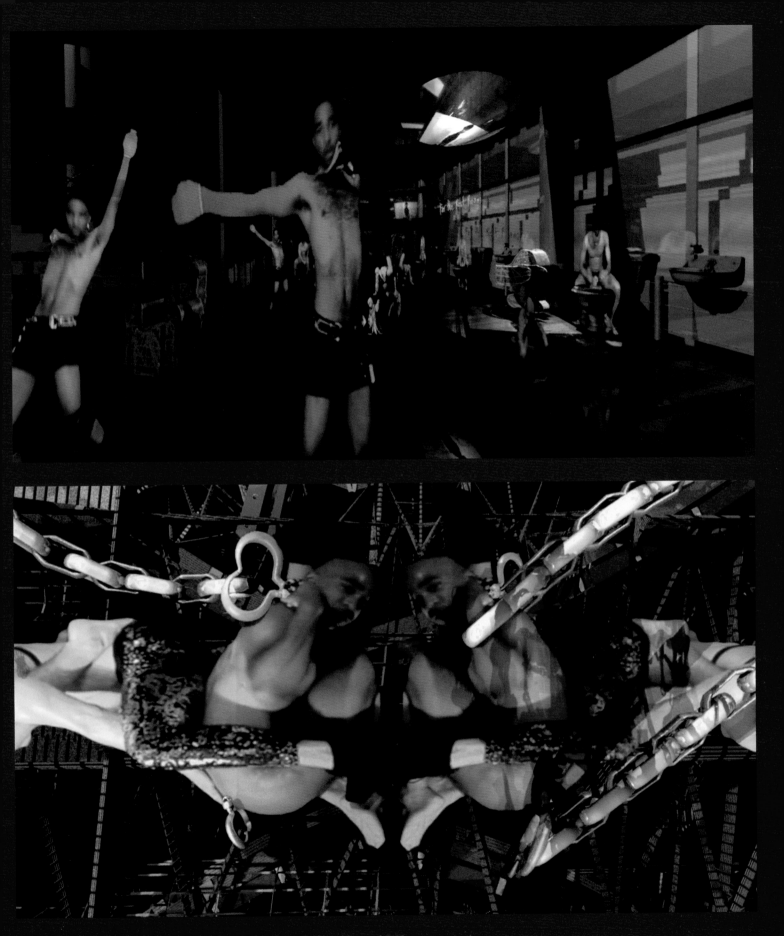

Stills of *Healing in My House*, 2016. 3-D animation and video with sound. 9:26 minutes. Courtesy of the artist; Courtesy of the artist; Lundgren Gallery, Palma de Mallorca, Spain; Mitchell-Innes & Nash, New York and Morán Morán, Los Angeles

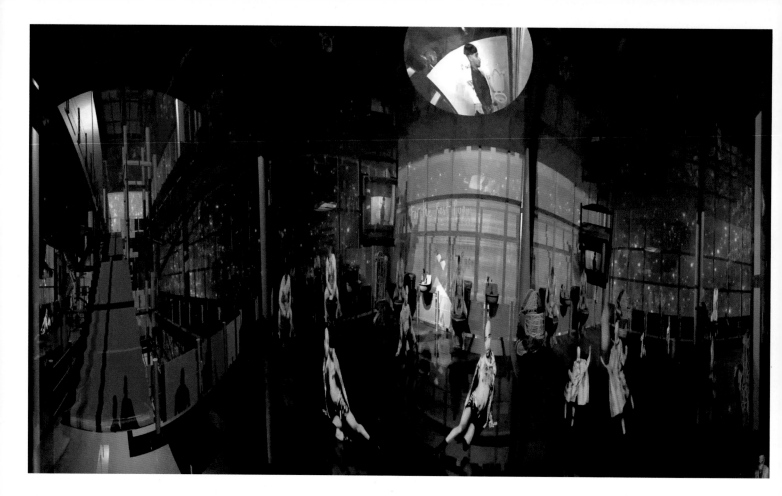

Domestika

Stills of *Domestika*, 2017. Virtual reality video
with sound. 15:24 minutes. Courtesy of the
artist; Lundgren Gallery, Palma de Mallorca, Spain;
Mitchell-Innes & Nash, New York and Morán Morán,
Los Angeles.

Domestika is an intergalactic journey of an imagined three-dimensional virtual reality environment inhabited by Satterwhite alongside computer-generated figures. With multiple choreography sequences as its centralized form of nonverbal communication, Satterwhite offers his body as sacrifice to his practice. He spins, death drops, and buoyantly levitates from a bouncing twerk into a jump-kick as a physical replication of the ways in which one has to remain limber, flexible, and inventive to survive in this realm. The malleability in his movement is fluid as he takes flight, unbound. He shifts his weight between the eroticism and reactive protective defense postures because the line between desirability and the invocation of fear is obscure. Despite a lack of mobility in his right arm due to his experience with osteogenic sarcoma as a child, he pushes his physical form to the same limits that he expects of his flying computer-generated figures. The nature of this alternative universe is backed by a remixed house-techno track produced by the artist with vocals by his late mother Patricia Satterwhite. The matriarch's comforting voice rings out with assuredness, "There is healing in my house," which the younger Satterwhite institutes as priority in the manifested world of *Domestika*. Digital muscle-clad masculine figures take stride throughout in chains from ankles to wrists, shackled and enslaved by the impossible limitations of societal norms of masculinity. As a Black femme, Satterwhite exemplifies liberation through movement. The Black diaspora was contained physically for over four hundred years in the Americas and beyond, and physical mobility has always been the initial point of a departure from captivity.

S.B.

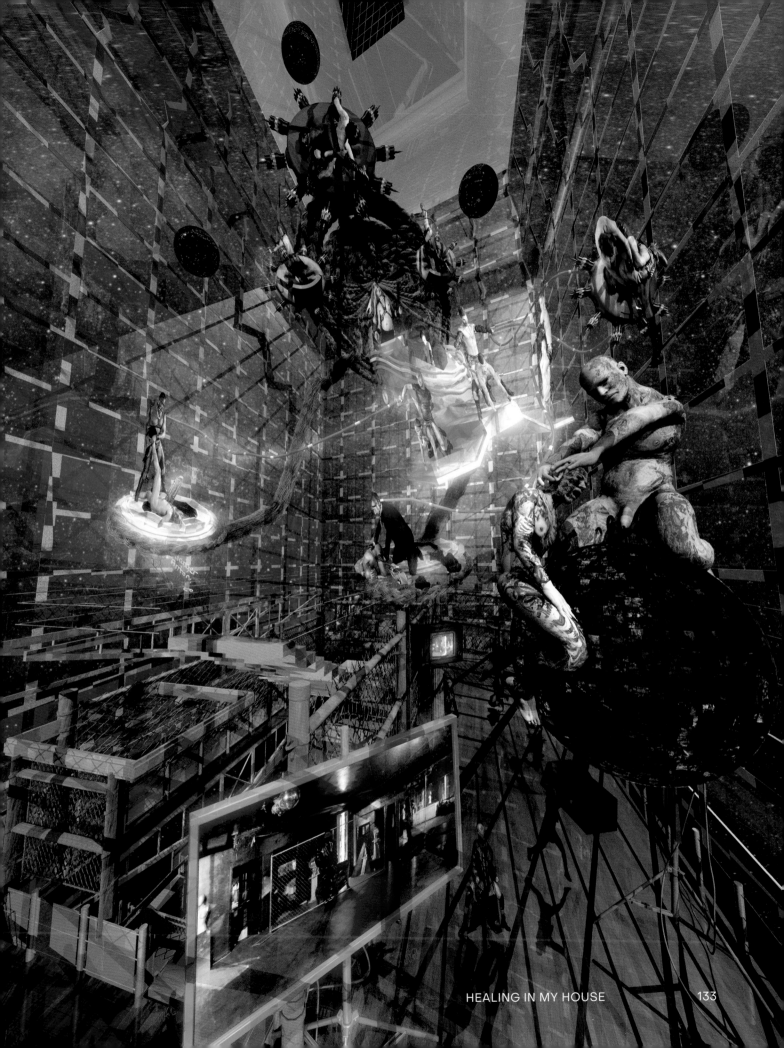

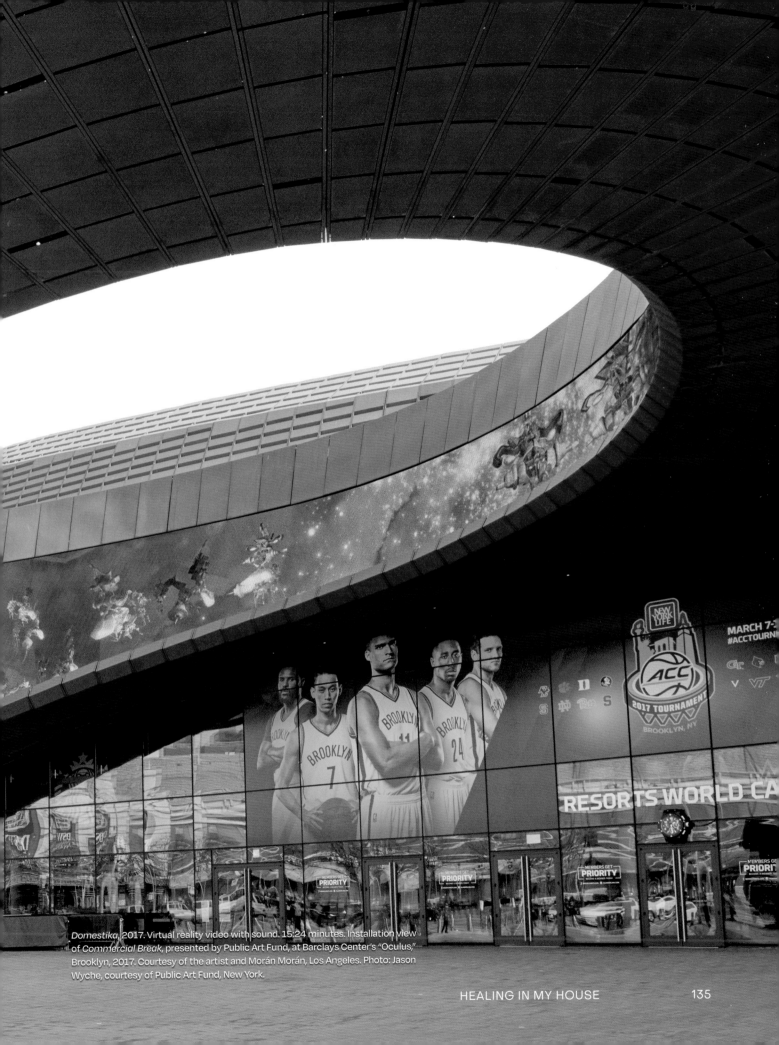

Domestika, 2017. Virtual reality video with sound. 15:24 minutes. Installation view of *Commercial Break*, presented by Public Art Fund, at Barclays Center's "Oculus," Brooklyn, 2017. Courtesy of the artist and Morán Morán, Los Angeles. Photo: Jason Wyche, courtesy of Public Art Fund, New York.

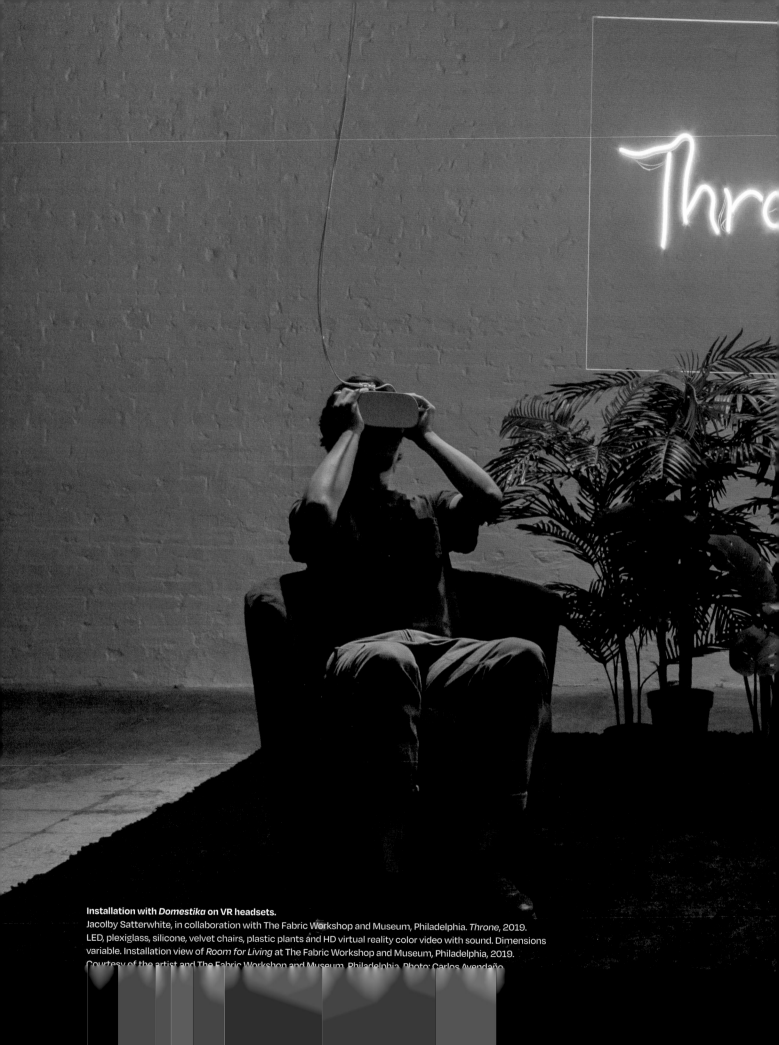

Installation with *Domestika* on VR headsets.
Jacolby Satterwhite, in collaboration with The Fabric Workshop and Museum, Philadelphia. *Throne*, 2019.
LED, plexiglass, silicone, velvet chairs, plastic plants and HD virtual reality color video with sound. Dimensions
variable. Installation view of *Room for Living* at The Fabric Workshop and Museum, Philadelphia, 2019.
Courtesy of the artist and The Fabric Workshop and Museum, Philadelphia. Photo: Carlos Avendaño.

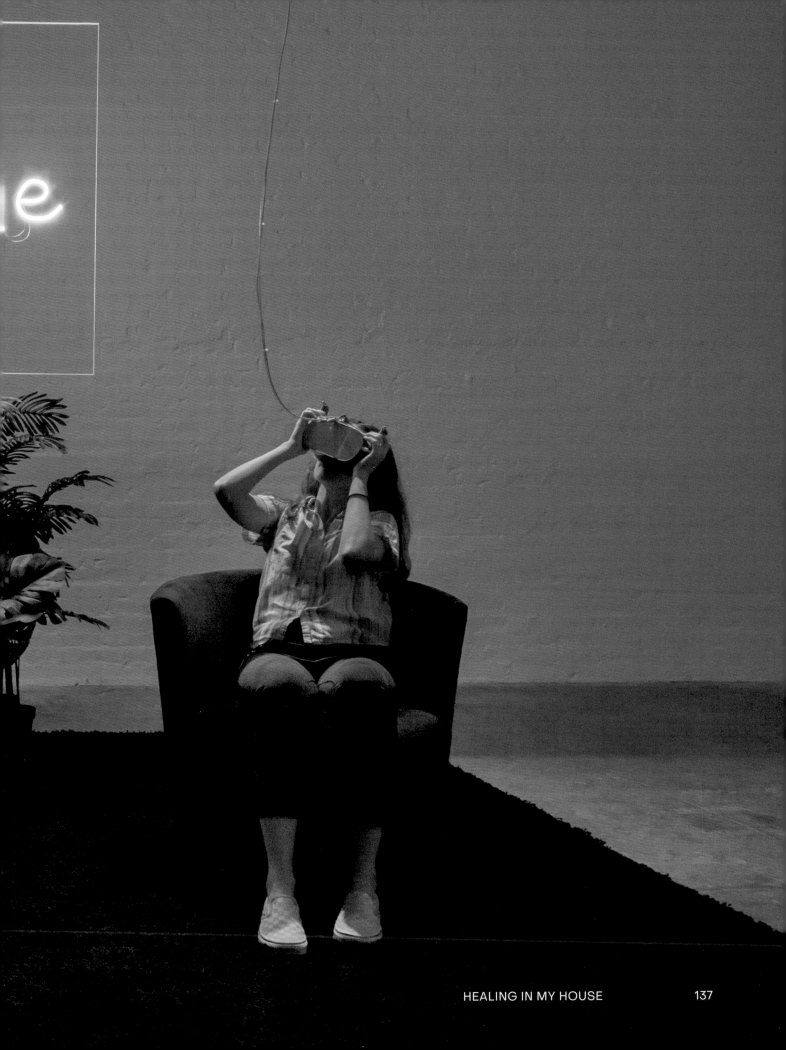

A Dancer's World

MALIK GAINES

There is "a sense of hazard," says Martha Graham in the film *A Dancer's World* (1957) as she turns to her mirror and places a forked scepter designed by Isamu Noguchi in her hair, becoming a modern Jocasta. A dancer describes the risk of performance, the physical danger, its exertion and loss, its affect, its phenomena that exceed the apparatus of measurement (its physics), its ontological dis-integrity, its originality all over again. Graham-like in his commitment, Jacolby Satterwhite repeatedly appears in this dangerous field, dancing in a swirl, extending a repertoire of swoops and kicks that feel like voguing as a martial art. Usually these are set in animated space after having been shot portrait-style against a green screen. In their looping stationariness, these dances hold a ground while they also perpetually transform. On video, his body shapes a spiral that blurs the space where high-end modernism's expressive drives edge against the underwhelming plentitude of our consumption and its oversaturated markets, its work-from-home production, its punishing austerity.

The sense of hazard is more than the expectation of injury on the job. In offering a body to the world, to appear in its scopic field, to move around its platforms, is to spin against forms of nonlife that predict outcomes other than human, person, artist even, and to welcome those predictions. Modernist concepts that symbolize such figures on the outside of life—objecthood, the commodity, the monster, the uncanny double, the criminally deviant: none are enough to constitute what's always extra, what Satterwhite enacts with will, labor and technique, ambivalent desire, ancestral knowledge, and grace. In actions that relinquish presence into mediated forms of control, reprogramming the mechanics of representation itself while redistributing the excesses of his own deficits, Satterwhite risks his life to give life. To think of Satterwhite as a performer means to observe these moves.

An early impression of Satterwhite's work was given in the 2012 group exhibition, *Fore* at the Studio Museum in Harlem, one of the museum's signature roundups of young African American artists. The galleries then (before their still unfinished renovation) were set around a narrow, tall chamber with a mezzanine. Suited to show artworks of the modern style and not very theatrical, these rooms hadn't housed much performance; in those days, the museum's influential director Thelma Golden had noted more than once that performance might be redundant in relation to the museum's mission of showing

Black art in Harlem, given the legendary Apollo Theater right across the street. Implicit in these comments was a comparison between the deskilled, antitheatrical sensibility often associated with downtown New York performance art and the demand for virtuosity that Black performance can require, even of its amateurs.

Satterwhite performed in Harlem nonetheless. Situated on a small platform in a prominent gallery corner, he moved around the space while wearing a silver reflective tech-y bodysuit with sequined hot pants over it, his face obscured by a headdress made of a reflective textile with beaded fringe, which housed a video monitor. The costume suggested an imagined sacred attire of a queer Afro-futurist world. Playing on the monitor on top of Satterwhite's head: an animation in which Satterwhite also performed. Rather than gaze into the performer's eyes, the viewer was confronted, in intimate scale, with a screen and its projection of the performer, doubling the action of seemingly real space. Bold in his art-opening appearance, Satterwhite asserted a self-replicating reflective body that made virtual the idea of presence.

A recent impression of Satterwhite's work formed in a sprawling 2019 exhibition at Brooklyn's Pioneer Works, where three video installations, an architectural expanse containing numerous small videos and objects, and an austere gallery display of primary documents configured the artist's many collaborations with his late mother Patricia Satterwhite. The elder Satterwhite's brilliant and privately composed drawings, texts, and audio recordings met an unanticipated public through the younger Satterwhite's extended reworking of these materials into a set of gestural score, animated signs, 3-D printed sculptures, and a gorgeous, darkly luminous fourteen-track LP of moody electronic music, *Love Will Find A Way Home* (2019). Produced in collaboration with Nick Weiss, multiples of the album were displayed in an installation evocative of the warehouse stores that used to inhabit malls back when music was an object, and which included poster racks, stylish branded t-shirts, and vinyl display bins for the foldout record. Set here were virtual reality goggles that viewers could don to immerse themselves in a digital space populated by repeated Jacolby Satterwhites moving inside of a 360-degree architecture. These VR scenes include dynamic space-scapes, sci-fi architecture, and moody interiors filled with Satterwhite's dancing body, conjuring all sorts of speculative references,

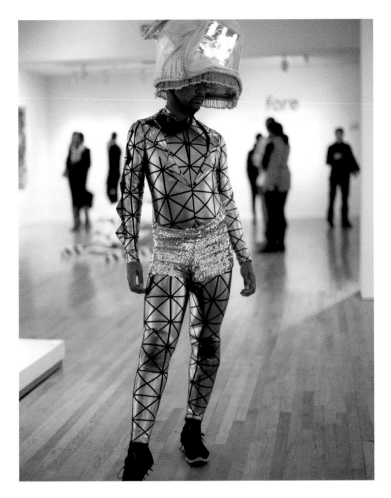

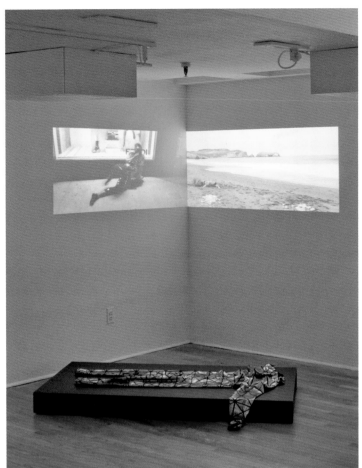

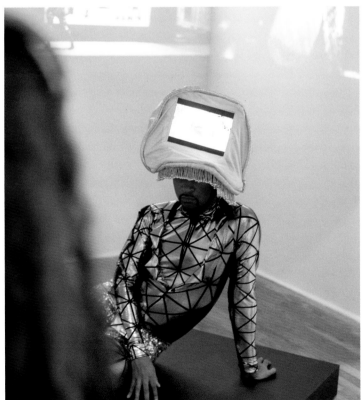

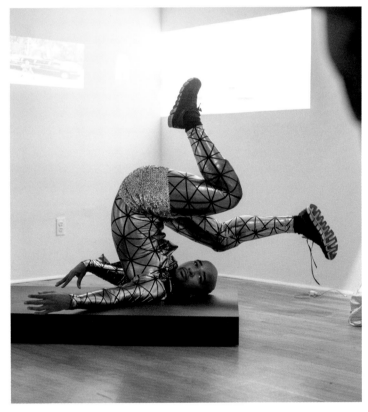

Top left and bottom: *Reifying Desire – Model It*, 2012. Two-channel video installation; painted wooden platform, spandex catsuit and live performance. 60 × 36 × 6 inches (152.4 × 91.44 × 15.24 cm). Performance as part of the exhibition *Fore* at The Studio Museum Harlem, New York, 2012. Courtesy of the artist and The Studio Museum in Harlem Archives. Photo: © 2012 Scott Rudd.

Top right: Installation view of *Reifying Desire – Model It*, 2012. Courtesy of the artist and The Studio Museum in Harlem Archives. Photo: Adam Reich.

141

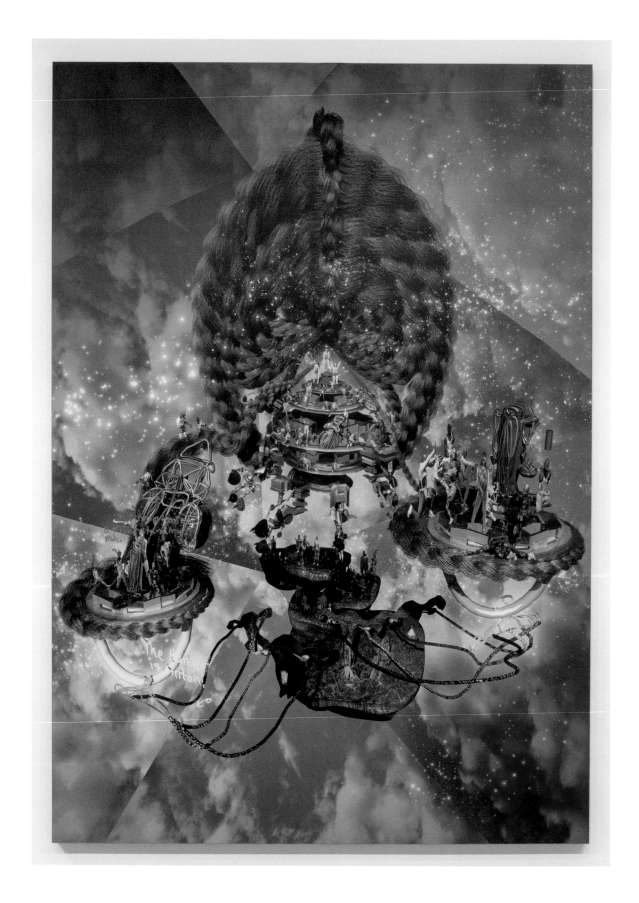

En Plein Air: Abduction II, 2014. C-print in artist's frame. 84 × 60 × 3 inches
(213.4 × 152.4 × 7.6 cm). Courtesy of the artist and Morán Morán, Los Angeles.

from the virtual astrophysics of Cixin Liu's *Three Body Problem* (2014) to the mid-apocalyptic liberation of Janet Jackson's *Rhythm Nation 1814* (1989). Here, cyborg winged horses, nude muscle-thots, rhizomatic skyscrapers, anthropomorphic megavehicles and starbursts of purple and green set a stage for unlimited Satterwhites to spin, squat, extend, and pivot. Meanwhile, the musical soundtrack plays, consisting of one of the album's most important messages, assured in the tempering voice of Patricia Satterwhite: "There's healing in my house."

These two examples offer a range of contexts Satterwhite integrates with his performing body. The white-walled gallery and the colorfully overloaded virtual space join with the street, the club, and the studio to form a world unbounded by disciplinary expectation. "The movement is so lyrical, it's really about drawing and accessing space," Satterwhite elaborates in a 2013 documentary about his practice. Describing himself as "an extended frame video installation performance diva," this kind of proliferation, mobility across boundaries, and quest for access and for making one's mark summons that strain of virtuoso thinking that frames Black performance. Not unproblematic, this historic force calls upon economies of compulsory production and reproduction, the spectacle of achievement as liberatory effort, and the *jouissance* of Black exertion—or pleasure in the excess of the other. The probability of dying at work haunts Black performance, as does the expansive promise of extending past punishment and restriction. The life that is radically proliferative, when measured against the nonlife that organizes Black subjection, produces something extra. Rather than subsume this excess in a coherent self-presenting body, Satterwhite offers himself in overflowing abundance, in multiple bodies, moving in all the places. This exertion is so far beyond a critique of institutions, of disciplinary spaces, or proprietary software that house these works. Satterwhite's performance welcomes these limitations while dispossessing them of their regulatory defaults.

In a segment of the video *Country Ball 1989–2012* (2012), Satterwhite includes an excerpt from a home movie of a family barbecue in South Carolina, which is embedded within a larger animation where he appears as a very small child. Young Jacolby tries to play clapping games and execute synchronized dance routines with all of the little girls. The girls play along until they don't, and little

143

Jacolby is pushed to the periphery. This primary example of Satterwhite's performance mode shows an undaunted expressivity, and the risky permeability of a circle of belonging to which his actions attempt to belong. The virtuoso dynamic is intersected with a queer axis. It's a dimension that modulates an upward striving with a constant in-and-out movement. In *Queer Times, Black Futures* (2019), Kara Keeling offers some helpful framing:

> The production of "queer" is violent, material, and excessive to the management and control of sociability. "Queer" is palpable, felt as affect. It is also not only an imposition but simultaneously a becoming. Queer fluidly anchors and defines the normative. It flows through capital itself. Queer might be felt as utopian or dystopian, quotidian, banal, spectacular, public, private; yet in each of its material operation on and through bodies, it carves out our relations temporally and spatially and proliferates connections within difference.[1]

This sense of queer, apart from stable identifications, describes a process that is also a material condition that is also a feeling and a resistant mode; it exists across multiple genres of sociality and regimes of space, a history and a future. It also offers some ideas about how Satterwhite's actions reorient the performance traditions he deploys, from visionary artist in the modernist sense to avatar of digital space, from virtuoso worker to repository of feelings, from cyborg to mother's son. Funnily, his collaborations with the popular performer Solange, such as his animated sequence for her 2019 video album *When I Get Home*, demonstrate a metonymic chain of relation: Satterwhite is a queer muse of the artsy sister of Black excellence.

In interviews, Satterwhite speaks of mortality. Throughout his work, this proliferation of life and forms of life allude to the death on the other side of Black expression, of queer becoming, of commercial culture and fine art commodities, and less abstract forms, too. There's the loss of his mother that his tremendous deployment of her work never undoes, as well as his own experiences with serious illness that nearly destroyed him before he reached adulthood.

1 Kara Keeling, *Queer Times, Black Futures* (New York: New York University Press, 2019): 18.

When I say Satterwhite risks his life in his work, I mean both the figurative sense in which he offers himself up for consumption, or delivers himself over to exhaustion, or exposes himself without shelter, but also in those more specific ways. And his dancing bears this weight. His stylized form of movement offers a choreography marked by a lack of strength and mobility in his right arm, a disability acquired as a result of cancer surgery. Each of his pivots, turns, and extensions is a careful maneuver that manages weight and reach that can't be distributed bilaterally. What this right-handed artist achieves with his left hand is itself queer Black virtuosity. The world he configures for this performance is full of hazard, but truly beautiful, aesthetically, but also in the articulations of life it animates.

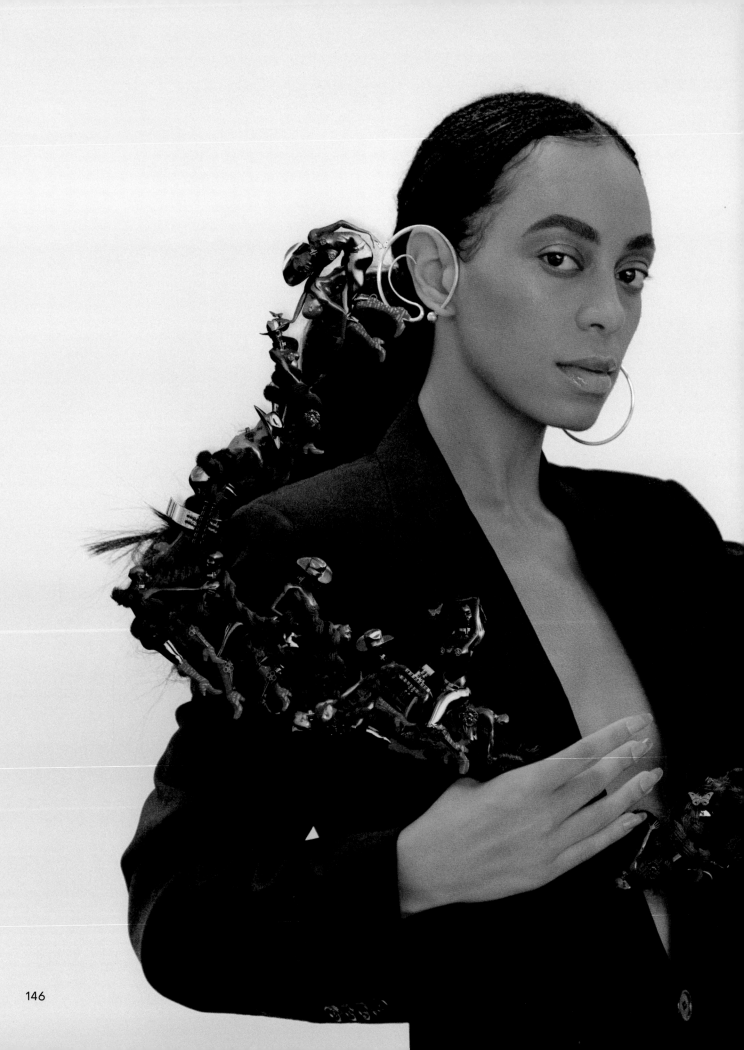

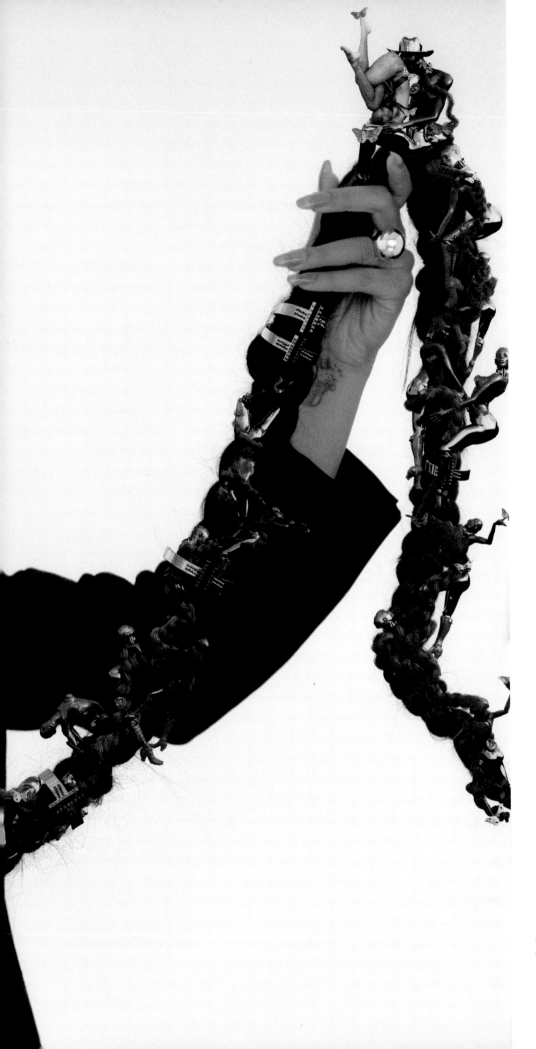

Solange and Jacolby Satterwhite for
Garage magazine, 2019. Photo: Ronan
McKenzie. Fashion Editor: Kyle Luu.

147

Love Will Find A Way Home

Love Will Find A Way Home is a culmination of all that precedes it. Satterwhite conceptualized this album in 2008 but was not prepared artistically to create it until much later. After harnessing his skillset, Satterwhite chose fourteen of his mother's a capellas to draw out the parallel experiences between them and create a robust audio double-portrait in collaboration with musician, Nick Weiss. This collection was conceived as an electronic soundscape inspired by trip-hop, drum and bass, folk, and R&B. In contrast to the ephemeral experience of streaming music, Satterwhite grounds the album within a multi-sensory experiece by pairing it with other elements like his 2017 performance, *En Plein Air*, and the installation *PAT's Record Store*. *Love Will Find A Way Home* is Satterwhite's multiform answer to creating a visual album, empasizing that the sonic experience takes on infinite form.

S.B.

Photograph of Jacolby Satterwhite, 2016.

Moments of Silence
We Are In Hell
Birds in Paradise
Born to Free
Spirits Roaming On The Earth

Model It

Heart and Mind Connection
Rain vs Sunshine
Blessed Avenue
Second Time Around
Because Love Came
Love Will Find a way Home
Youre At Home
I Will Never Go Back

En Plein Air: Music of Objective Romance, 2017. Performance commissioned by the San Francisco Museum of Modern Art as part of *Performance in Progress*, 2017. Courtesy of the artist and San Francisco Museum of Modern Art, San Francisco. Photo: Charles Villyard.

Opposite: Neon rendering of tracklist for *Love Will Find A Way Home* LP.
Birds in Paradise, 2019. Neon. 71 1/2 × 52 1/2 inches (181.61 × 133.35 cm). Courtesy of the artist and Mitchell-Innes & Nash, New York. Photo: Photoservice Art Basel 2019.

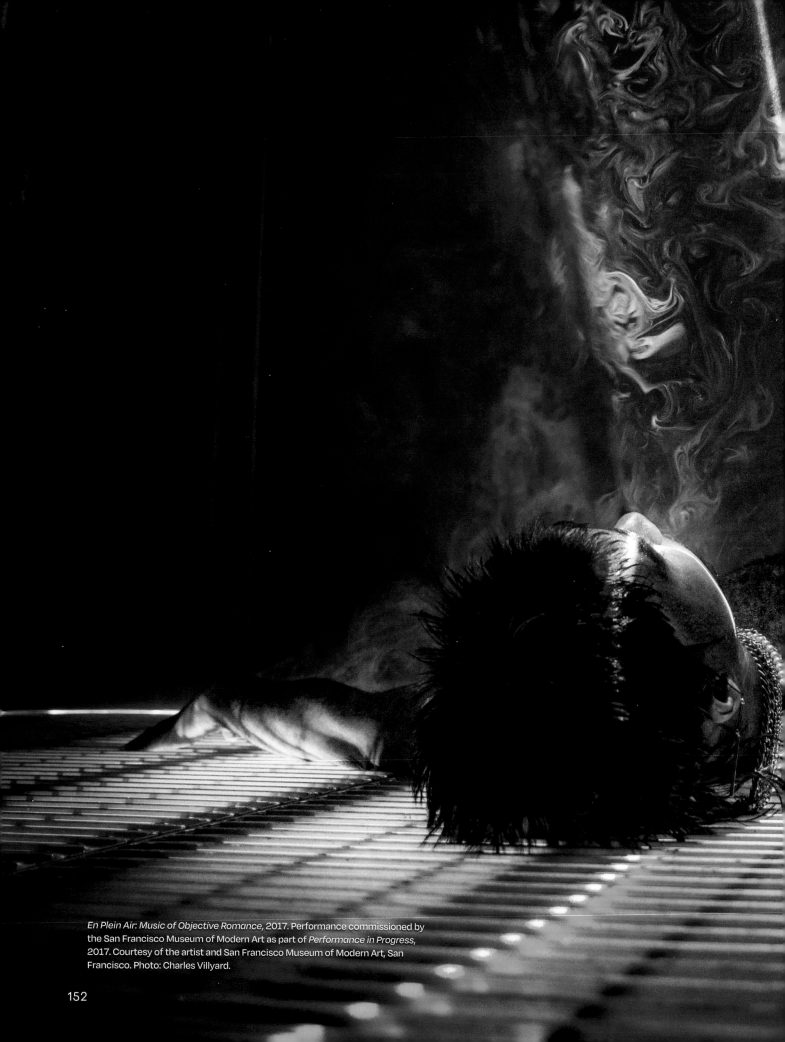

En Plein Air: Music of Objective Romance, 2017. Performance commissioned by the San Francisco Museum of Modern Art as part of *Performance in Progress*, 2017. Courtesy of the artist and San Francisco Museum of Modern Art, San Francisco. Photo: Charles Villyard.

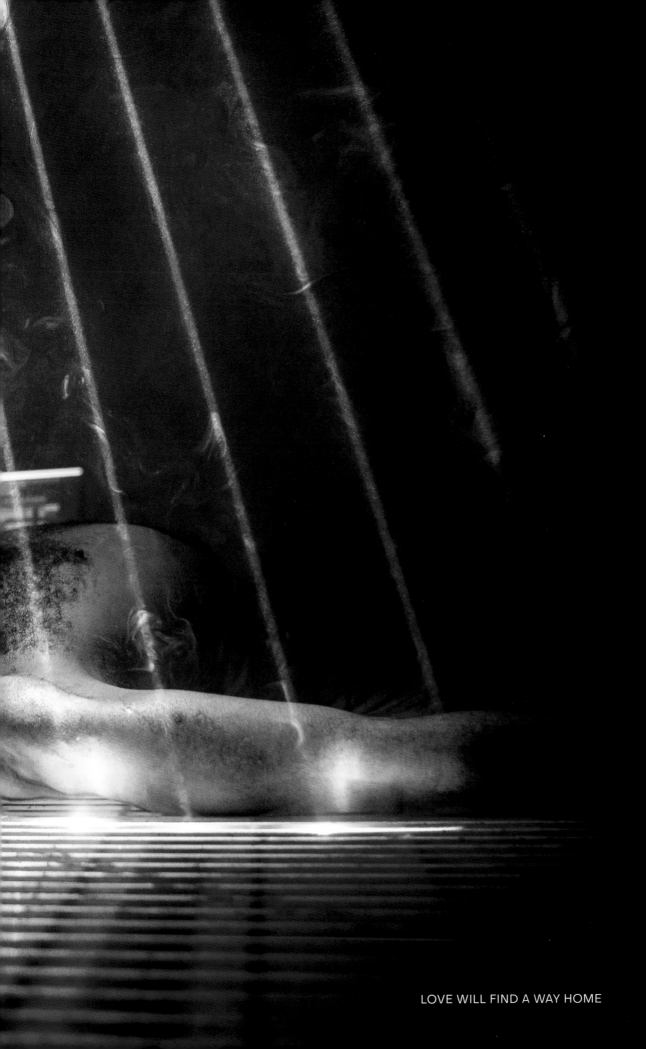

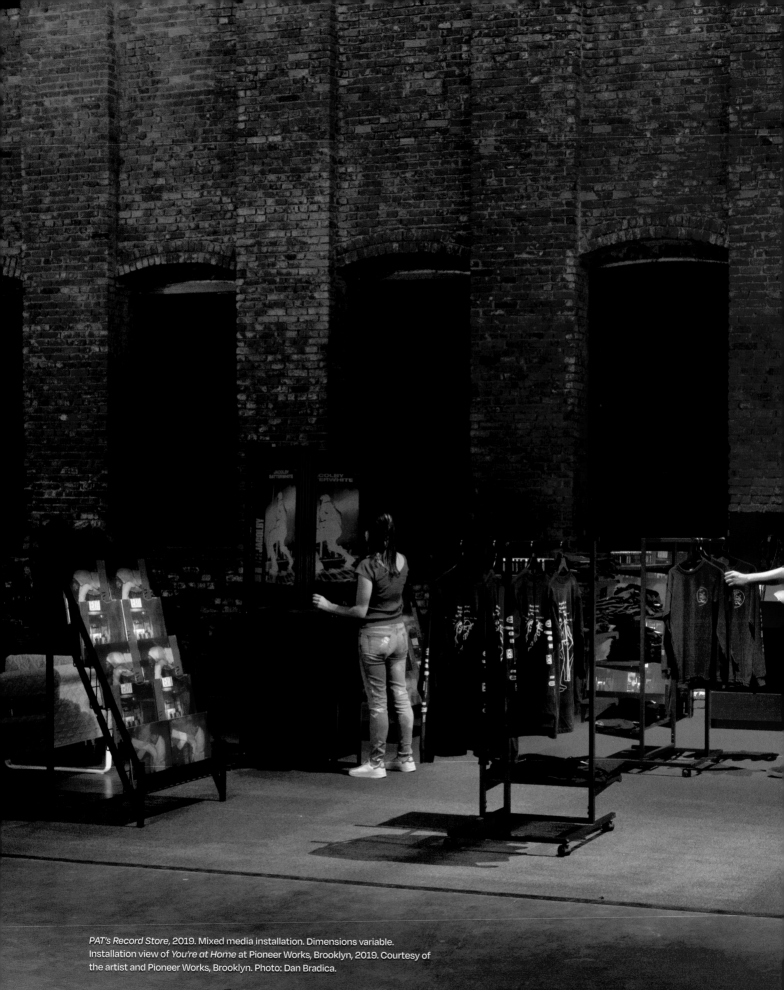

PAT's Record Store, 2019. Mixed media installation. Dimensions variable.
Installation view of *You're at Home* at Pioneer Works, Brooklyn, 2019. Courtesy of
the artist and Pioneer Works, Brooklyn. Photo: Dan Bradica.

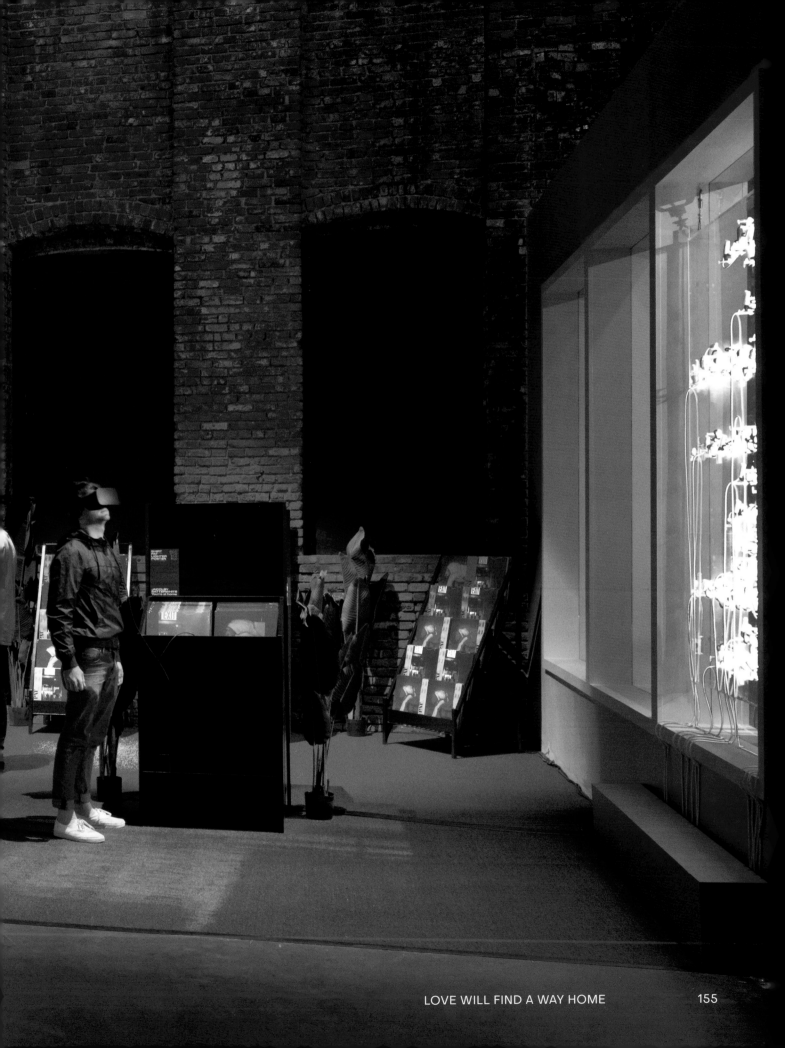

PAT (Collaboration between Jacolby Satterwhite and Nick Weiss). Interior spread
from *Love Will Find A Way Home*, 2019. Double vinyl LPs and 34-page artist book.
12 3/4 × 12 3/4 × 3/4 inches (32.4 × 32.4 × 1.6 cm). Released by Pioneer Works
Press. Courtesy of the artists and Pioneer Works, Brooklyn. Photo: Dan Bradica.

Cruising Utopia, Troubling Modernity[1]

LEGACY RUSSELL

1 Reference to the late José Esteban Muñoz's 2009 book, *Cruising Utopia: The Then and There of Queer Futurity*

"The wanton manipulation of gendered and sexual codes is essential to the production of antiblackness generally, irrespective of self-identification."

— Zakiyyah Iman Jackson[2]

"I believe that the fact of the juxtaposition of the White and the black races has created a massive psychoexistential complex. I hope by analysing it to destroy it."

— Frantz Fanon[3]

To begin with a painting:

Edouard Manet's *Le Déjeuner sur l'herbe* (Lunch on the Grass) (1863) begs you to wrestle with it. A traditional analysis of the work often focuses on the two men in the painting, who appear with what historically has been read as a nude woman; behind them, another woman wearing a sheer dress bathes in a lake. The original title of the work, *Le Bain* (The Bath), lends the viewer some clues as to what we are supposed to see here—women in various stages of undress, men picnicking, a decadent afternoon tucked away from the city, enclosed in the privacy of a wooded verdure. When first exhibited, the painting drew shock, scandal and ire for its representation of a naked white woman suggested in this context to be a sex worker. While representations of nude female figures painted by men at this point was nothing new to art history, the fact that these women veer away from allegory or mythology and firmly plant themselves

2 Zakiyyah Iman Jackson, *Becoming Human: Matter and Meaning in an Antiblack World*, (New York: New York University Press, 2020), 9.

3 Frantz Fanon as quoted in Sylvia Wynter and Katherine McKittrick, "Unparalleled Catastrophe for Our Species? Or, to Give Humanness a Different Future: Conversations," in *On Being Human As Praxis*, ed. Katherine McKittrick (Durham: Duke University Press, 2015), 52.

in "the real" amplifies their audacity. The work, a trouble to its audience, was rejected outright by the Salon jury in Paris in 1863. Determined to still show the piece, Manet brought the work to Napoleon III's *Salon des Refusés* (Exhibition of Rejects), organized that same year. Reflecting on the tempest of contention that arose at the time, French novelist Emile Zola observes:

> Painters, especially Édouard Manet, who is an analytic painter, do not have this preoccupation with the subject which torments the crowd above all; the subject, for them, is merely a pretext to paint, while for the crowd, the subject alone exists.[4]

This is remarkable—Zola points out that the presence of the femme forms that drew such controversy at the time of the painting's unveiling are intended to be decorative at best, "merely a pretext to paint." Thus, the public's ongoing obsession with "the subject alone" is shallow. This observation intersects explosively with the fact that the men in the painting seem to not notice the figures in the first place, prompting one to wonder if the women—existing as a painterly device and tool—even exist at all. If we accept Zola's thesis that these female figures are mere pretext—devices, not subjects, and thereby worthy of the public's attention—then what this work proposes shifts drastically. This shows us how the gendered form, when deployed within the academy of canonized mastery, functions purely as a prop, catalyst, challenge, and opportunity. The leisure of the two men is not extended to the women in Zola; their presence is intended to labor on behalf of not only the two male figures as they work, but the viewer; they function as a mechanical device intended to demonstrate what the material of painting as an art form and technology can do. As we encounter them, these women, the ultimate appliances, are working for us, for the men, and for art history—for free.

We began with *Le Déjeuner sur l'herbe* because Jacolby Satterwhite engages the troubles, history, and presence of this painting actively in his 2020 exhibition at Mitchell-Innes & Nash in New York, "We Are In Hell When We Hurt Each Other."

4 Émile Zola, Édouard Manet, 1867, et lps 91

In her 1992 essay "Olympia's Maid: Reclaiming Black Female Subjectivity," artist and critic Lorraine O'Grady notes:

> The female body in the West is not a unitary sign. Rather, like a coin, it has an obverse and a reverse: on the one side, it is white; on the other, non-white or, prototypically, [B]lack. The two bodies cannot be separated, nor can one body be understood in isolation from the other in the West's metaphoric construction of "woman." White is what woman is; not-white (and the stereotypes not-white gathers in) is what she had better not be. Even in an allegedly postmodern era, the not-white woman as well as the not-white man are symbolically and even theoretically excluded from sexual difference. Their function continues to be, by their chiaroscuro, to cast the difference of white men and white women into sharper relief.[5]

If Manet could be called by Zola an "analytic painter," Satterwhite is a somatic one. In his work Satterwhite makes the "reverse" an empowered subject, walking us through a tear in Black and queer space-time into an alternate universe, where we find ourselves lunching on the grass in a symphonic crowd of cyborgian Black femmes. Here the question of existence is impossible to discount as the presence of Black femmehood enacts a cosmic expansion and redefinition of the idyllic pastoral and who "belongs" to these utopias. Satterwhite's new-world blueprint in a flawless high-def 360-degrees. Refusing the assumption of automation that can come with new media technology as a medium, Satterwhite is deliberate and intentional in ensuring that his hand remains present in production. In this, the artist returns the digital to its etymological roots—the hand and machine central to the digitality of his making, underscoring the corporeal as a machinic force in this future-forward paradise where a viewer, using VR, can vogue, radically recline, and ecstatically survive within paradise, all at once. "When you consolidate all these mediums," Satterwhite explains, "You're creating a visceral body." Satterwhite's application of his creative hand and his painterly touch creates a blurred subjectivity that activates and accelerates the possibilities for a non-binary being that transcends

5 http://lorraineogrady.com/wp-content/uploads/2015/11/Lorraine-OGrady_Olympias-Maid-Reclaiming-Black-Female-Subjectivity.pdf

the trap of gender through the visceral choreography of the Black femme figures we see on-screen. These queered figures proudly lean, revel, and remain encrypted within the architectural slant of masculine / feminine. Manifesting across a dynamic intersection of installation, pigment-prints, neons, sculptures, and virtual reality, the artist instructs that the work—a "body" in and of itself that animates the history, labor, economy, of the painter as subject—is intended to surround the viewer immersively, "mak[ing] a painting [in] five-dimensions." It is this fifth-dimension site of strategic reversal that Satterwhite cracks open, granting the viewer access to a hagiographic cryptography that adores, delights, and dialogues with the bodies he brings into the gilded frame.

Guided further by O'Grady's words, you might call into view here Manet's *Olympia* (1863), that was first exhibited at the Paris Salon of 1865. This work shows us a white female form in nude repose, propped up on a chaise lounge.[6] In the background a Black female servant attends to the white woman, bringing her a bouquet of flowers. In 2019, it was widely reported[7] that the Musée d'Orsay "temporarily retitled works featured in its exhibition 'Black Models: from Géricault to Matisse' to honor the [B]lack subjects and figures in iconic paintings."[8] Despite this superficial institutional gesture, Manet's *Olympia* was still overlooked, failing to receive even the provisional gloss of "Laure," the name of the Black woman thought to have modeled for this painting.[9] The interior private space Laure occupies in *Olympia* creates a unique enclosure, whereby Laure, as a Black woman, has direct gaze and sightline to Victorine, which bears witness to the white female sitter and verifies for the viewer that Victorine's presence in the work does something more than operate as a painterly device.[10] This signification stands in stark contrast to the gaze of the two men lunching in the grass in Manet's other frame, where Laure as a "stabili[zing]" force for Victorine in Olympia echoes in her function the role the two bathers play for

6 Gender identifications here based on historical readership of the work.

7 https://www.smithsonianmag.com/smart-news/musee-dorsay-renames-manets-olympia-honor-its-little-known-black-model-180971812/

8 https://www.artsy.net/news/artsy-editorial-musee-dorsay-retitled-artworks-including-manets-olympia-honor-black-subjects

9 See "Editor's Note," source: https://hyperallergic.com/491738/musee-dorsay-black-models/

10 https://pallant.org.uk/manets-olympia-laure-and-victorine/

the men in *Le Déjeuner sur l'herbe*.[11] Taken together, though separated by nearly two centuries, Manet and Satterwhite say so much about the modern building of bodies and the construction of gender under the weight of modernism, most especially the ways in which Black femmehood has historically labored to aid in the articulation and designation of "human" as a localized taxonomy for non-Black people. Black women, cyborgian in the (im)possibility of what their presence asserts, for so long have held space making the existent humanity of the construct of the white woman—a fantasy figurine long deemed unequal to the construct of the "real" white man, yet participatory in the violence of its power and ascendancy of its patriarchy—possible.

Satterwhite's collaboration with his late mother Patricia Satterwhite underscores the artist's ongoing dialogue with Black women and the ways in which they can be necessarily centered with care both in life and in death. The artist's rhizomatic practice creates a dynamic site of remembrance for his mother, ecstatically engaging the viewer in paying homage to Patricia Satterwhite's life and contributions, vivifying both her spirit and her genius as it lives on, beyond her. A son speaking to and through the spirit of his mother ritualizes the practice of production, winding through it a spirituality of devotion deserving of religious icons and pop star divas alike. For Patricia Satterwhite who dreamed of being a pop star and recorded cassette tapes of her melodic masteries, her son's work makes possible the ultimate swan song and sermon, the lyrics themselves tenderly animated illuminated manuscripts, mantras to move to and read aloud. As an artist herself, Patricia Satterwhite exercised an active drawing practice, proposing new products and inventions that she both patented in America and shared with the QVC shopping network. These proposals left their mark, a body of work that is felt in its sustained breathwork. Still, perhaps her greatest work of all lies in the legacy of her son and his practice as it continues to expand, an engineering of futurity that explodes the limits of the world she once walked through, beyond anything that could have been imagined.

11 "Laura's *[sic]* place is outside what can be conceived of as woman. She is the chaos that must be excised, and it is her excision that stabilizes the West's construct of the female body..."
http://lorraineogrady.com/wp-content/uploads/2015/11/Lorraine-OGrady_Olympias-Maid-Reclaiming-Black-Female-Subjectivity.pdf

PAT (Collaboration between Jacolby Satterwhite and Nick Weiss). *Love Will Find A Way Home*, 2019. 34-page artist book with Double vinyl LPs. 12 3/4 × 12 3/4 × 3/4 inches (32.4 × 32.4 × 1.6 cm). Released by Pioneer Works Press. Courtesy of the artists and Pioneer Works. Photo: Dan Bradica.

Satterwhite's work calls out from a breaking point, a moment where the COVID-19 pandemic collapsed the world we thought we knew, showing us, with brutal honesty, the very real capital conditions of hell and harm we all have already been coping under for so long. The care-full navigation of the visual and historical vernacular of "pastoral" and "paradise" as guided by the artist helps us think through the ways in which these sites that traverse the realm of the real and the imaginary have been mutually guarded and occupied over time, with Black femmehood so often kept just outside the gates—refused, but sentinel. In this pastoral concert as Satterwhite conducts it, Black femmehood greets us centerstage and resists collapse in spite of an advancing dystopia.[12] For the artist, the murder of twenty-six-year-old Breonna Taylor at the hands of the Louisville Metro Police Department in her own home on March 13th, 2020 is a central subject, a heartbeat felt across dimensions that beats as a necessary drum within us, too.

This past spring and summer as the urban pastoral of city parks filled with people gathering in protest against state violence and in celebration of the matter of Black life, we kept mourning. In this collective prayer, we asked for Taylor's life to matter, too. Patricia Satterwhite, her voice remixed and layered gorgeously into the dense tracks that accompany the artist's neon-infused landscapes reminds us: "When we see the truth, we will all be free / ... I will never go back to the way I used to be." The insistent failure to accept the erasure of Black femmehood—lives lived, and lives lost and stolen—posits the ultimate glitch in the grid. In this remembrance, we identify new modes of viewership, ways of seeing that validate, a mark-making that says, We're still here. If Laure's sacrifice in presence, labor, and visibility paved the way for the green of modernism, it is Pat and Satterwhite that join forces here and together emancipate it.

Seen, remembered, loved, we celebrate.

12 Reference to *The Pastoral Concert* (ca. 1510) by Titian, Louvre, Paris, cited as an inspiration for Manet's painting

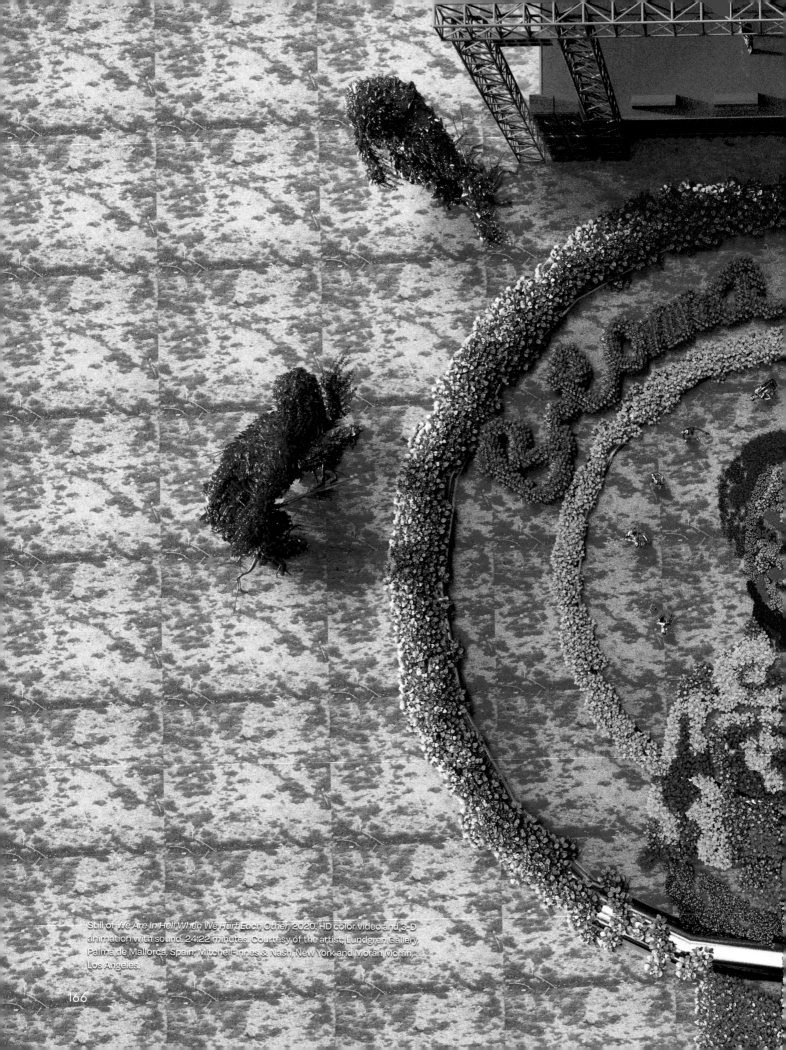

Still of *We Are In Hell When We Hurt Each Other*, 2020. HD color video and 3-D animation with sound, 24:22 minutes. Courtesy of the artist; Lundgren Gallery, Palma de Mallorca, Spain; Mitchell-Innes & Nash, New York and Morán Morán, Los Angeles.

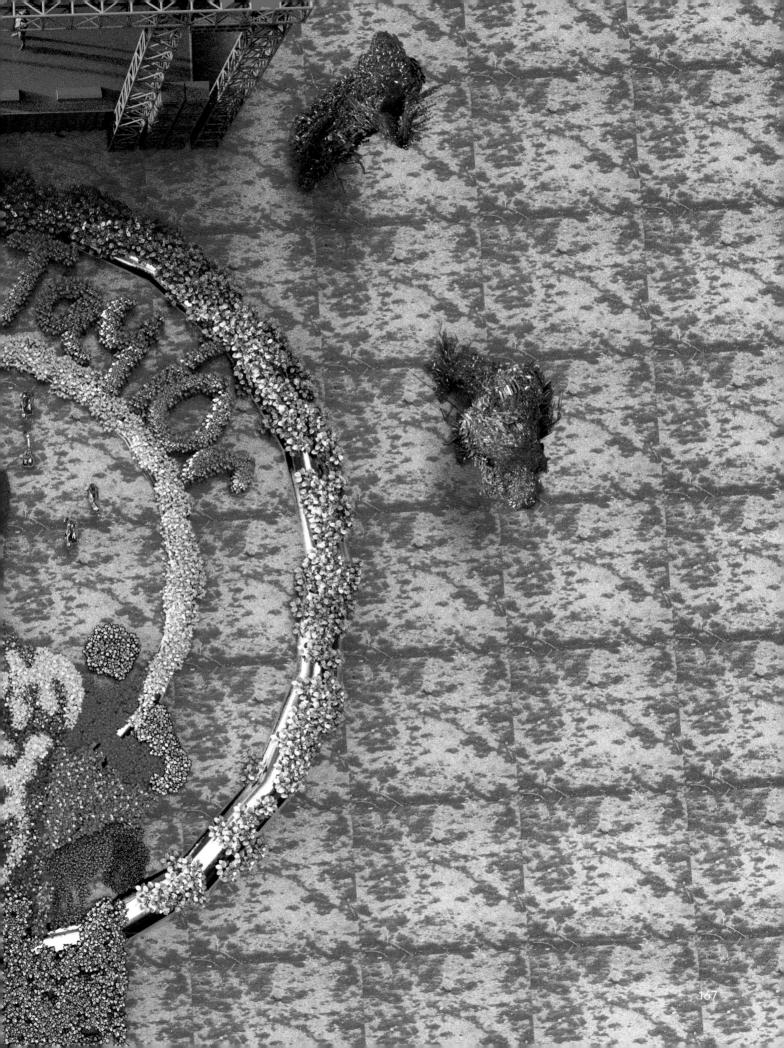

Birds in Paradise

The *Birds in Paradise* collection is a six-part video installation series that includes *Birds in Paradise, Moments of Silence, Blessed Avenue, Avenue B, We Are In Hell When We Hurt Each Other*, and *Shrines*. Every song from the concept album, *Love Will Find A Way Home* is articulated and housed into these films as he worked on these projects in tandem to create an archipelago of sculptural production. Satterwhite's conceptualizing of the ways that sound can be aligned with imagery is a tool used to immerse the viewer into a tangible, nearly tactile world. Beyond the films, in his C-prints, sculptures, and photography of this series, Satterwhite has extracted stills from these labyrinthine visuals to allow the viewer to savor and linger on moments. This is an interconnected constellation of thought inspired from the Nigerian practice of worshipping mother God through dance and the mind of Patricia, resulting in Satterwhite's creation of this multisensory experience.

Satterwhite's foundational inspiration is the Nigerian practice of worshipping the mother of all Gods through dance, which resists stagnation and stillness. Much of his work offers the point of view of a bird soaring, as if to say, levitation is an interlude, a space to bear witness. A space for liberation. The mythology of the flying Negro was a radically imagined response to hundreds of years of enslavement, and is a representation of the ways in which the mind can move beyond the captivity of the physical form, allowing for the groundwork of new worlds to be realized through imagination and movement.

This section holistically focuses on healing through the sonic experience and the movement that's brought forth. The music is the foundation; the movement is the remedy; and the love is the cure. Dancing and music are the through line as a spiritual meditation, a form of worship, and a form of communication. A way to show all the ways that Black bodies can bend without breaking. Toni Cade Bambara once wrote in *The Salt Eaters*, "wholeness is no trifling matter. A lot of weight when you're well."[1] At the commencement of the two-channel film, *Avenue B*, we see moving frames of *Anton* (2018), a close-cropped diptych of two Black men in bejeweled crown-like durags, caught up in the rapture of love as their lips lock in passion while threatening flames erupt to the soft melodic reminder of Bambara's words as Patricia sings, "Although the time is right for love/the pain is still fresh."

In *We Are In Hell When We Hurt Each Other*, created during the COVID-19 global pandemic, we see the face of Breonna Taylor, a twenty-six-year-old EMT worker who was murdered by Louisville police officers as she lay dreaming in her bed. When there are so many ways to die in a Black body, one must imagine so many ways to stay alive. Satterwhite is looking back and merging the ideas of the past with the technology of today. The cyclical nature of history offers the possibility of reimagining the masters of the past, including but not limited to, Patricia. In *Black Luncheon* (2020), Satterwhite reimagines Édouard Manet's *Luncheon on the Grass* (1863) with a flickering between a cellular form and the

1 Toni Cade Bambara, *The Salt Eaters* (New York: Vintage, 1992), 5.

Birds in Paradise, 2019. Neon. 13 3/8 × 72 inches (34 × 182.9 cm). Courtesy of the artist and Mitchell-Innes & Nash, New York. Photo: Dan Bradica.

graphic, "BOOM." The Boom, or biochemical explosive threat, is extinguished by the nude background woman's neon ponytail. Manet was known for his refusal to conform to convention, and Satterwhite's reference to his work is a nod to this sentiment of questioning power dynamics and dismantling systems built in the art world to exclude artists who look like Satterwhite. If Manet's *Luncheon* introduced the commencement of modernism, *Black Luncheon* serves as the catalyst for progress in the contemporary context. In *Skeptic's Allegory* (2020), Satterwhite references Ernie Barnes' *The Sugar Shack* (1976) that was famously incorporated into the credits of the Black cult classic sitcom *Good Times* and as the cover of musician Marvin Gaye's fourteenth album, *I Want You* (1976).

In a very Warholian way, he calls on pop-cultural muses that inspire him to be featured in the work. One can see the rapper Trina show up in many frames as she represents a type of mythological lore, in the way that she takes up space and her sense of control of her own image. Satterwhite sees her as the ultimate refusalist as she takes agency of her own body. A body that men and White America attempt to lay hands on in an effort to project their own stereotypes. Trina is positioned as a hero throughout this series of works that began during his work on *Sound of Rain*, a four-minute video created with musician Solange Knowles, for her album, *When I Get Home* (2019).

Bethann Hardison is a vessel selected to sit in *Black Luncheon* as a model of survival and exaltation of the unrepresented Black femme body. Hardison appears in both the foreground and background taking on different shapes to signify the multiplicity of living within a Black femme body, while dressed in a red cloaked garment that resembles that of a deity or religious figure of divine stillness. When George Floyd yelled out to his deceased mother in front of the world as he gasped for air, it was the equivalent of calling out to God in the final moments of life. When we face fear, our mothers come to us first. Patricia's work is a guide for learning how to live presently, within the wounded body, and multiply through a wounded womb. In a gaslit neon glow Satterwhite reimagines his mother's text, *I Will Never Go Back* (2020).

In *Flying in Paradise, All Above the Business* (2020) Satterwhite incorporates British musician Dev Hynes of Blood Orange as the centralized figure set above a fecund community environment and beneath the writings of Patricia, where the figure resides in the liminal space. The in-between can be a place of extrication that embodies the complexity of the human experience. This series is evidence of Satterwhite's refusal to exist grounded in singularity.

S.B.

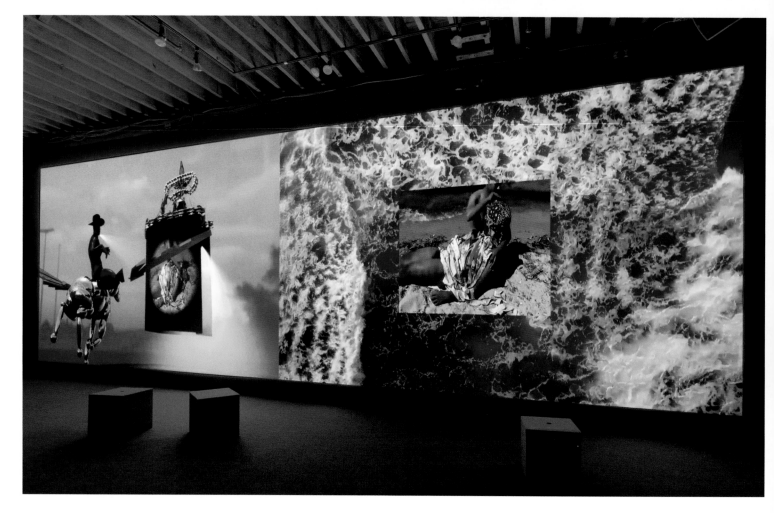

Birds in Paradise

Birds in Paradise, 2019. Two-channel HD color video
and 3-D animation with sound. 18:20 minutes.
Installation view of *You're at Home* at Pioneer Works,
Brooklyn, 2019. Courtesy of the artist and Pioneer
Works, Brooklyn. Photo: Dan Bradica.

Birds in Paradise is a two-channel non-linear thematic film that serves as the crescendo of this sextet collection. Satterwhite worked on this film throughout the creation of the series after a conversation with artist Solange Knowles, with whom he collaborated with on her 2019 visual album, *When I Get Home*, a musical meditative homage to Houston and origin spaces. There are traces of Houston's influence as the film opens with a bare-skinned cowboy figure erotically riding a chrome-winged stallion above a coliseum in the left channel and closes hovering over the downtown cityscape. Satterwhite began thinking about the coliseum as an archaic parallel to the 360-degree spectatorship of a virtual reality space, bridging the historical with the contemporary. The right channel opens with performance artist Tameka Norris as the

Mami Wata mermaid figure, an ancient African deity, unfettering Satterwhite at the shoreline, a liminal space, where he is baptized. To exist at the precipice is a visual acknowledgement of the duality of being, like the duality of water; it heals, and it can hurt. Mami Wata, tenderly scrubs Satterwhite's limp limbs as the figures in the opposing channel move in ritualistic circularity, a representation of the variations on the process of healing. Patricia sings, "Don't come around/talking about the way I used to be/I'm not the same/and that's the way I want to be." A rebirth emerges after each process, the healing is not done, but the figures lean slightly closer towards freedom.

S.B.

170

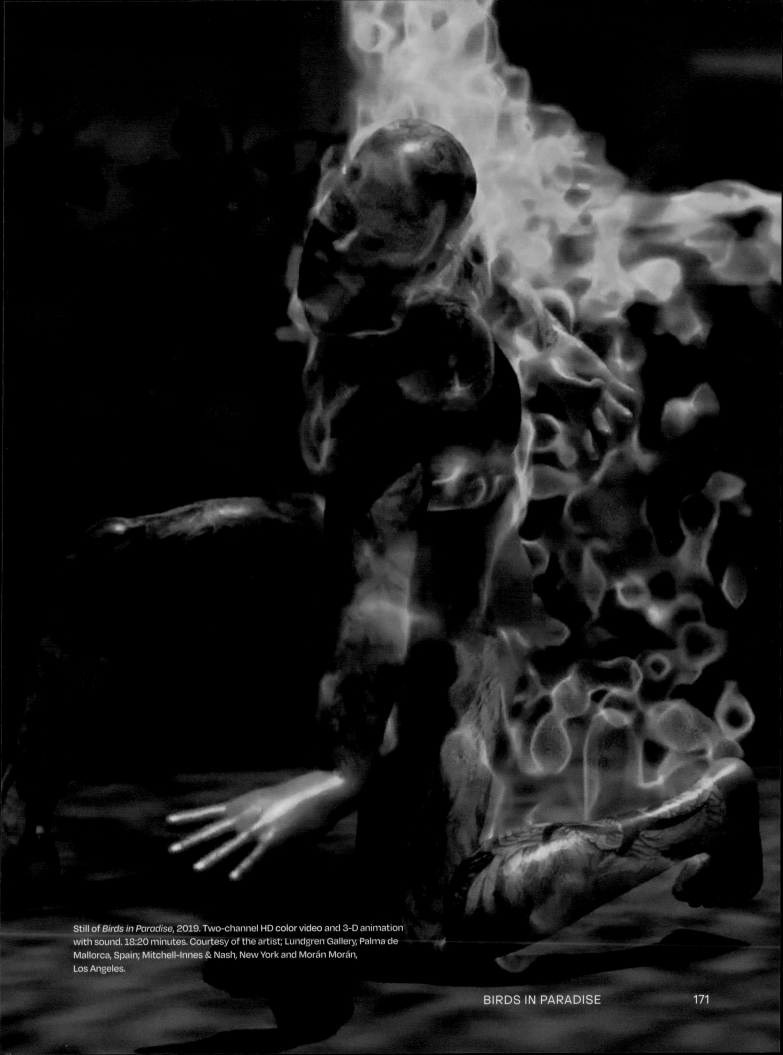

Still of *Birds in Paradise*, 2019. Two-channel HD color video and 3-D animation with sound. 18:20 minutes. Courtesy of the artist; Lundgren Gallery, Palma de Mallorca, Spain; Mitchell-Innes & Nash, New York and Morán Morán, Los Angeles.

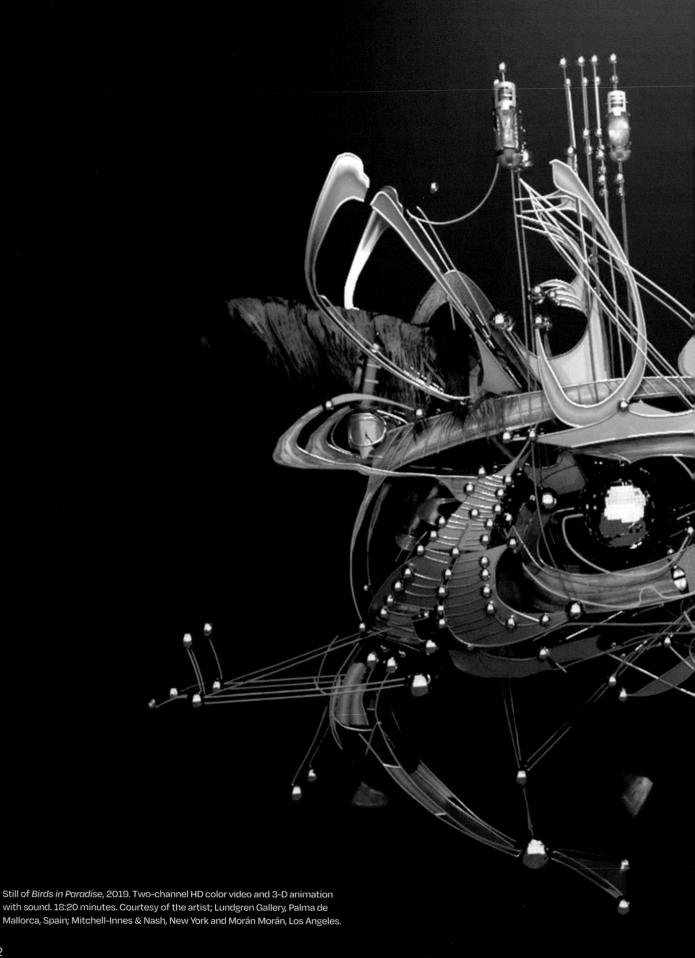

Still of *Birds in Paradise*, 2019. Two-channel HD color video and 3-D animation with sound. 18:20 minutes. Courtesy of the artist; Lundgren Gallery, Palma de Mallorca, Spain; Mitchell-Innes & Nash, New York and Morán Morán, Los Angeles.

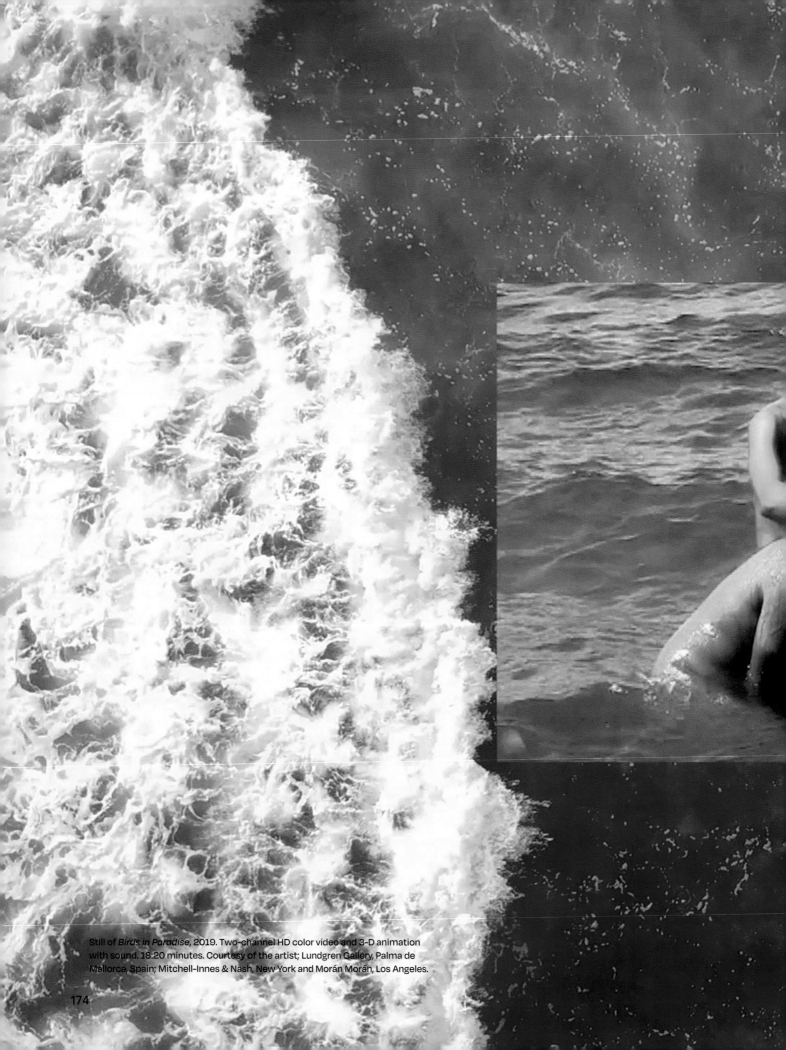

Still of *Birds in Paradise*, 2019. Two-channel HD color video and 3-D animation with sound. 18:20 minutes. Courtesy of the artist; Lundgren Gallery, Palma de Mallorca, Spain; Mitchell-Innes & Nash, New York and Morán Morán, Los Angeles.

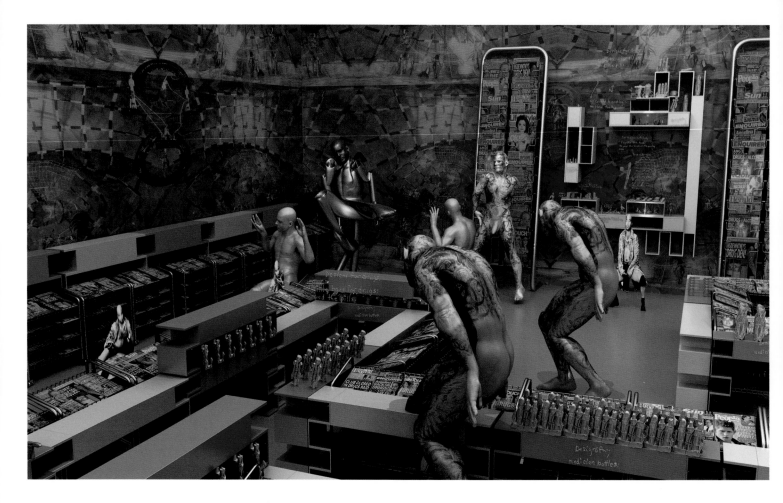

Moments of Silence

Stills of *Moments of Silence*, 2019. Two-channel
HD color video and 3-D animation with sound. 5:23
minutes. Courtesy of the artist; Lundgren Gallery,
Palma de Mallorca, Spain; Mitchell-Innes & Nash,
New York and Morán Morán, Los Angeles.

This work shows Satterwhite inside a historic Brooklyn underground nightclub of the 2010s called Spectrum, that served as an incubation space for many queer millennials. For Satterwhite, who frequented Spectrum, it felt like an extension of home, a place for reinvention and acceptance without question. Much of the footage was recorded inside the iconic club before it shut down. Just as he celebrated his mother, Satterwhite wanted to create a relic of the space that built him up. In a raging nightlife where queer intellectuals let it all go, he is able to set a tone that mimics Spectrum in *Moments of Silence*, a cavernous post-apocalyptic environment.

On one channel of the two-channel film, three-dimensional animated rooms contain pathological devices like pharmaceuticals and tabloids. These spaces reveal the normalization of addiction in contemporary society. On the second channel, Satterwhite employs queer athletic behavior as a way to question these norms and their attendant gender constructions. He brings into question America's aversion to queerness and Blackness as he shows vignettes of a virus infecting the living rooms of America, like Jerry Springer and the Kardashians. Each room that the viewer is taken into reflects on the dark norms Americans digest through popular culture. This work serves as the prelude to *Shrines*, and sets up the tone for *Birds of Paradise*.

S.B.

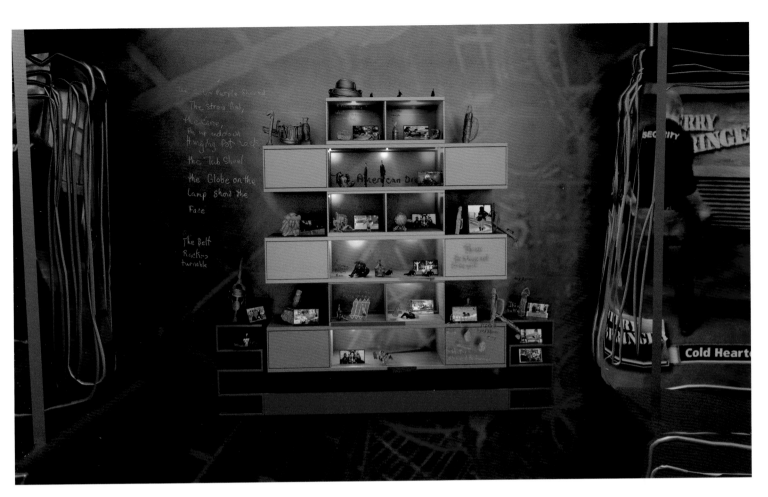

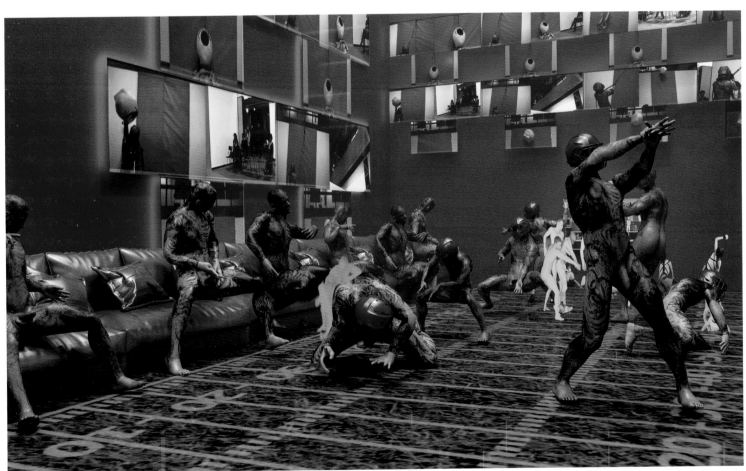

BIRDS IN PARADISE

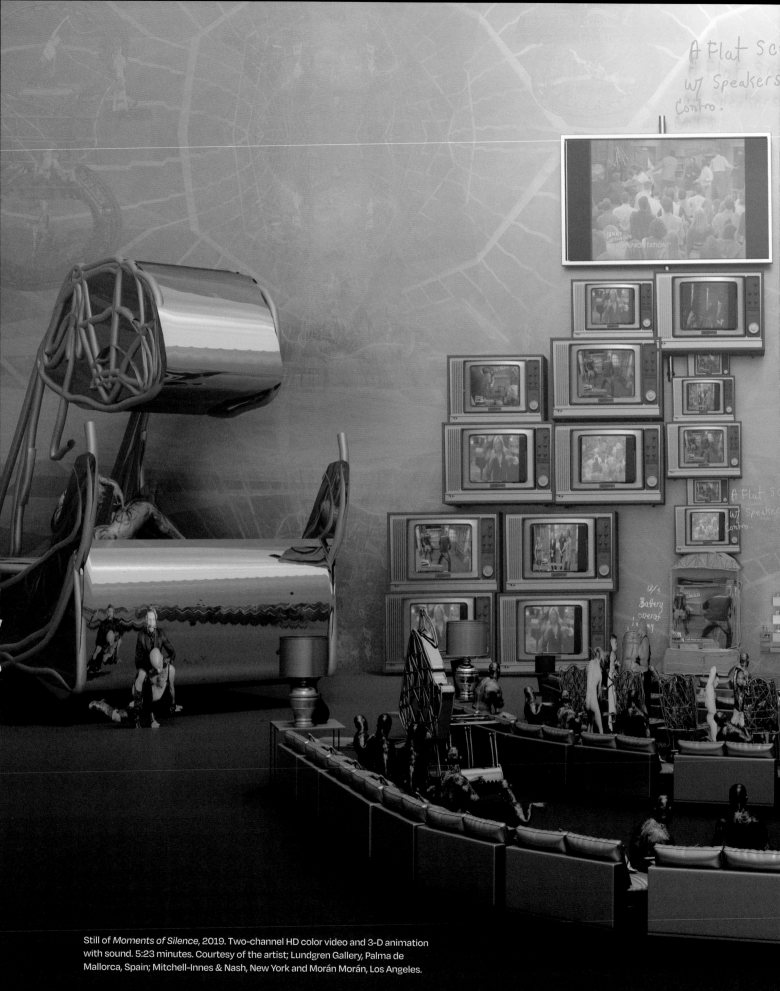

Still of *Moments of Silence*, 2019. Two-channel HD color video and 3-D animation with sound. 5:23 minutes. Courtesy of the artist; Lundgren Gallery, Palma de Mallorca, Spain; Mitchell-Innes & Nash, New York and Morán Morán, Los Angeles.

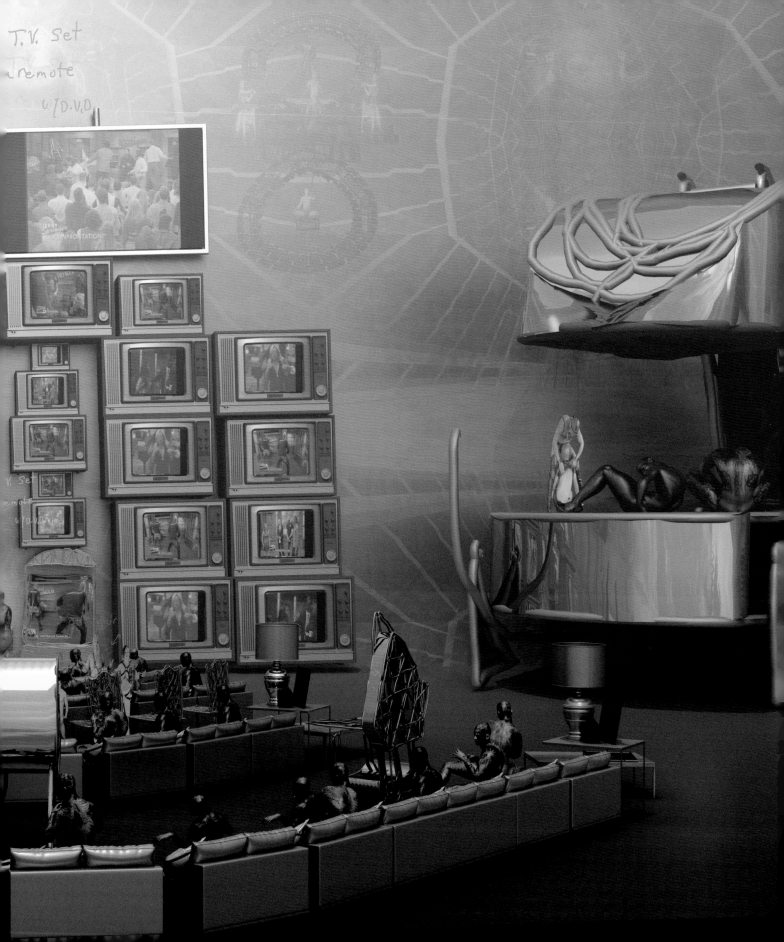

Still of *Moments of Silence*, 2019. Two-channel HD color video and 3-D animation with sound. 5:23 minutes. Courtesy of the artist; Lundgren Gallery, Palma de Mallorca, Spain; Mitchell-Innes & Nash, New York and Morán Morán, Los Angeles.

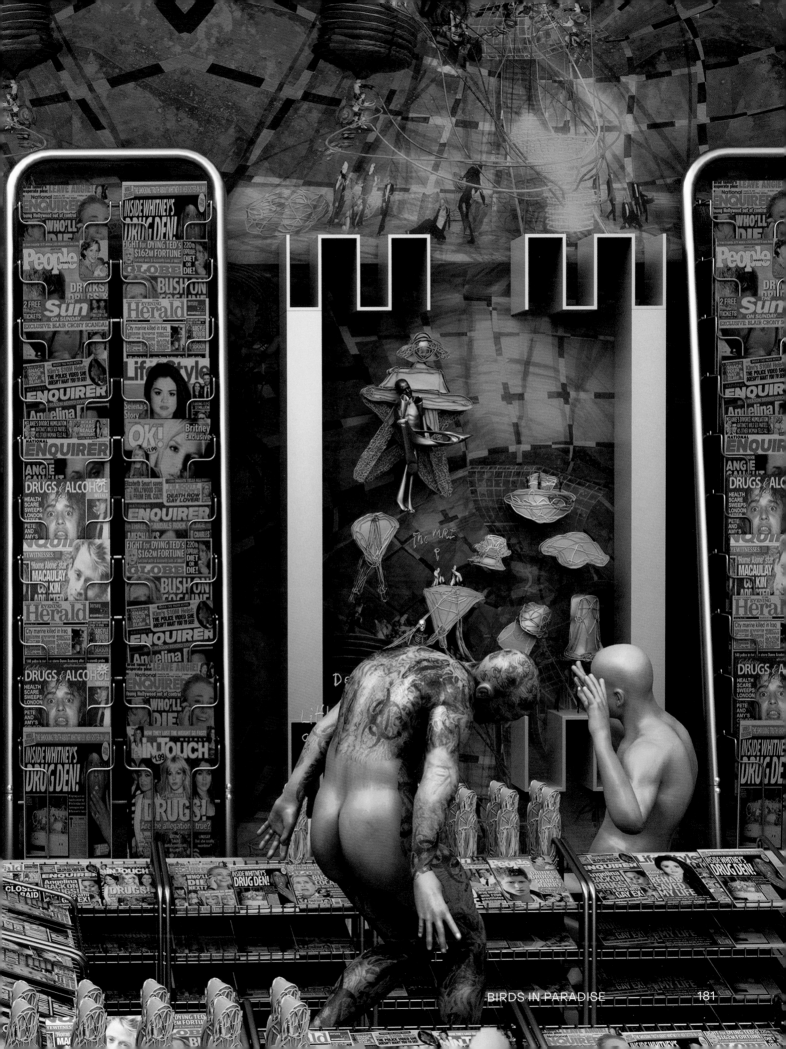

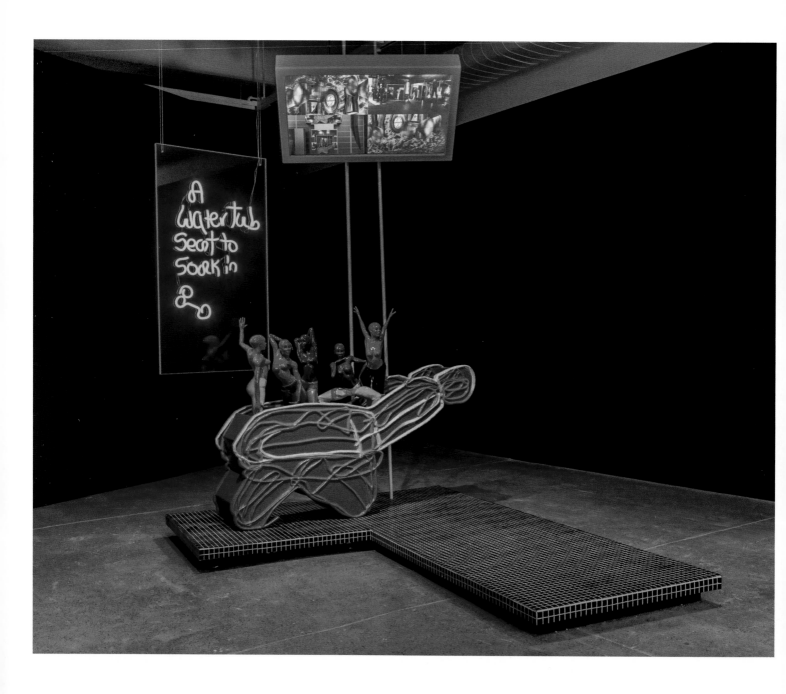

Installation views of sculpture derived from *Reifying Desire 5* and *Moments of Silence*.
Jacolby Satterwhite, in collaboration with The Fabric Workshop and Museum, Philadelphia. *Room for Cleansing*, 2019. Plexiglass, LED, HD color video, silicone, MDF, enamel, latex paint, PLA filament, epoxy, epoxy resin, enamel, bond filler, tile, grout, plywood and aluminum. Height variable, platform: 96 × 72 inches (243.84 × 182.88 cm). LED and plexiglass: 47 5/8 × 27 1/4 × 3/4 inches (121 × 69.22 × 1.9 cm). Installation view of *Room for Living* at The Fabric Workshop and Museum, Philadelphia, 2019. Courtesy of the artist and The Fabric Workshop and Museum, Philadelphia. Photo: Carlos Avendaño.

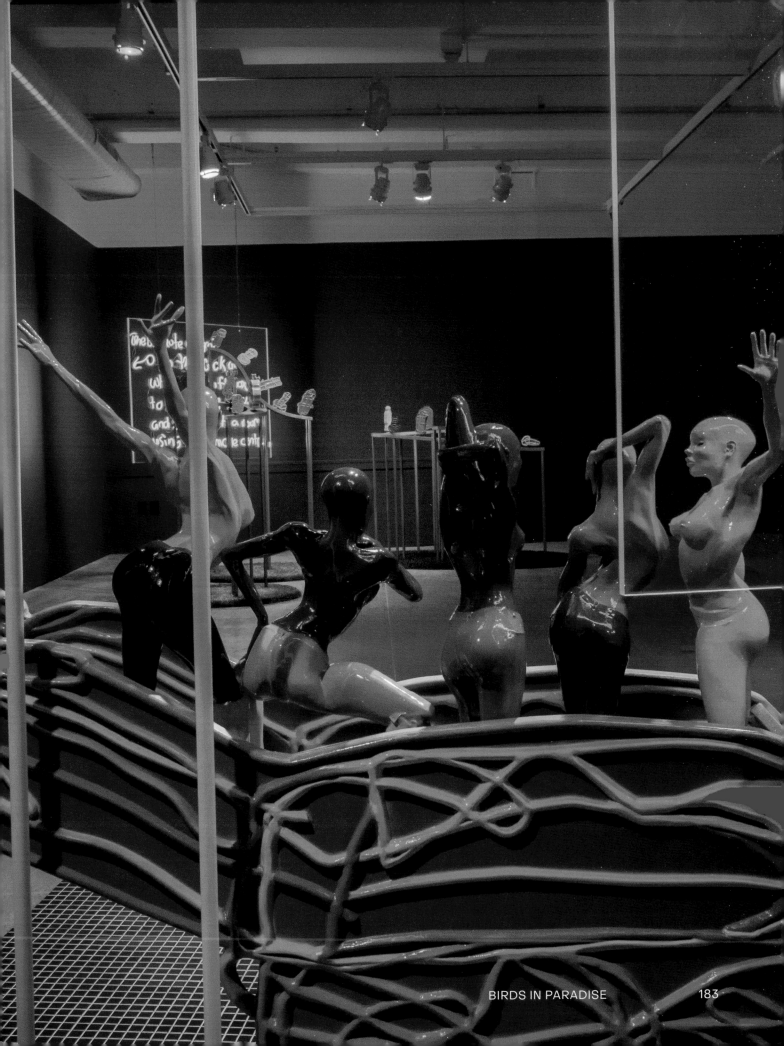

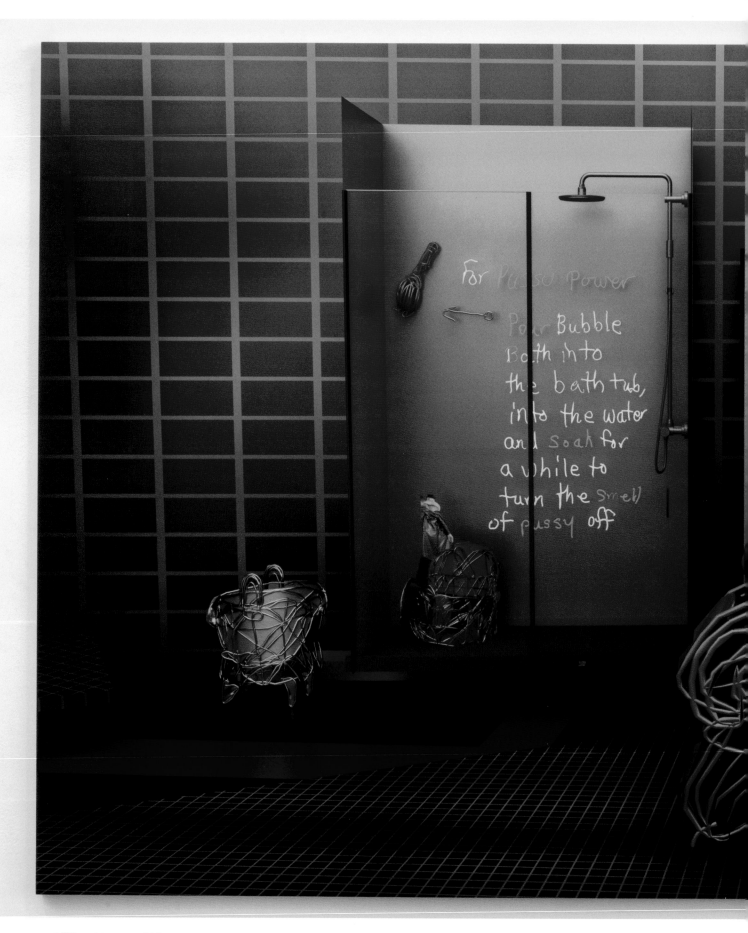

Still from *Moments of Silence.*
Watertub for Demoiselles Two, 2019. C-print. 45 × 60 inches (114.3 × 152.4 cm).
Courtesy of the artist and Mitchell-Innes & Nash, New York.

184

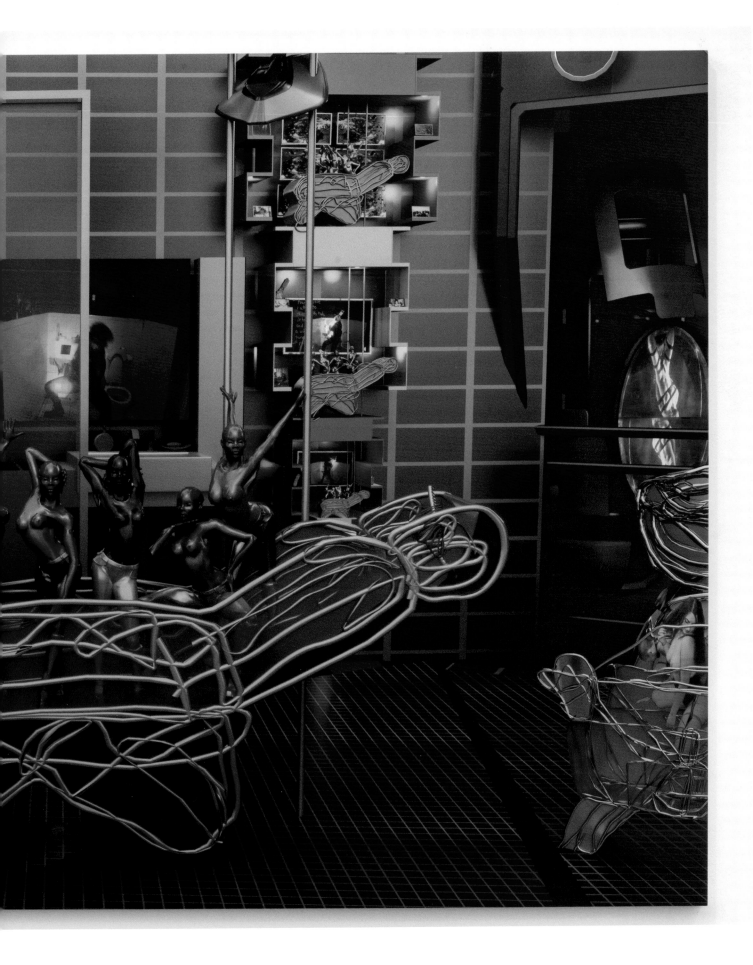

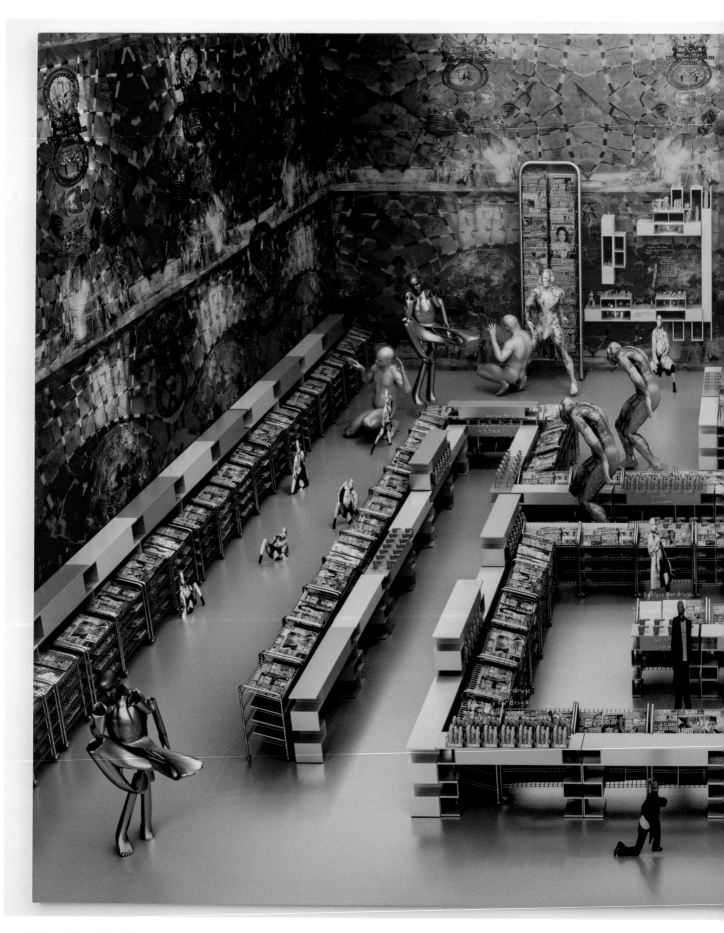

Still from *Moments of Silence.*
Designs for Drug Stores, 2019. C-print. 47 × 80 inches (119.4 × 203.2 cm).
Courtesy of the artist and Mitchell-Innes & Nash, New York.

186

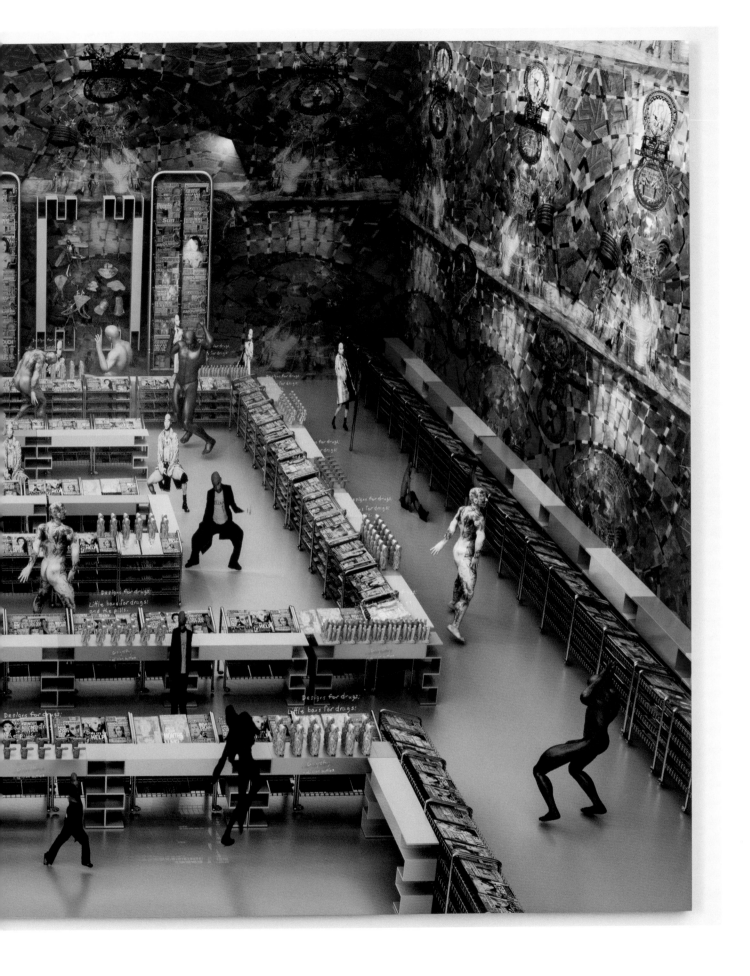

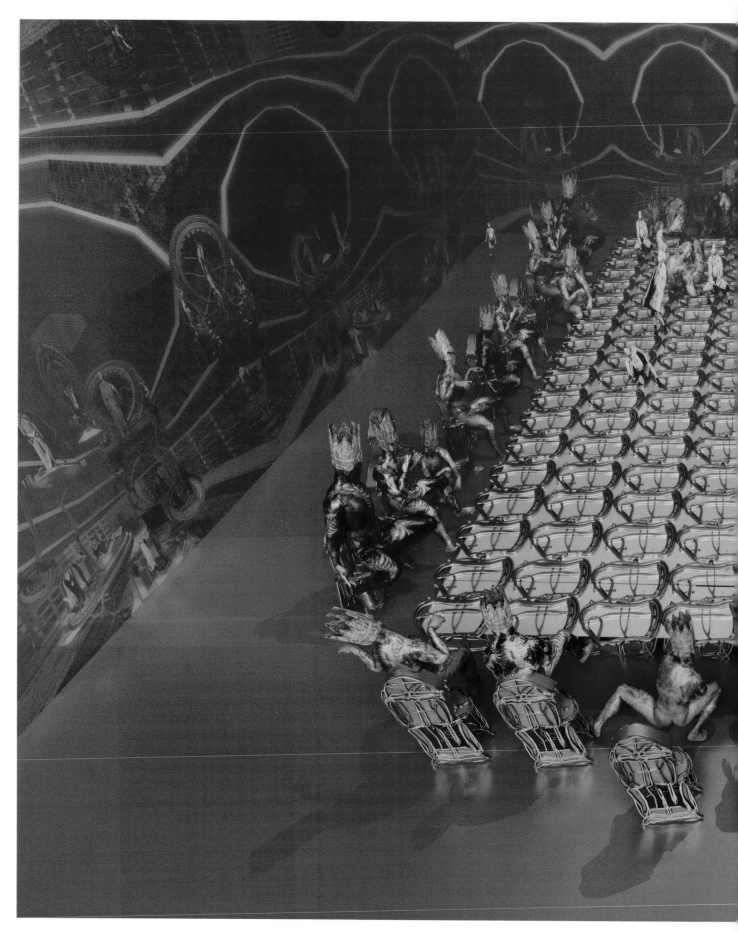

Still from *Moments of Silence.*
Money Room, 2019. C-print. 47 × 80 inches (119.4 × 203.2 cm). Courtesy of
the artist and Mitchell-Innes & Nash, New York.

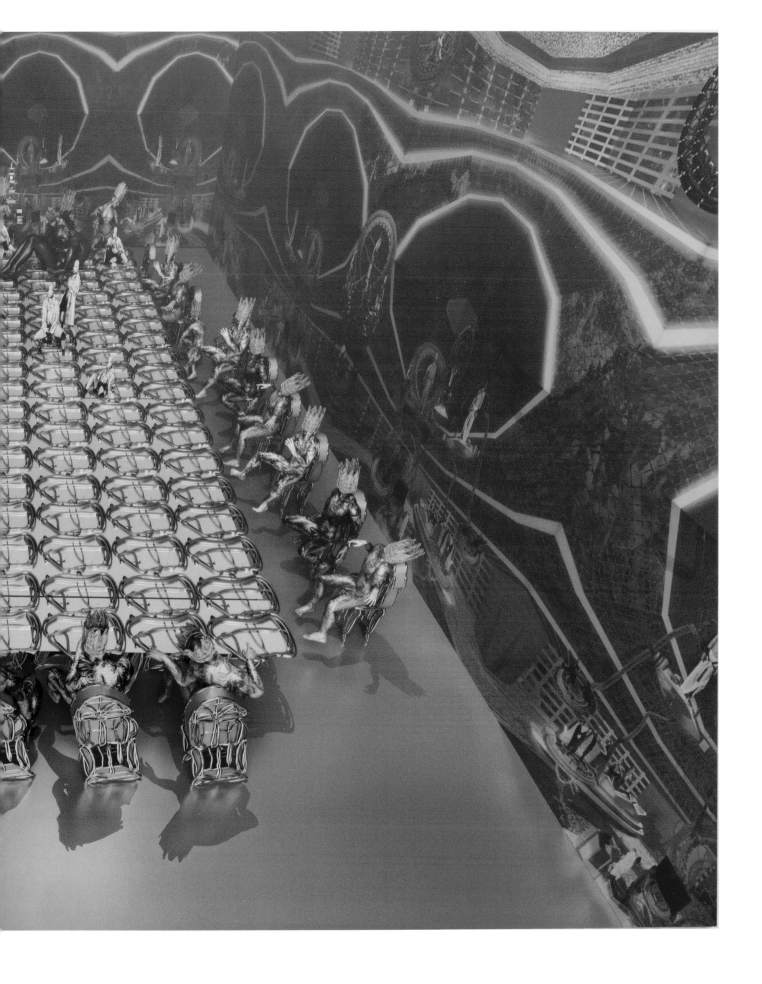

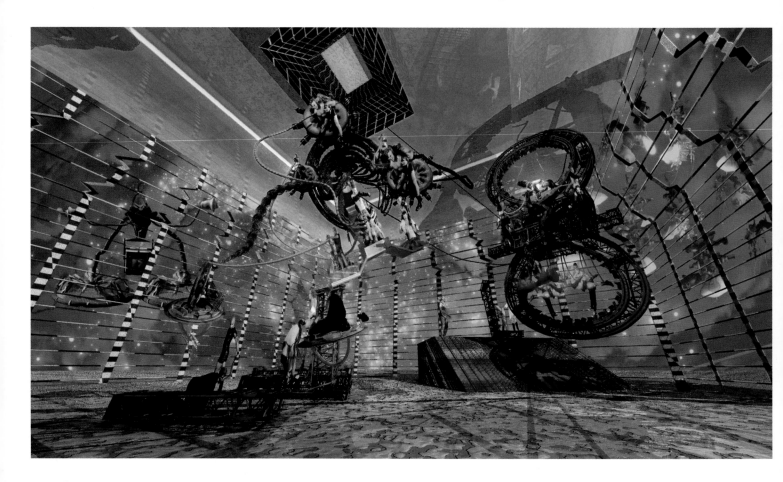

Blessed Avenue

Still of *Blessed Avenue*, 2018. Two-channel HD color
video and 3-D animation with sound. 19:18 minutes.
Courtesy of the artist; Lundgren Gallery, Palma de
Mallorca, Spain; Mitchell-Innes & Nash, New York
and Morán Morán, Los Angeles.

This complicated piece has three versions that are each set against a myriad of climate change disaster zones that the viewer hovers over, bearing witness to all that has been destroyed by humanity's carelessness. Within this two-channel video, complacency is a form of S&M between nature and humanity. Here Satterwhite uses fictional figures to exemplify the recreation of slave versus master dynamics in humanity's relationship with the earth we inhabit. The connective chords that run between each of the channels are a sort of chain or umbilical cord that tethers each figure to one another, as well as to their environment.

Entertainment Center continues Satterwhite's practice of world-building in a more domestic setting. In a room wallpapered in a prismatic, hypnotic, digital vision, he incorporates a variety of elements, such as 3-D printed sculptures and ephemera housed in a custom entertainment unit, a VR piece, and video animation. Satterwhite's video animations fuse with music-based a capella melodies sung and recorded on cassette by his mother in the 90s that Satterwhite integrated with elements of electronic house, mundane noise, and deconstructed club music, to create a full length album titled, *Love Will Find A Way Home.*

S.B.

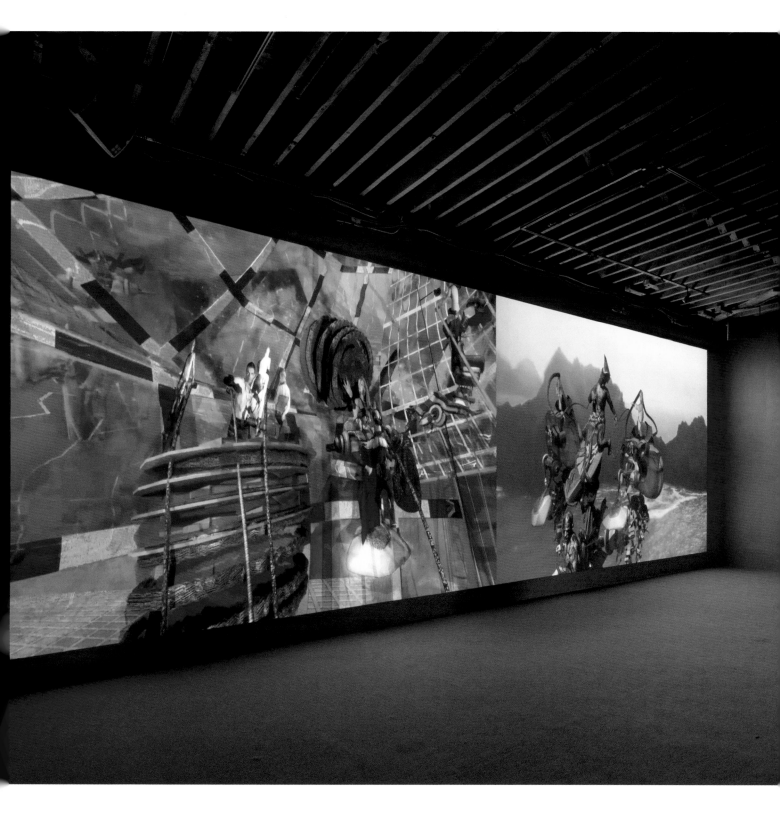

Blessed Avenue, 2018. Two-channel HD color video and 3-D animation with sound. 19:18 minutes. Installation view of *You're at Home* at Pioneer Works, Brooklyn, 2019. Courtesy of the artist and Pioneer Works, Brooklyn. Photo: Dan Bradica.

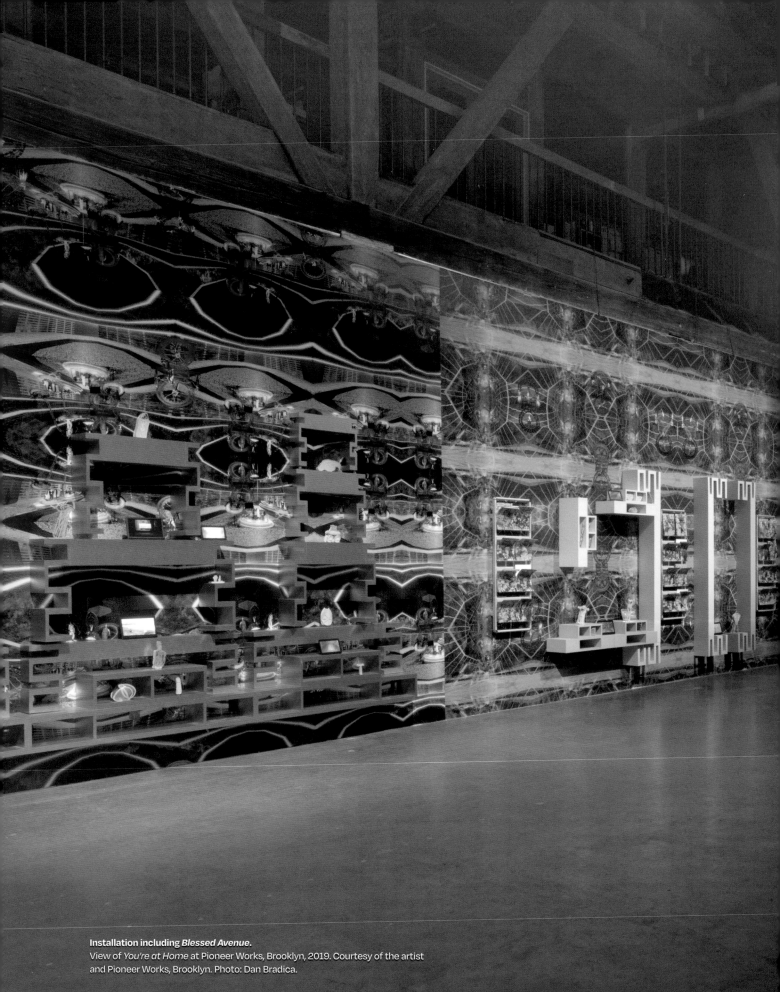

Installation including *Blessed Avenue*.
View of *You're at Home* at Pioneer Works, Brooklyn, 2019. Courtesy of the artist
and Pioneer Works, Brooklyn. Photo: Dan Bradica.

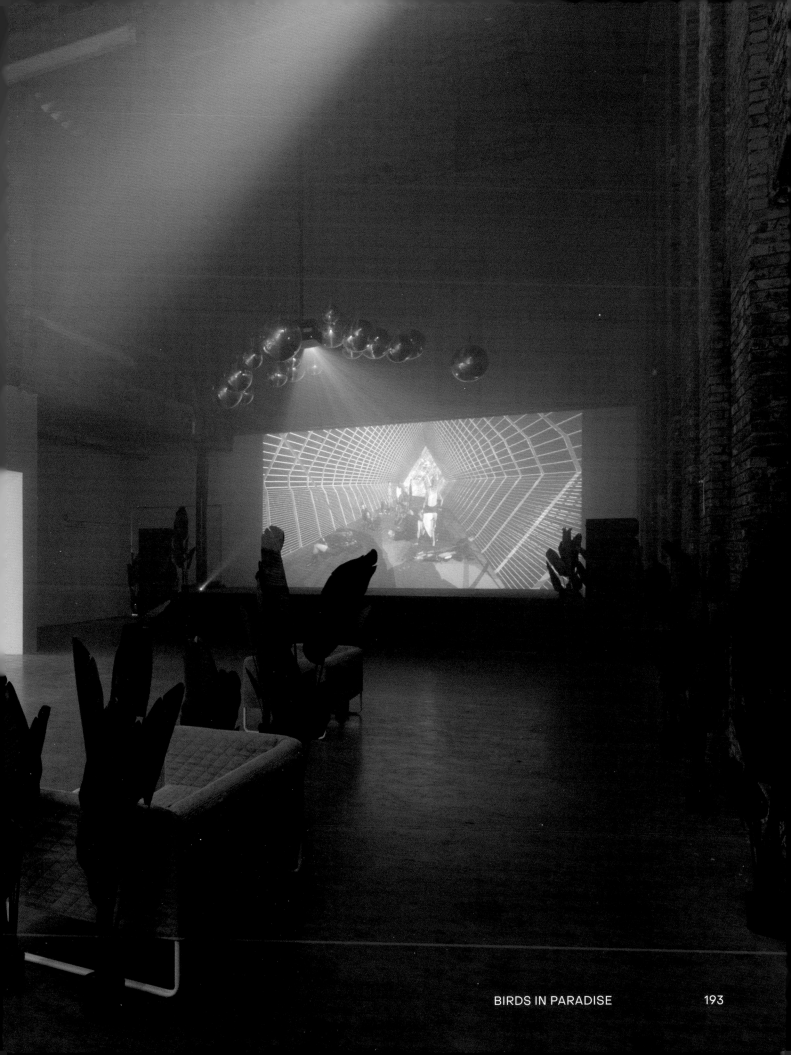

PUSH COME TO SHOVE

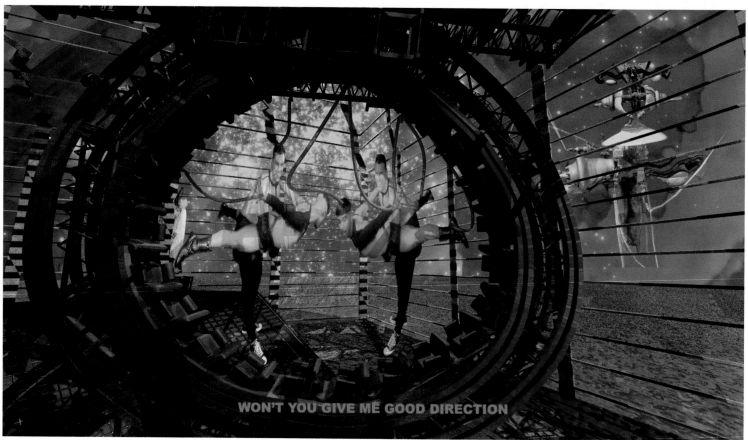

WON'T YOU GIVE ME GOOD DIRECTION

Stills of *Blessed Avenue*, 2018. Two-channel HD color video and 3-D animation
with sound. 19:18 minutes. Courtesy of the artist; Lundgren Gallery, Palma de
Mallorca, Spain; Mitchell-Innes & Nash, New York and Morán Morán, Los Angeles.

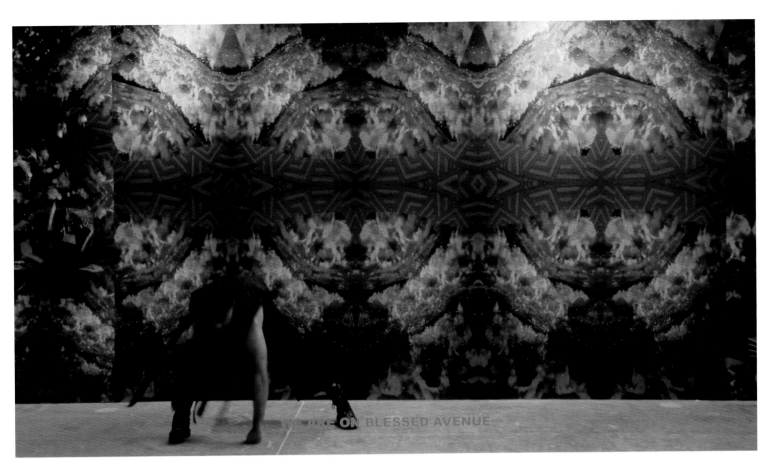

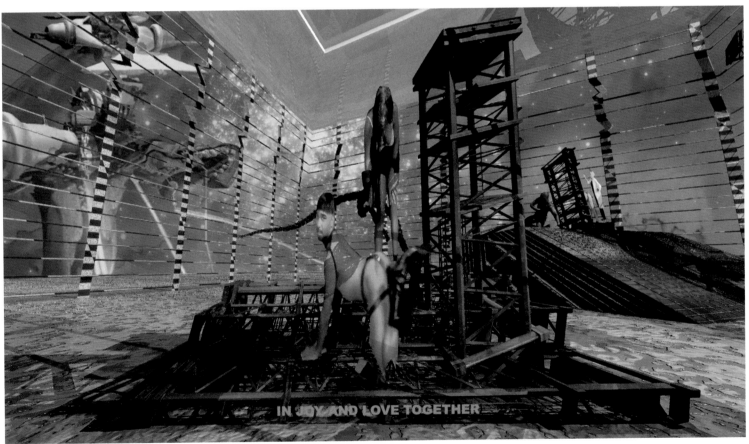

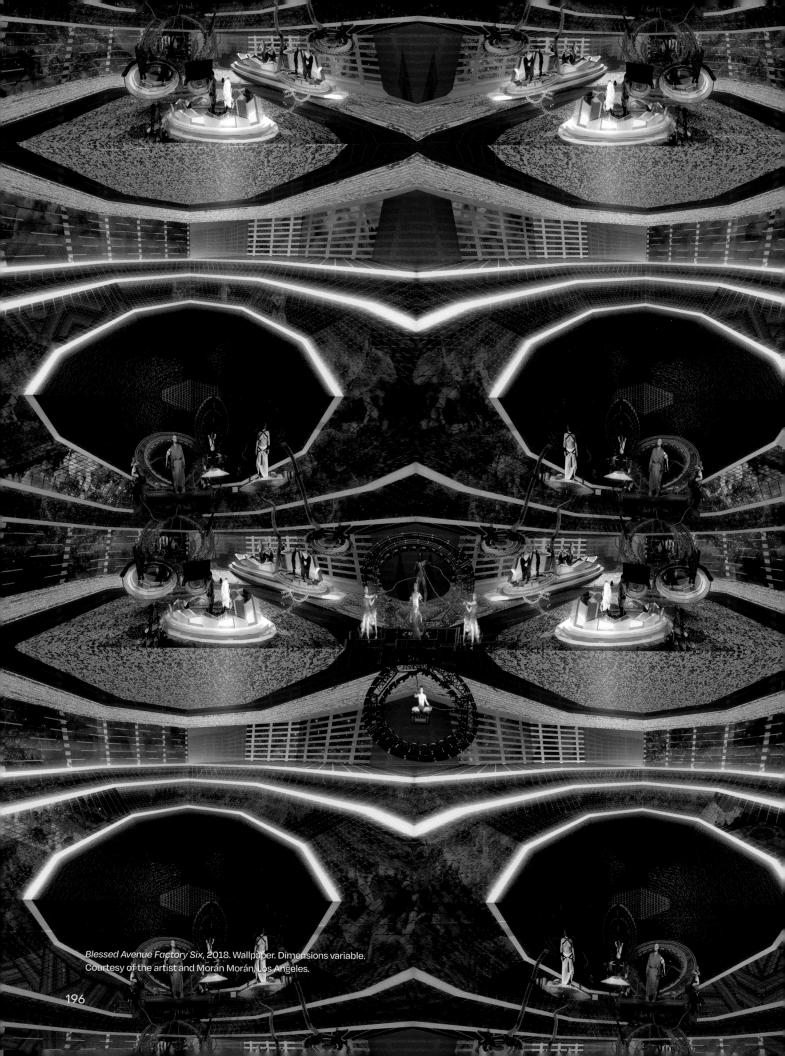

Blessed Avenue Factory Six, 2018. Wallpaper. Dimensions variable.
Courtesy of the artist and Morán Morán, Los Angeles.

196

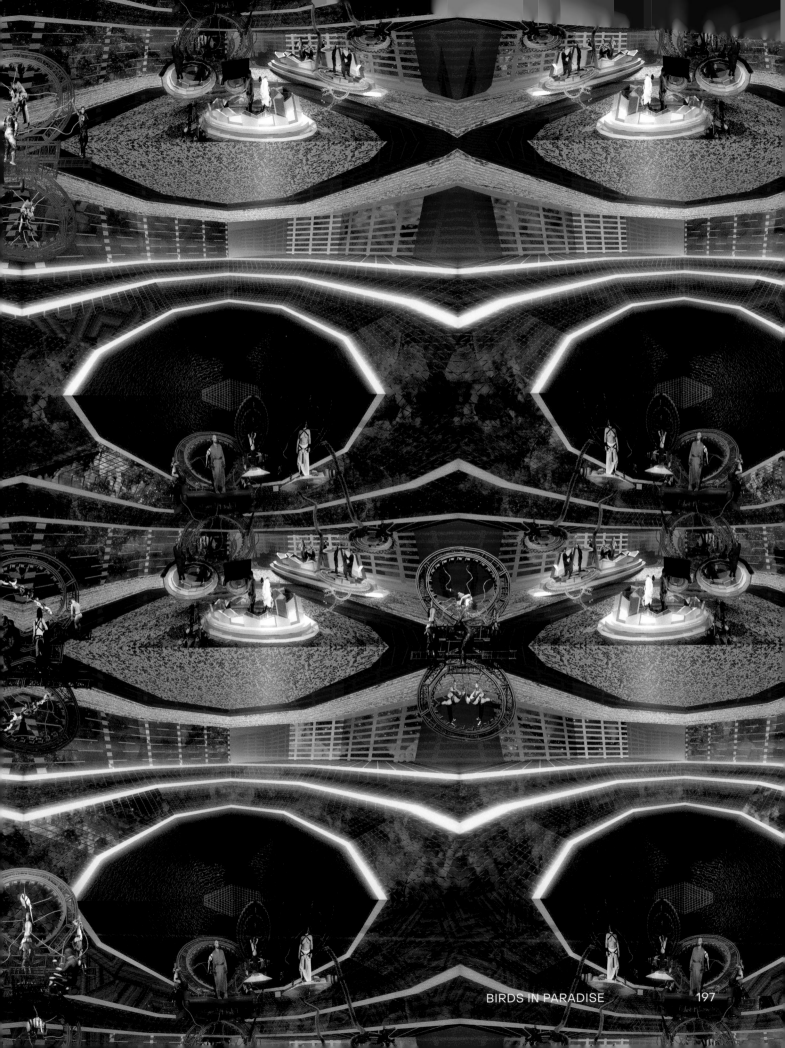

Installation including *Blessed Avenue* wallpaper, film, VR, and drawings by Patricia Satterwhite.
The Red and Gold Den, 2018. Installation view at Art Basel, Basel, Switzerland, 2018. Courtesy of the artist and Morán Morán, Los Angeles.

Cabinet with merchandise and *Blessed Avenue*.
Entertainment Center, 2018. Wood, latex paint, mixed media items, and video.
62 × 72 × 9 inches (157.5 × 183 × 23 cm). Courtesy of the artist and Morán Morán,
Los Angeles.

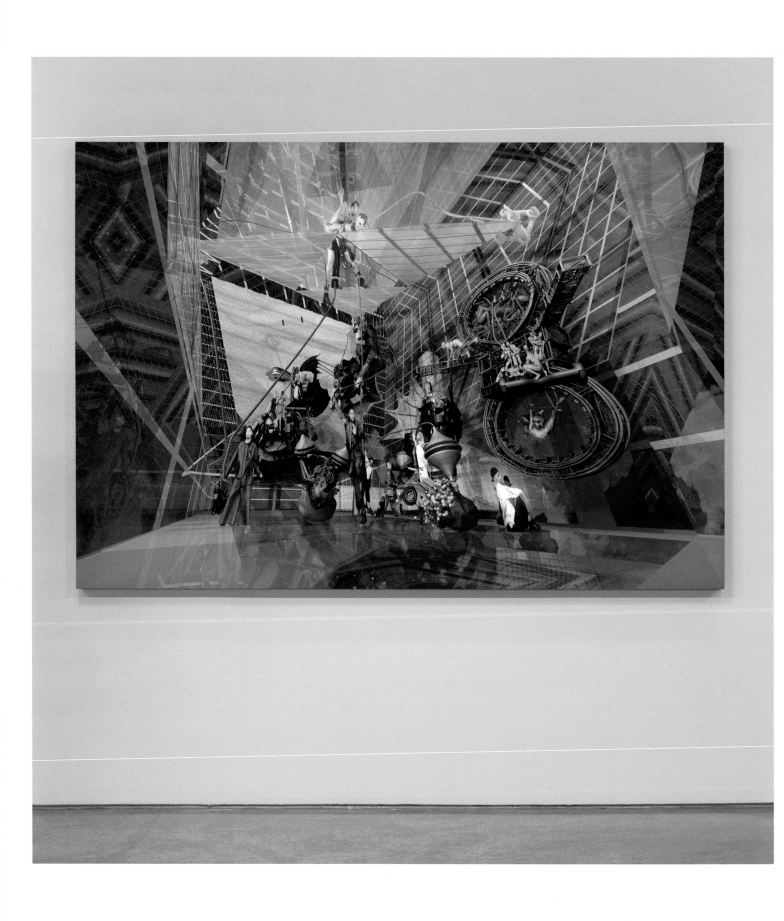

Blessed Avenue Factory 2, 2018. C-print in artist's frame. 48 × 72 × 3 inches
(122 × 183 × 8 cm). Courtesy of the artist and Morán Morán, Los Angeles.

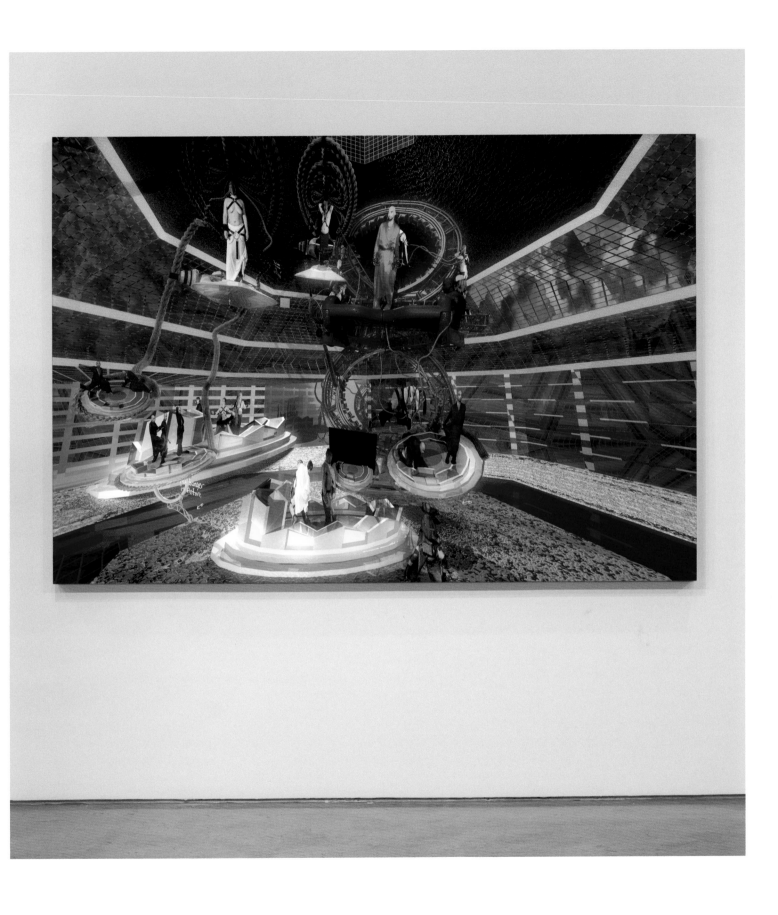

Blessed Avenue Factory 6, 2018. C-print in artist's frame. 48 × 72 × 3 inches (122 ×
183 × 8 cm). Courtesy of the artist and Morán Morán, Los Angeles.

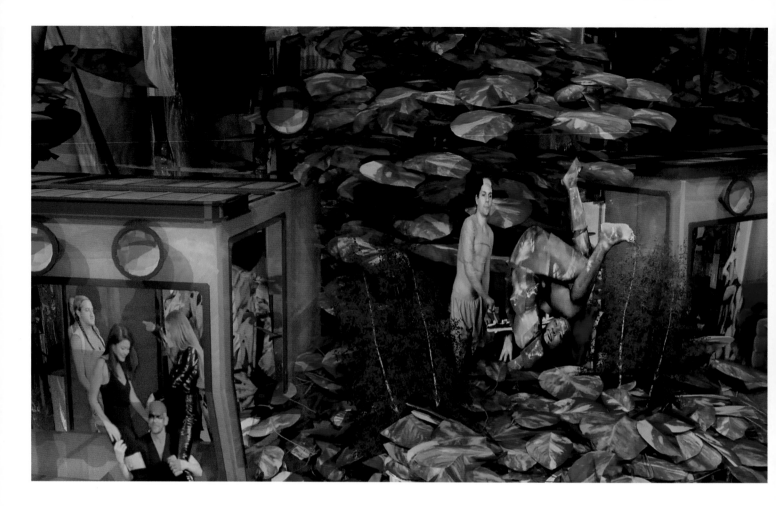

Avenue B

Still of *Avenue B*, 2018–19. Two-channel HD color video with sound. 20:38 minutes. Courtesy of the artist; Lundgren Gallery, Palma de Mallorca, Spain; Mitchell-Innes & Nash, New York and Morán Morán, Los Angeles.

The soundscape established at the close of *Blessed Avenue* continues at the commencement of *Avenue B*, which opens ambiguously between a ritual cleansing and a lynching of Satterwhite by a futuristic Ku Klux Klan. This threat can be interpreted as many different culprits, as the asphyxiation of Black bodies has extended well beyond the rope and the tree and into the environmental lack of clean air, clean water, and even a lack of protection in a global pandemic. Here, Satterwhite begins at the end. This film was inspired by a Nigerian masquerade ritual where people celebrate the Queen Mother in costumes around a circular fiery pit. Satterwhite reinterprets this practice in a cleansing ritual where his body is wiped with paint until it is rendered invisible. It asks the question: is the only way a Black body can be rendered clean, by making it vanish? A track of Patricia Satterwhite singing that she is the Queen Mother plays in the background of the film. Satterwhite returned to the folk song "Robin," from his earlier work, that his mother sang to him and employs this sonic memory to set the rhythmic tone of this piece.

S.B.

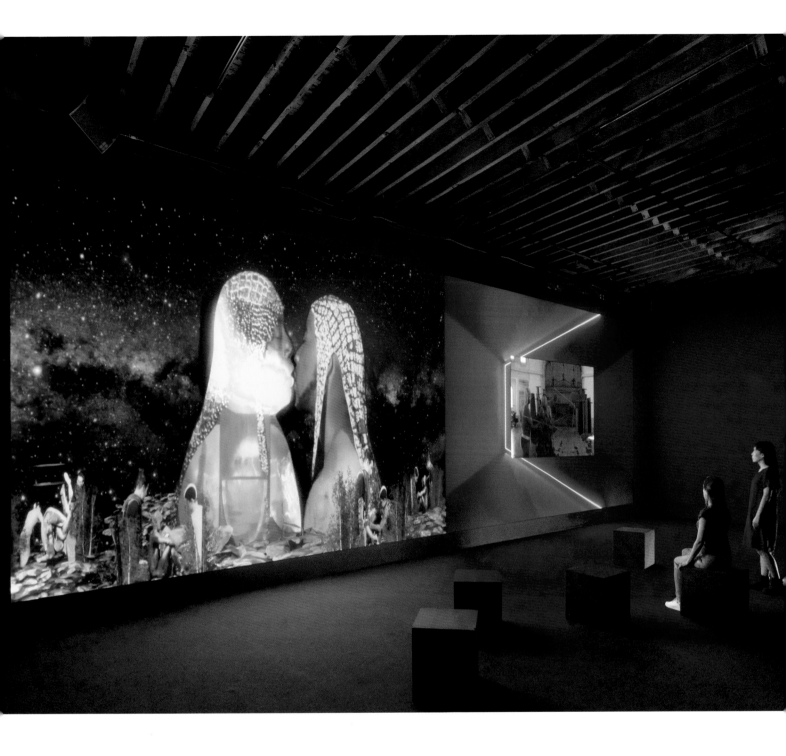

Avenue B, 2018–19. Two-channel HD color video with sound. 20:38 minutes.
Installation view of *You're at Home* at Pioneer Works, Brooklyn, 2019. Courtesy of
the artist and Pioneer Works, Brooklyn. Photo: Dan Bradica.

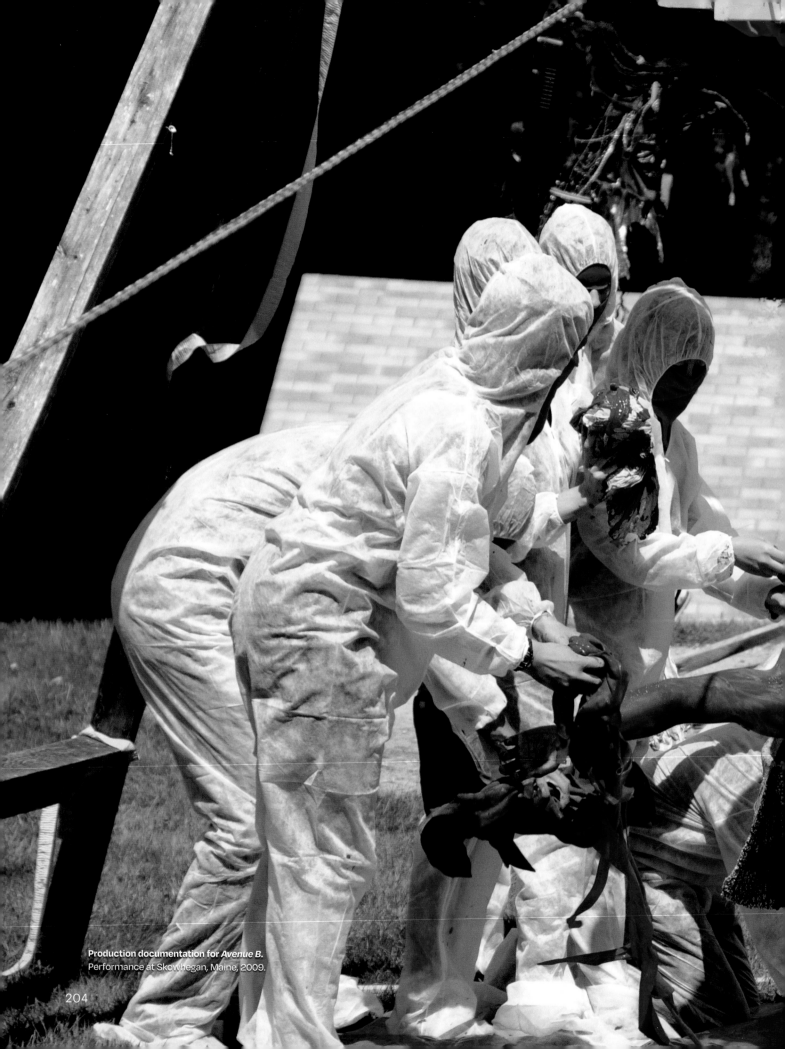

Production documentation for *Avenue B.*
Performance at Skowhegan, Maine, 2009.

204

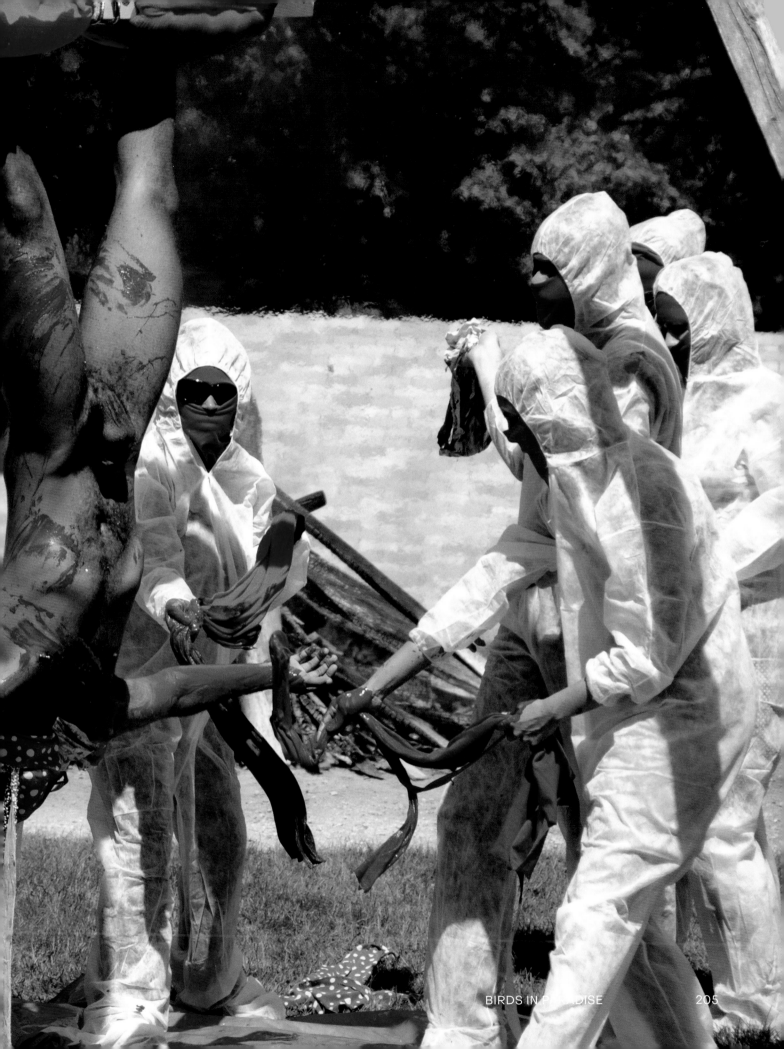

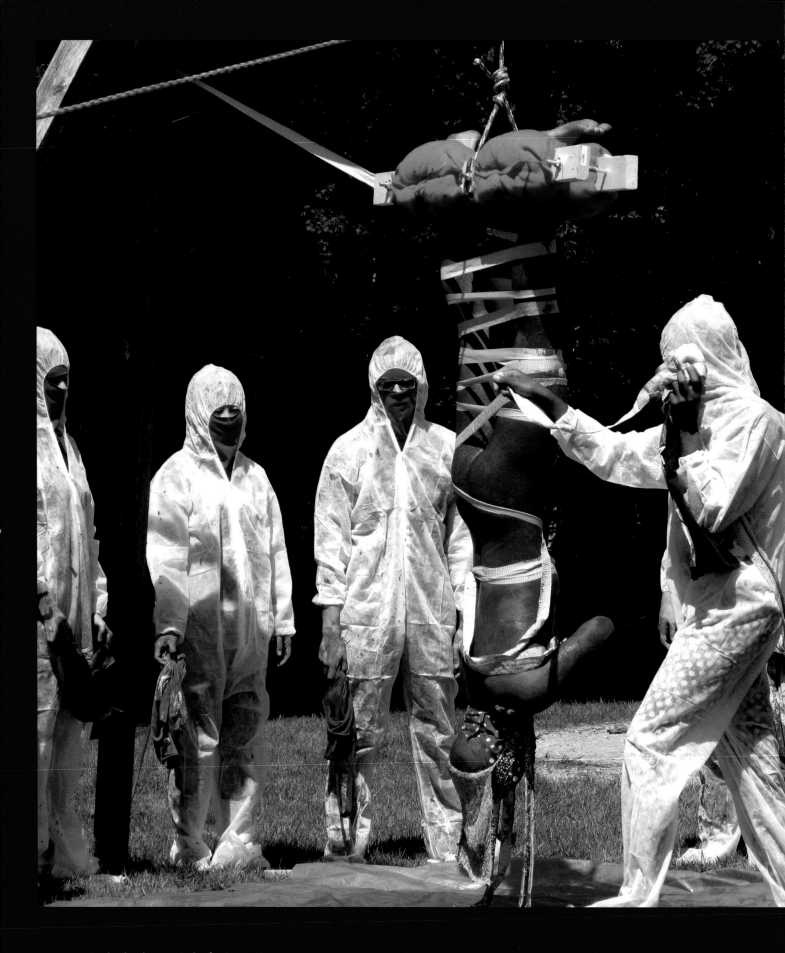

Production documentation for *Avenue B*.
Performance at Skowhegan, Maine, 2009.

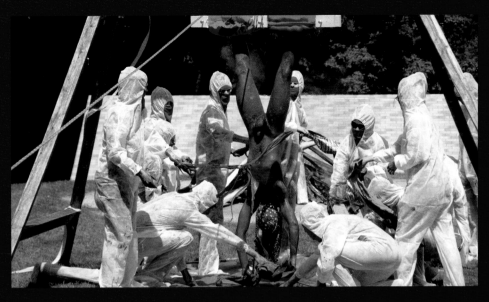
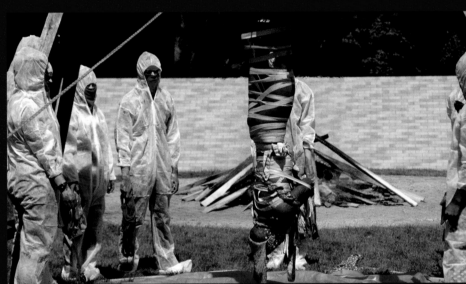
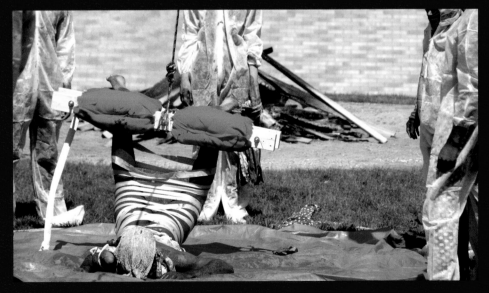

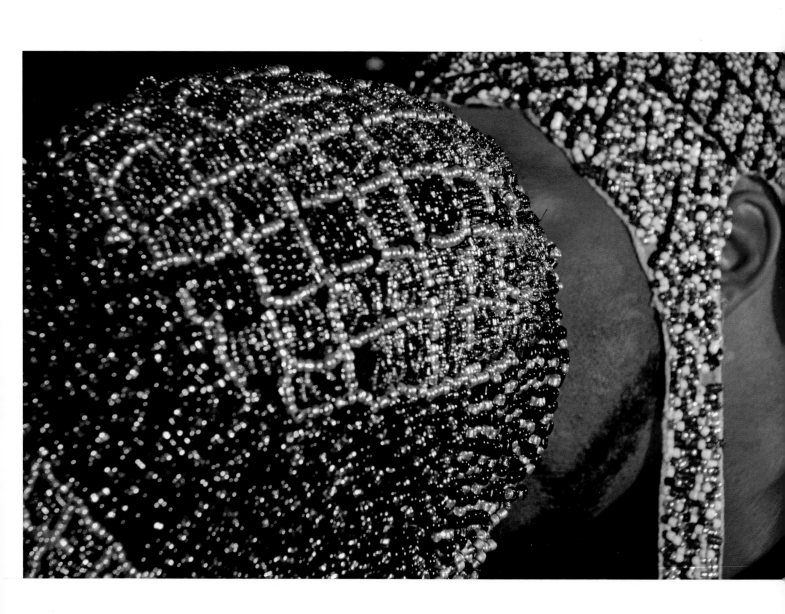

Production photography from *Avenue B*.
Anton, 2018. C-print. Diptych, each sheet: 33 × 50 inches (83.8 × 127 cm).
Courtesy of the artist and Mitchell-Innes & Nash, New York.

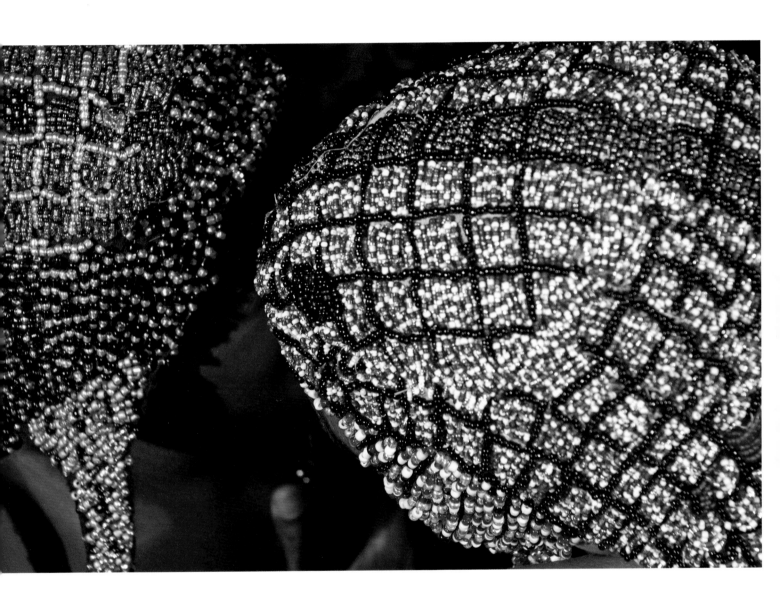

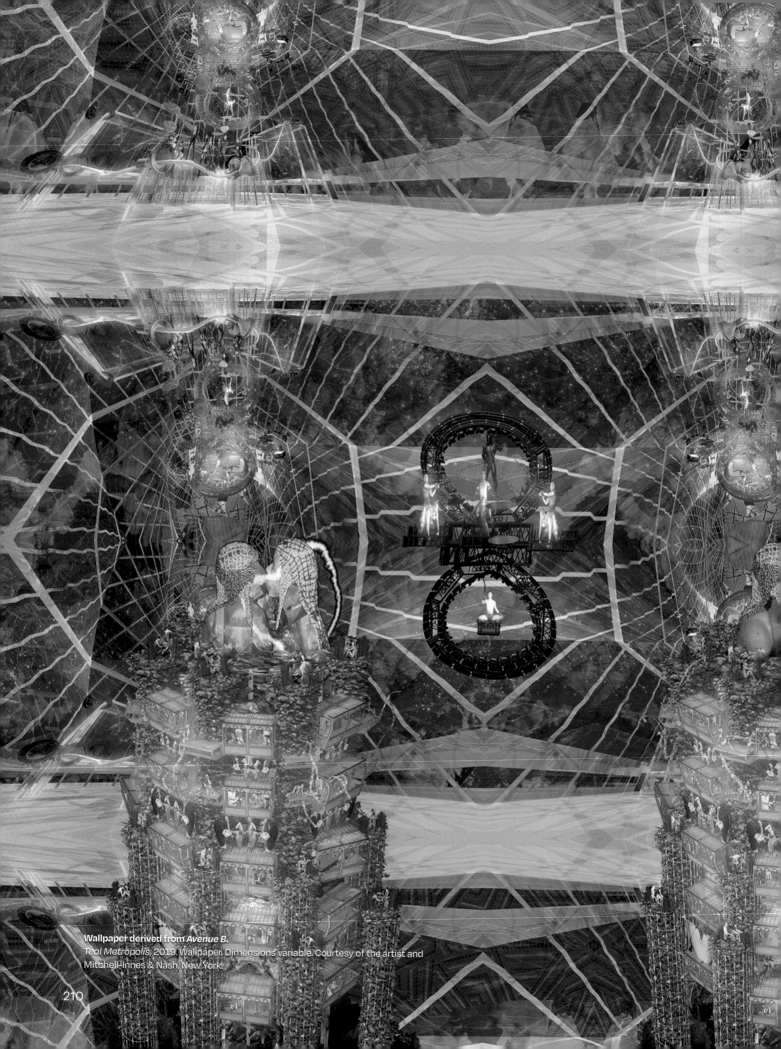

Wallpaper derived from *Avenue B.*
Teal Metropolis, 2019. Wallpaper. Dimensions variable. Courtesy of the artist and
Mitchell-Innes & Nash, New York.

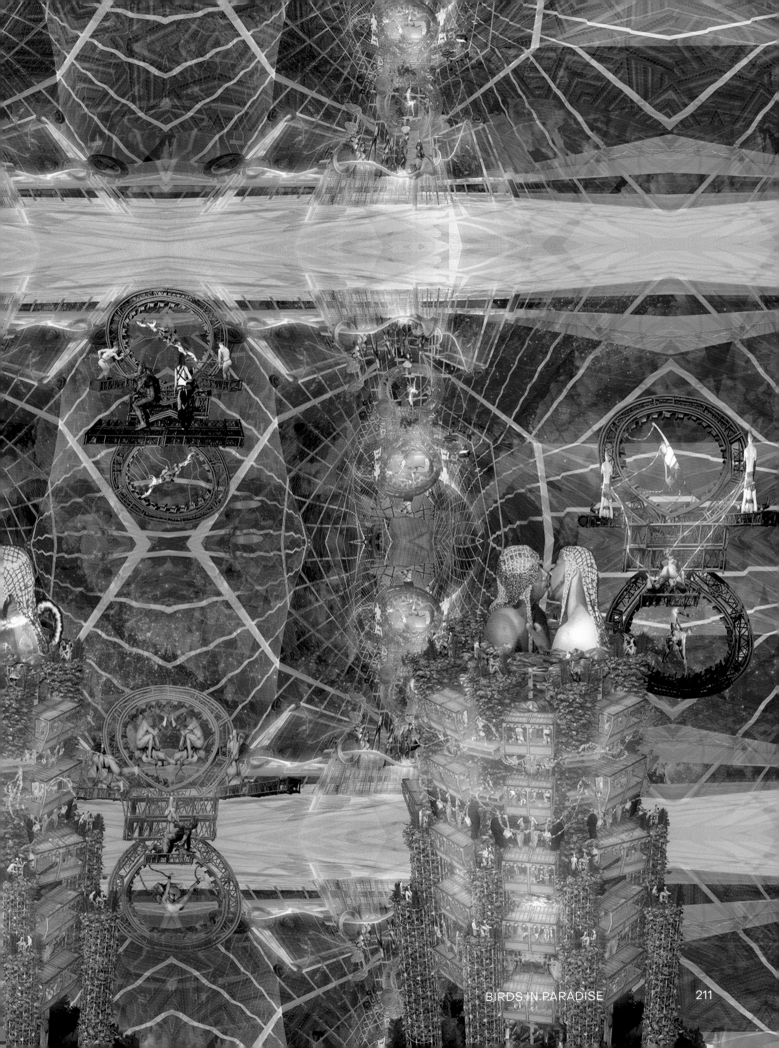

luded a triple combo of
...cors that would transform
...he bits into a digital sensing
...device. Joint to the Californian
...company Dynamics Graphic
...Inc., they developed the digital
...atforms CoViz 4D a software
...duce quantitative
...ation platforms of
...ant geospatial data.

...and a control room
...construction of the

Installation including *Avenue B.*
Jacolby Satterwhite and Andrés Jaque. Installation view of *Is This Tomorrow?* at
Whitechapel Gallery, London, 2019. Photo: Brotherton-Lock photography.

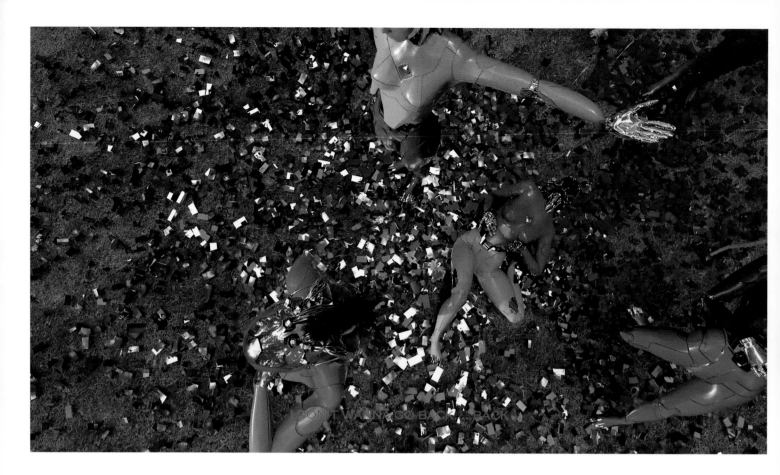

We Are In Hell When We Hurt Each Other

Stills of *We Are In Hell When We Hurt Each Other*,
2020. HD color video and 3-D animation with sound.
24:22 minutes. Courtesy of the artist; Lundgren
Gallery, Palma de Mallorca, Spain; Mitchell-Innes &
Nash, New York and Morán Morán, Los Angeles.

We Are In Hell When We Hurt Each Other is a twenty-four minute virtual pastoral concert space that is set to the sounds of a collaborative production with producer Nick Weiss. Satterwhite's visual utopia references Titian and transforms the inherited way of witnessing the Black body. Titian was one of the originators of imagery that hypersexualized Black women, which was created during the Renaissance, a period of time that coincided with the commencement of the African slave trade. Patricia Satterwhite's voice can be heard singing a capella, morphing the acid-house style track into a form of audio poetics. Her voice appears with a God-like presence when her lyrical cadence sings out, "we are in hell when we fail to exist." The echo effect speaks to the reality the sound of our mothers, the first voice we ever know, lives inside the soul for an eternity, ringing out in repetition in the subconscious. The Black mother is the Madonna often erased in history. This video subverts the erasure of Black women's existence and creates an imagined utopic space that celebrates their insistence on survival and creates an alternative utopia where they thrive as the foundation figures that they are in our contemporary global colonial reality. The Black femme figures featured are taken from the marginal shadows, where they are often confined, and centralizes the Black body in motion, not as erotic, but as ritualistic and divine. The contortions represent flexibility and resistance to being broken by the impossibilities of societal norms around race, gender, and sexuality.

S.B.

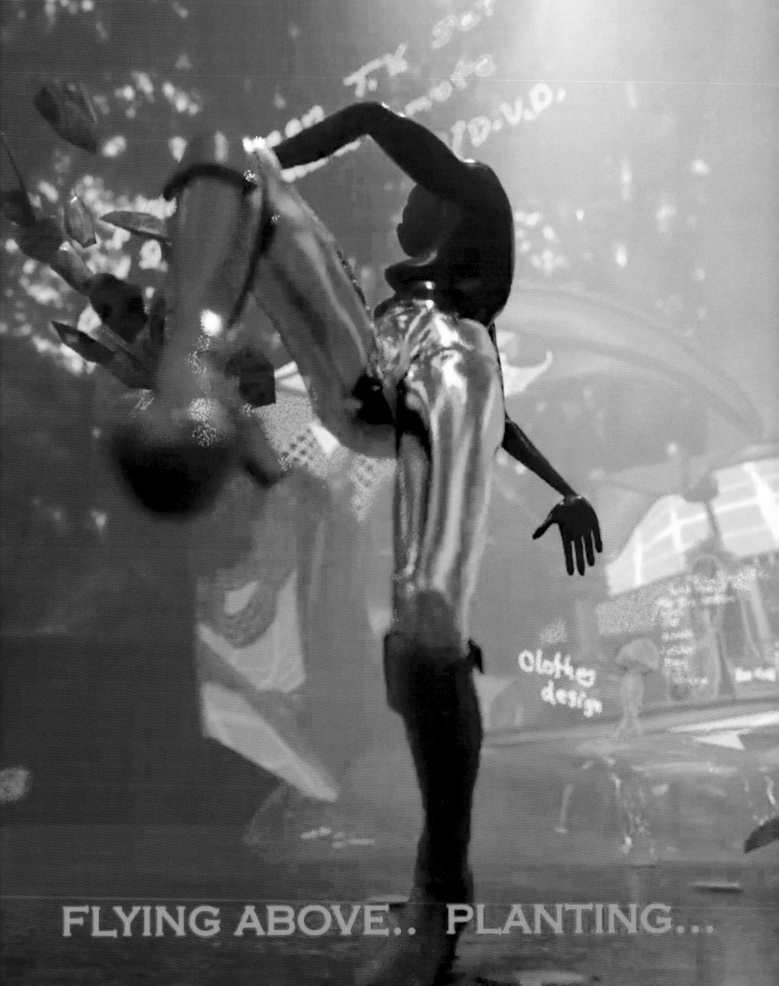

FLYING ABOVE.. PLANTING...

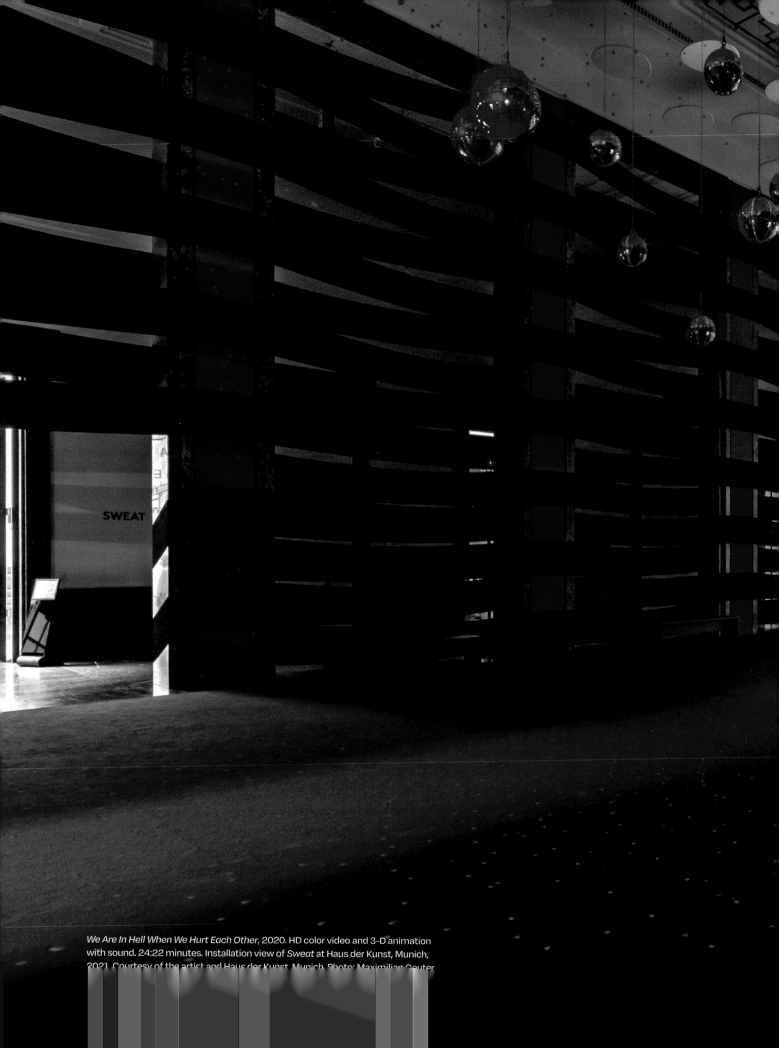

We Are In Hell When We Hurt Each Other, 2020. HD color video and 3-D animation with sound. 24:22 minutes. Installation view of *Sweat* at Haus der Kunst, Munich, 2021. Courtesy of the artist and Haus der Kunst, Munich. Photo: Maximilian Geuter.

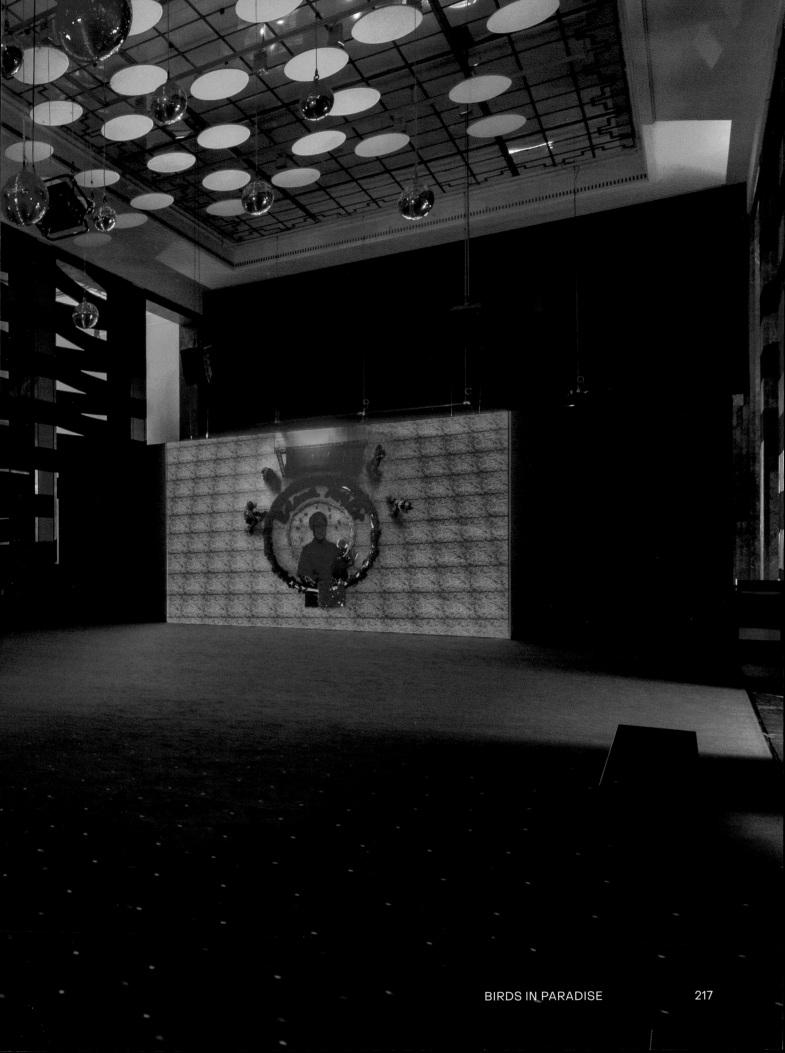

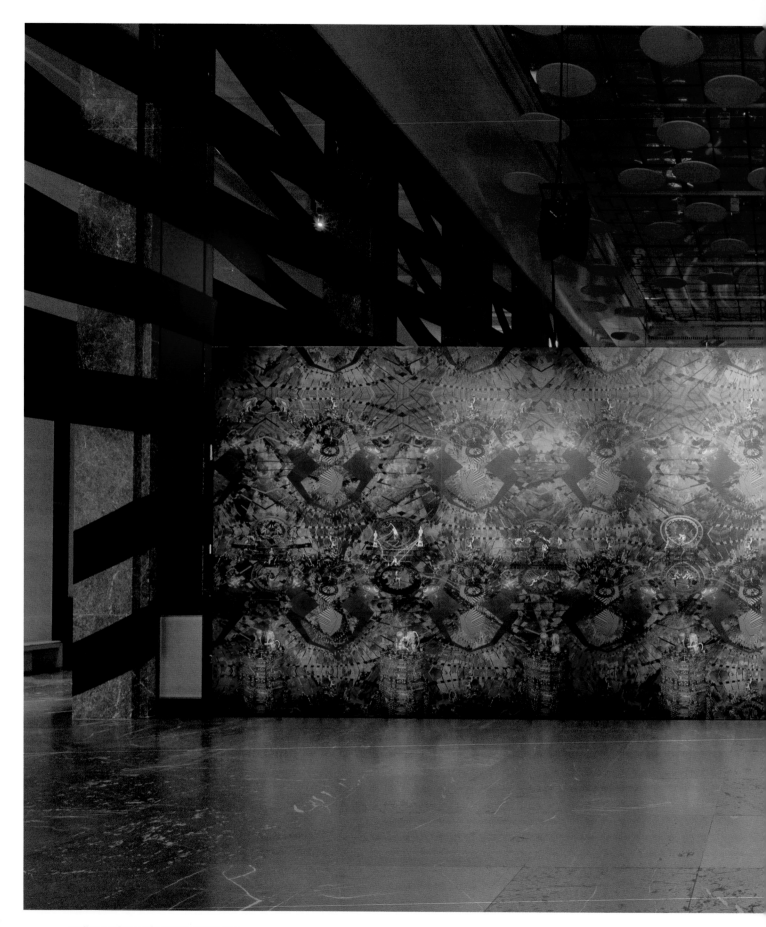

Wallpaper derived from *Blessed Avenue*.
Blessed Avenue Factory Five, 2018. Wallpaper. Dimensions variable. Installation view of *Sweat* at Haus
der Kunst, Munich, 2021. Courtesy of the artist and Haus der Kunst, Munich. Photo: Maximilian Geuter.

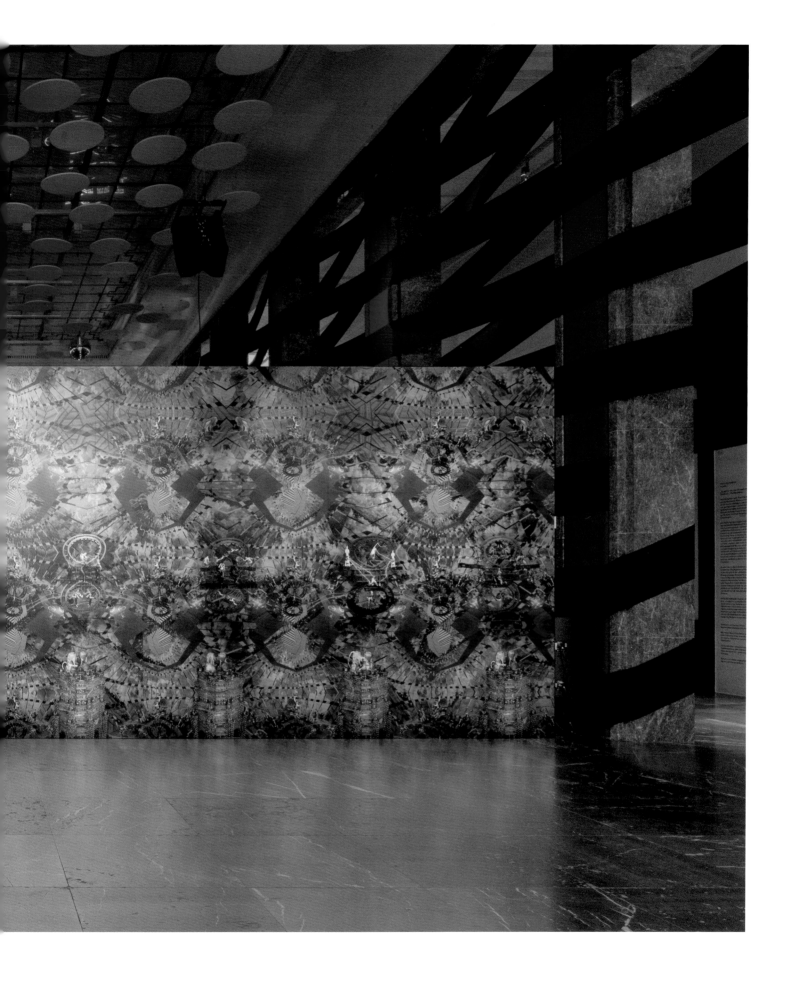

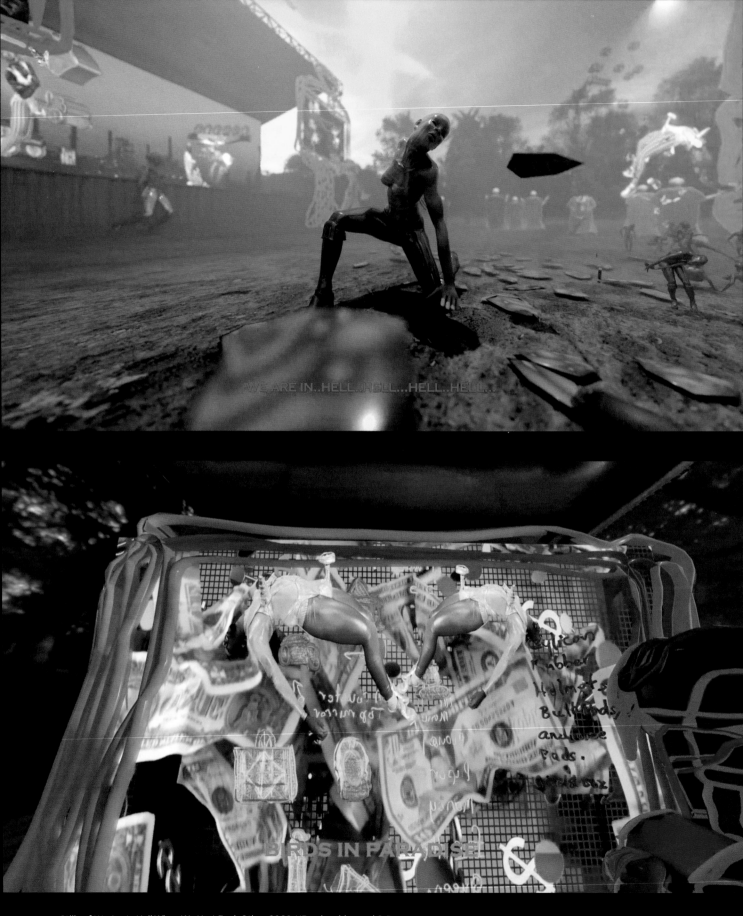

Stills of *We Are In Hell When We Hurt Each Other*, 2020. HD color video and 3-D animation with sound. 24:22 minutes. Courtesy of the artist; Lundgren Gallery, Palma de Mallorca, Spain; Mitchell-Innes & Nash, New York and Morán Morán, Los Angeles.

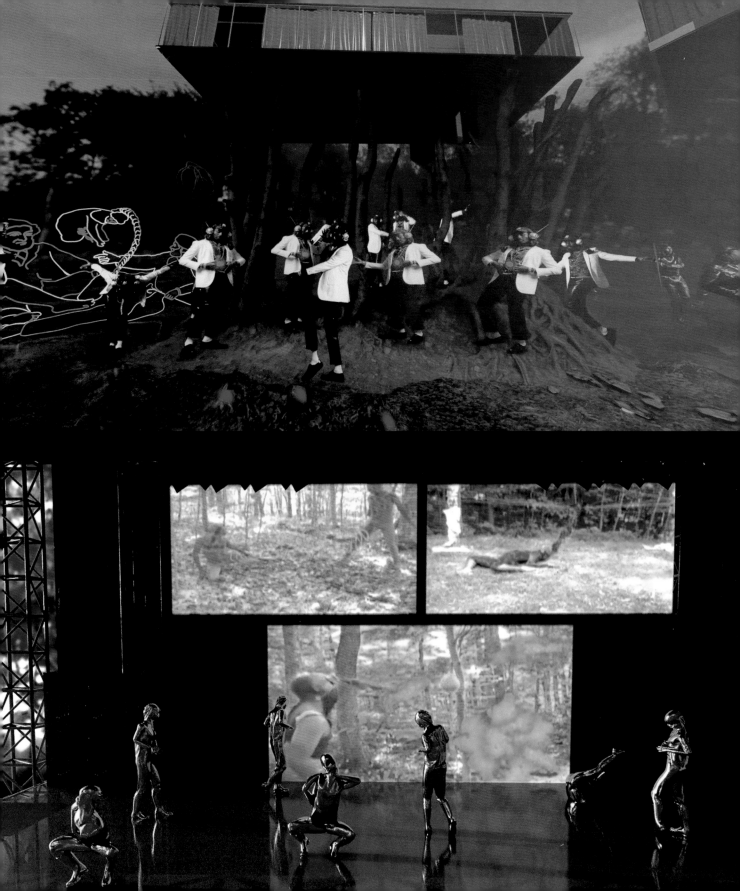

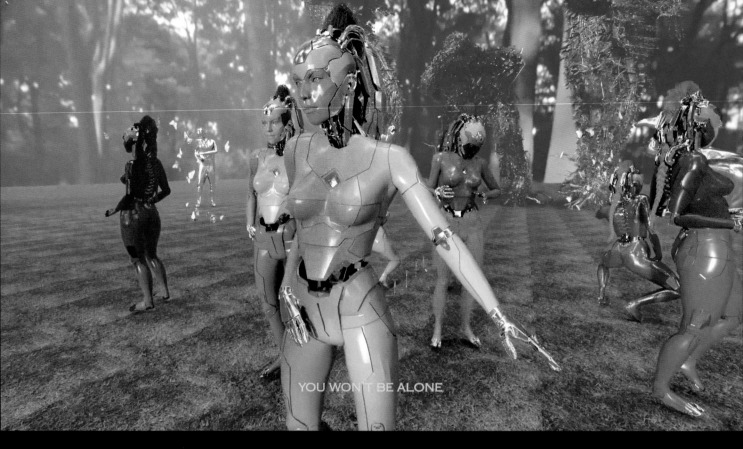

YOU WON'T BE ALONE

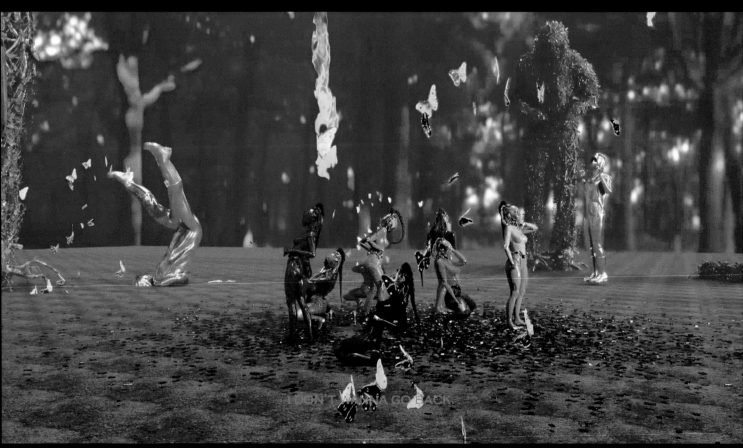

I DON'T WANNA GO BACK

Stills of *We Are In Hell When We Hurt Each Other*, 2020. HD color video and 3-D animation with sound. 24:22 minutes. Courtesy of the artist; Lundgren Gallery, Palma de Mallorca, Spain; Mitchell-Innes & Nash, New York and Morán Morán, Los Angeles.

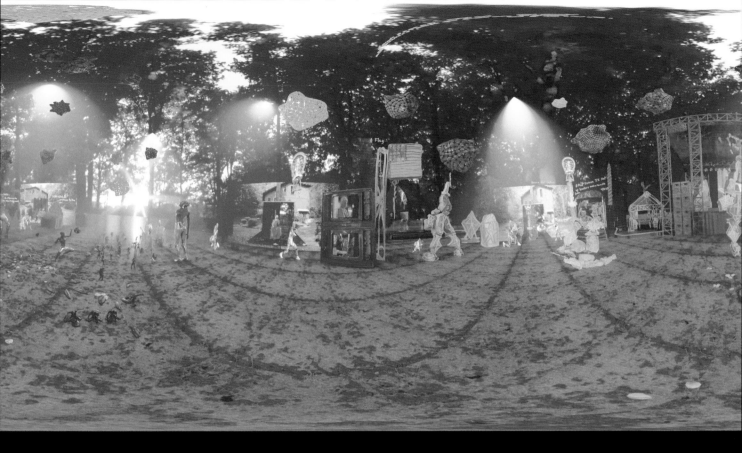

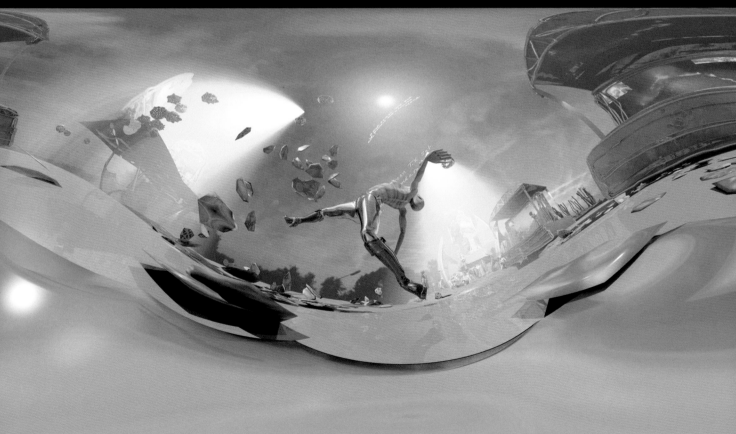

Stills of *We Are In Hell When We Hurt Each Other*, 2020. HD virtual reality video with sound. 18:07 minutes. Courtesy of the artist; Lundgren Gallery, Palma de Mallorca, Spain; Mitchell-Innes & Nash, New York and Morán Morán, Los Angeles.

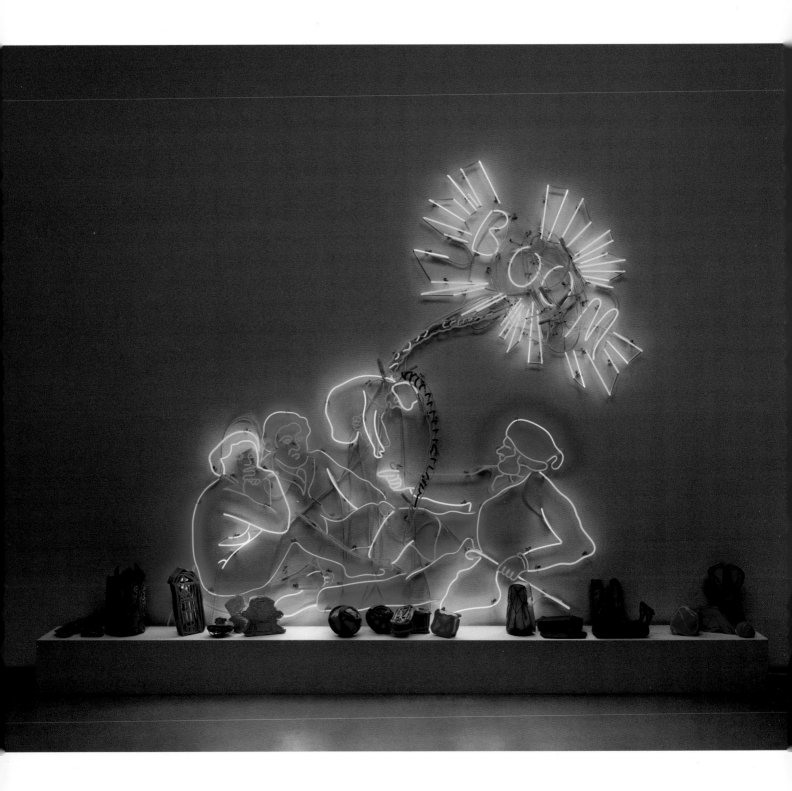

Neon derived from *We Are In Hell When We Hurt Each Other*.
Black Luncheon, 2020. Animated neon, hand-painted enamel on 3-D printed resin.
84 × 88 inches (213.4 × 223.5 cm). Installation view of *We Are In Hell When We
Hurt Each Other* at Mitchell-Innes & Nash, New York, 2020. Courtesy of the artist
and Mitchell-Innes & Nash, New York. Photo: Dan Bradica.

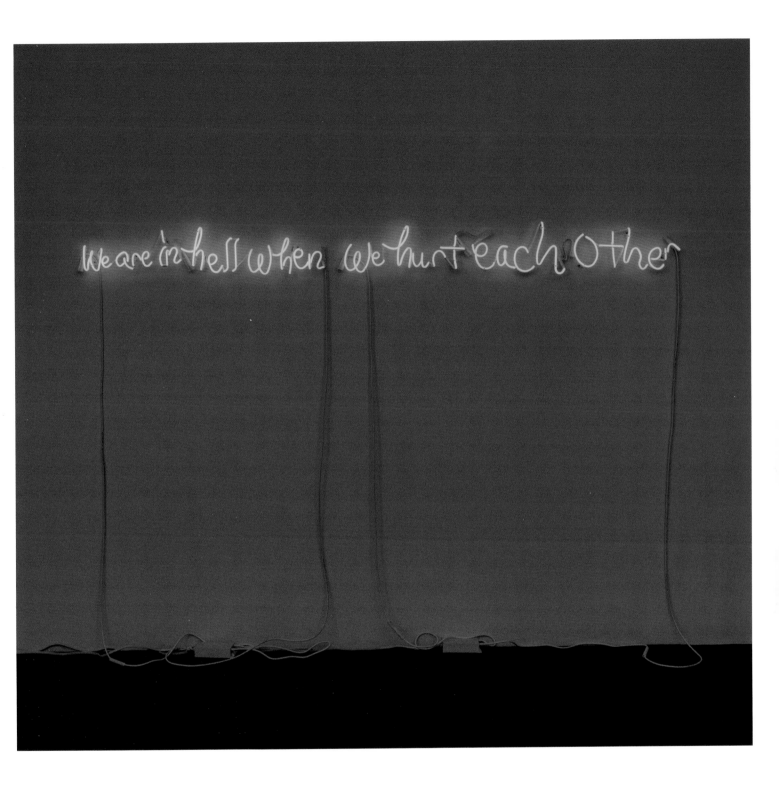

Neon rendered from Patricia Satterwhite's drawings.
We Are In Hell When We Hurt Each Other, 2020. Neon. 7 5/8 × 90 × 2 1/4
inches (19.4 × 228.6 × 5.7 cm). **Installation view of** *We Are In Hell When We
Hurt Each Other* at Mitchell-Innes & Nash, New York, 2020. Courtesy of the
artist and Mitchell-Innes & Nash, New York. Photo: Dan Bradica.

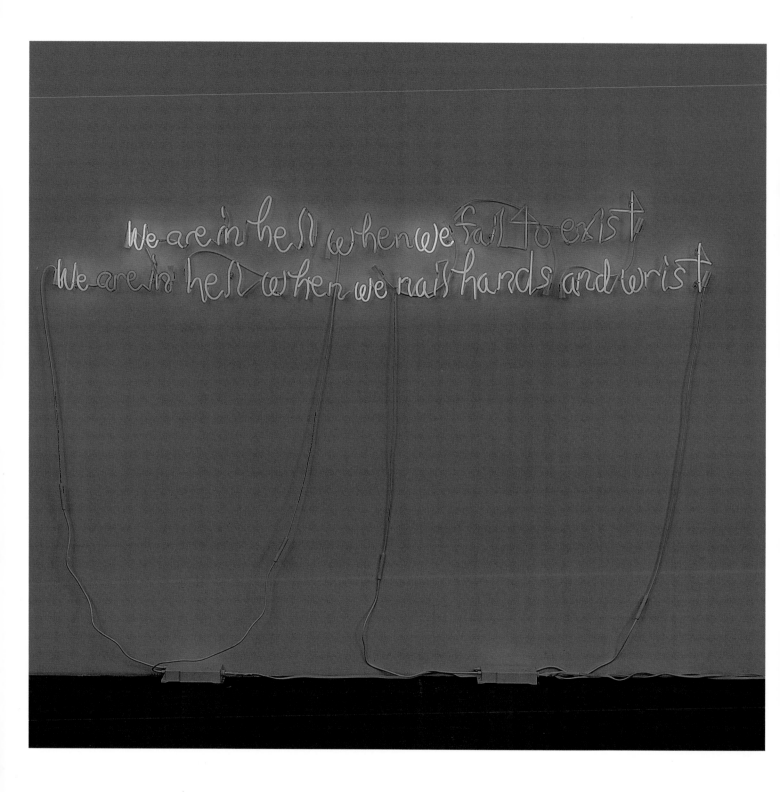

Neon rendered from Patricia Satterwhite's drawings.
Hands and Wrist, 2020. Neon. 13 1/2 × 90 × 2 1/4 inches (34.3 × 228.6 × 5.7 cm).
Installation view of *We Are In Hell When We Hurt Each Other* at Mitchell-Innes &
Nash, New York, 2020. Courtesy of the artist and Mitchell-Innes & Nash, New York.
Photo: Dan Bradica.

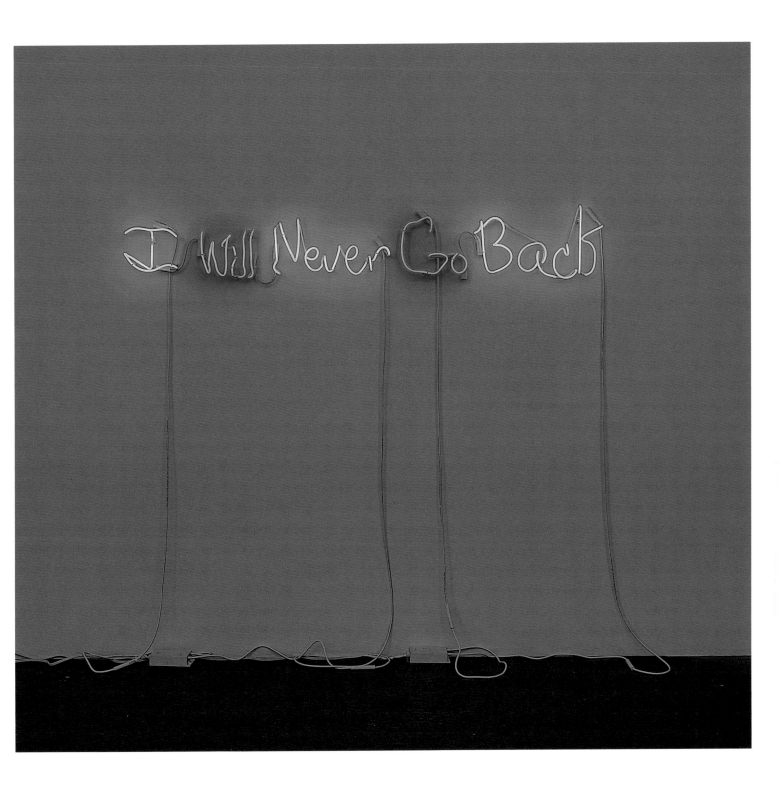

Neon rendered from Patricia Satterwhite's drawings.
I Will Never Go Back, 2020. Neon. 10 1/2 × 70 inches × 2 1/4 (26.7 × 177.8 × 5.7 cm).
Installation view of *We Are In Hell When We Hurt Each Other* at Mitchell-Innes &
Nash, New York, 2020. Courtesy of the artist and Mitchell-Innes & Nash, New York.
Photo: Dan Bradica.

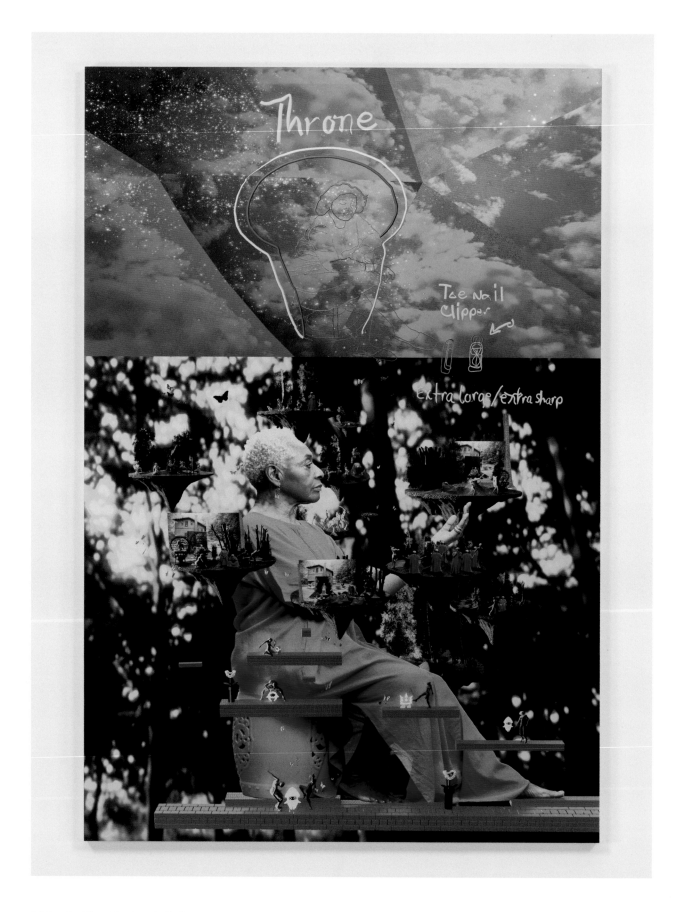

Print derived from *We Are In Hell When We Hurt Each Other* animations.
Pygmalion's Throne, 2020. UV pigment on aluminum. 65 × 45 inches (165.1 × 114.3 cm). Courtesy of the artist and Mitchell-Innes & Nash, New York. Photo: Dan Bradica.

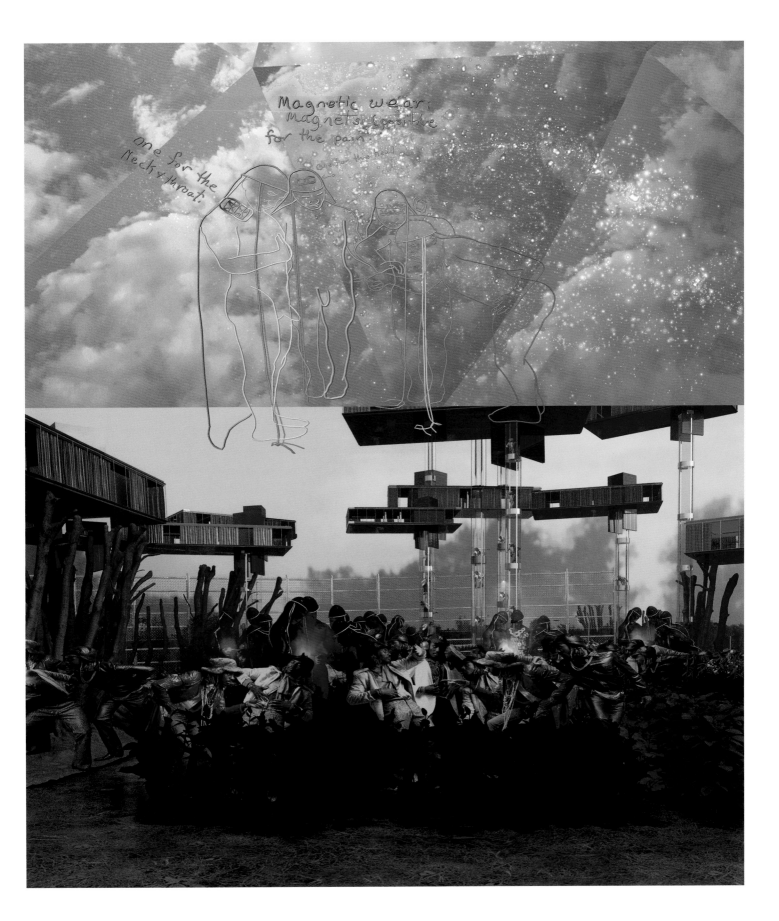

Print derived from *We Are In Hell When We Hurt Each Other* animations.
Skeptic's Allegory, 2020. UV pigment on aluminum. 65 × 56 inches (165.1 ×
142.2 cm). Courtesy of the artist and Mitchell-Innes & Nash, New York. Photo:
Dan Bradica.

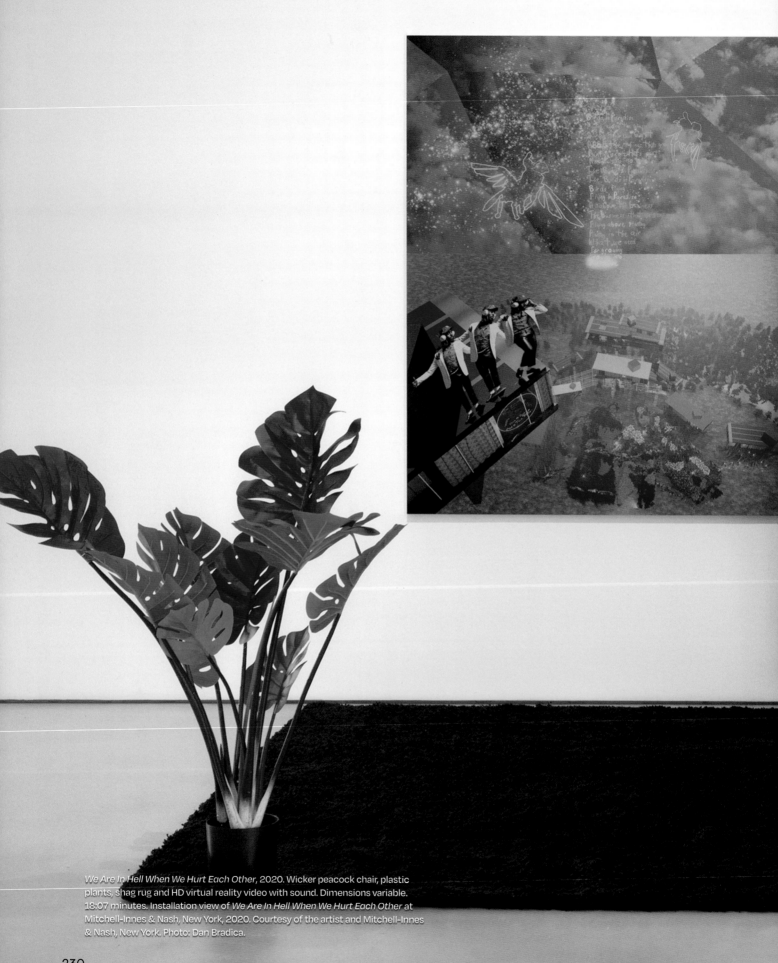

We Are In Hell When We Hurt Each Other, 2020. Wicker peacock chair, plastic plants, shag rug and HD virtual reality video with sound. Dimensions variable. 18:07 minutes. Installation view of *We Are In Hell When We Hurt Each Other* at Mitchell-Innes & Nash, New York, 2020. Courtesy of the artist and Mitchell-Innes & Nash, New York. Photo: Dan Bradica.

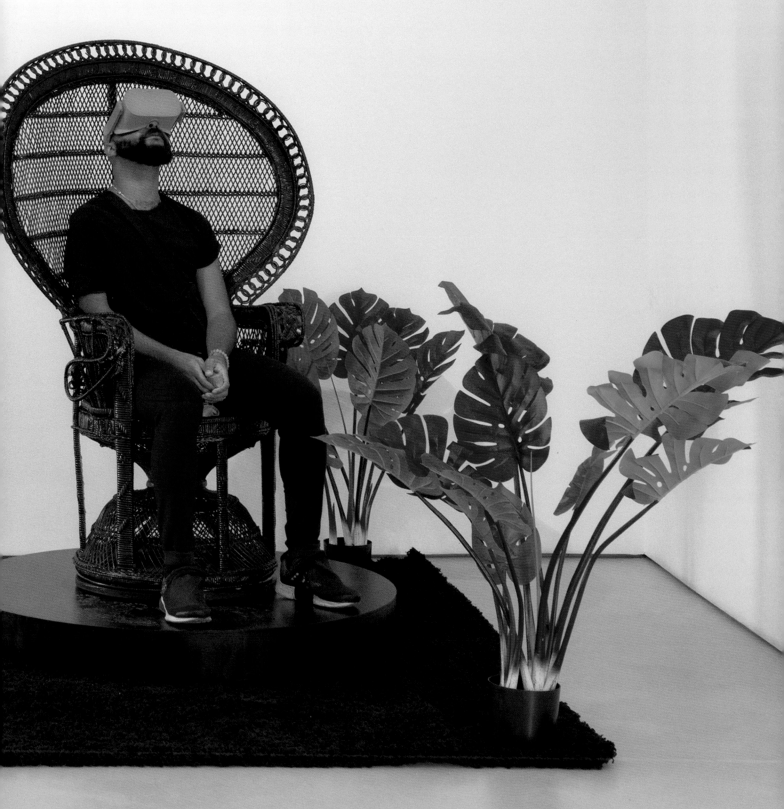

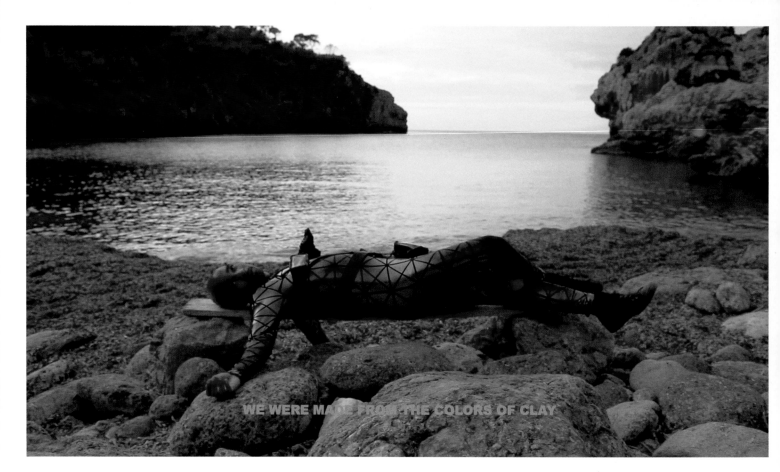

WE WERE MADE FROM THE COLORS OF CLAY

Shrines

Stills of *Shrines*, 2020. HD color video and 3-D animation with sound. 13:37 minutes. HD virtual reality video with sound. 10:23 minutes. Courtesy of the artist; Lundgren Gallery, Palma de Mallorca, Spain; Mitchell-Innes & Nash, New York and Morán Morán, Los Angeles.

This virtual reality 3-D video is an amalgamation of many of Satterwhite's visual, audio, and performance works. It sets the viewer into a multidimensional universe that reflects the complexities of Satterwhite's interiority.

Shrines blends virtual reality gaming tropes with the documentation of a performance piece *Robin vs. The Worm* (2009), where Satterwhite writhed on the floor in red, black, and tan oil paint over a large print of an infected T cell. In this performance, Satterwhite's body acted as an antibody attacking a foreign and threatening viral interloper, fighting a form of biological colonization. This video then plays on screens emmbedded into the bodies of larger-than-life brown, masculine figures within the 3-D animated world. Throughout the film, we hear Patricia Satterwhite's voice singing and

see her writings in neon letters float through the atmosphere. Patricia exisits within the work as an unseen guiding deity as she sings, "if you hurt me/you hurt you/you hurt yourself."

Figures like hiphop icon Trina, as well as Whoopi Goldberg as Celie in the film adaption of Alice Walker's novel, *The Color Purple* (1985), make apperances in *Shrines* above multiple television screens that play images of Ku Klux Klan members lighting torches. Purple shows up in much of Satterwhite's work. It is the color of womanism, further aligning his work with the Black femme experience as he channels Ms. Celie in a message to his fellow countrymen, "until you do right by me, everything you think about is gonna crumble!"

S.B.

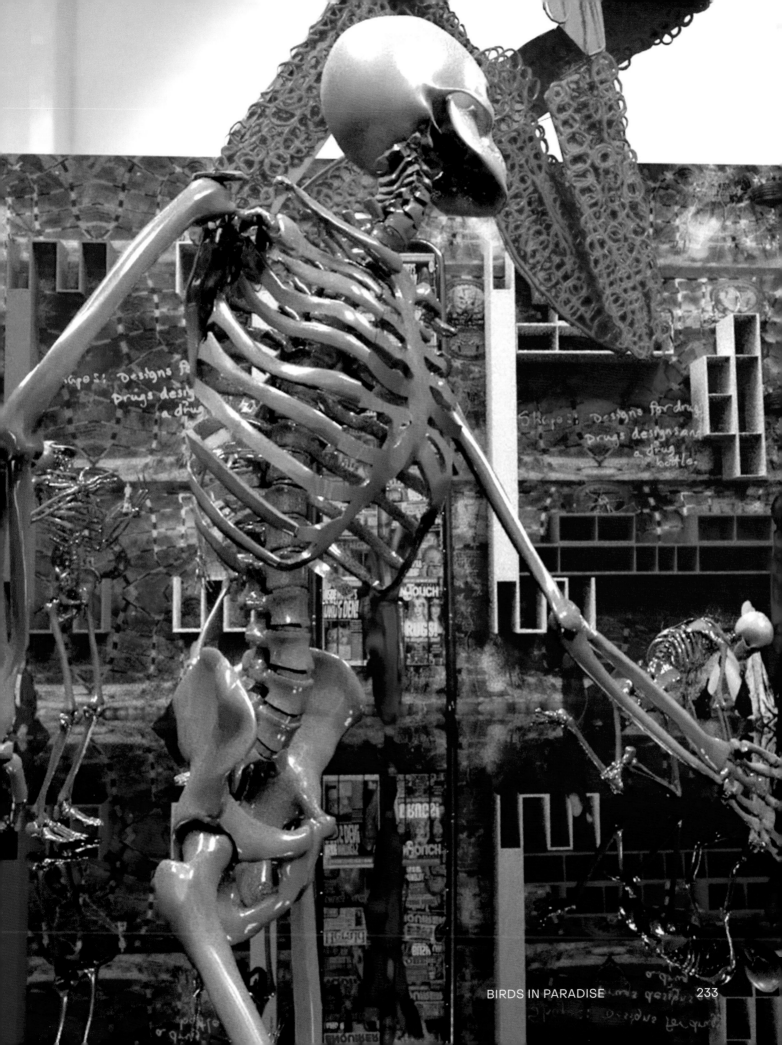

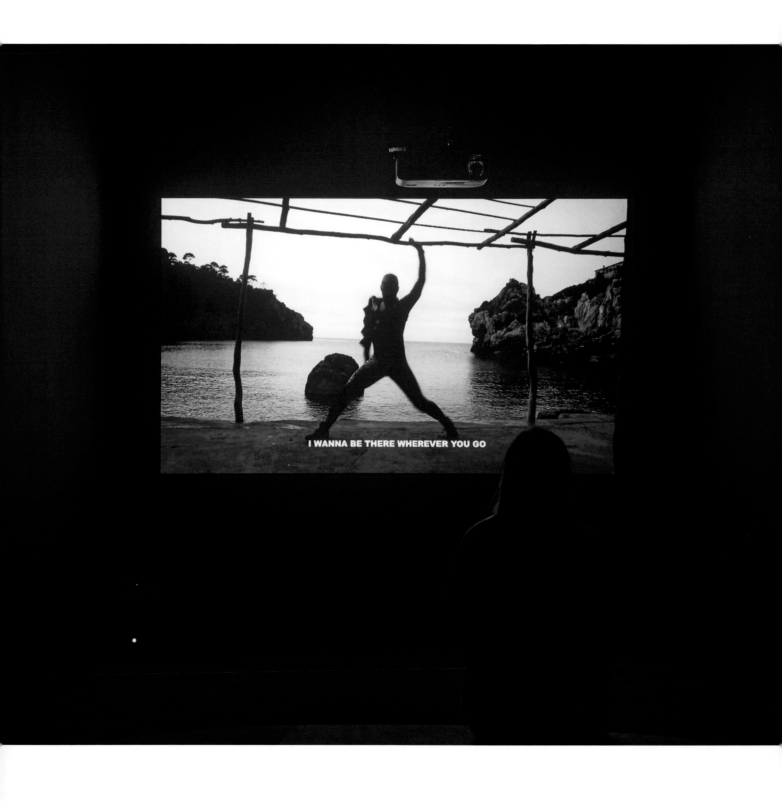

Shrines, 2020. HD color video and 3-D animation with sound. 13:37 minutes.
Installation views of *Shrines* at the 13th Gwangju Biennale, Gwangju, South Korea,
2021. Courtesy of the artist and Gwangju Biennale, Gwangju. Photo: Sang Tae Kim.

234

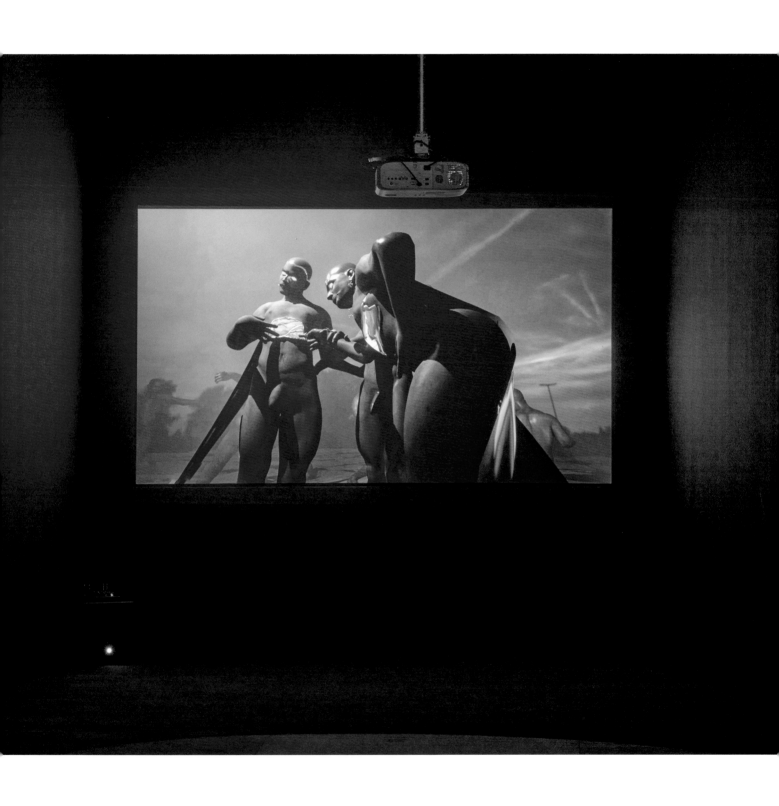

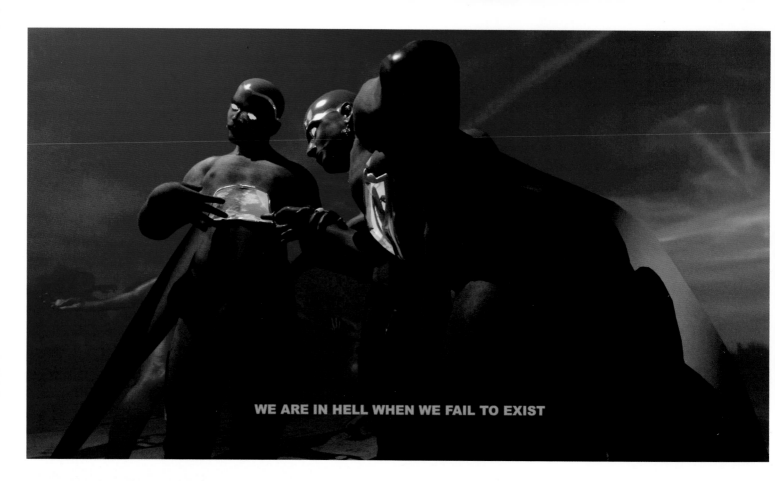

WE ARE IN HELL WHEN WE FAIL TO EXIST

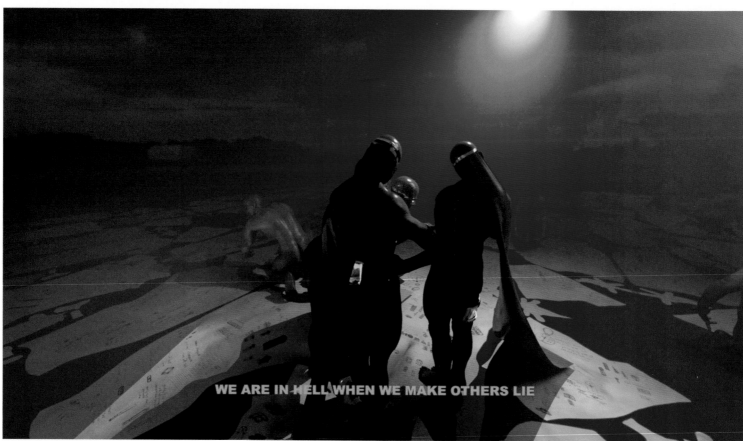

WE ARE IN HELL WHEN WE MAKE OTHERS LIE

Stills of *Shrines*, 2020. HD color video and 3-D animation with sound. 13:37 minutes. Courtesy of the artist; Lundgren Gallery, Palma de Mallorca, Spain; Mitchell-Innes & Nash, New York and Morán Morán, Los Angeles.

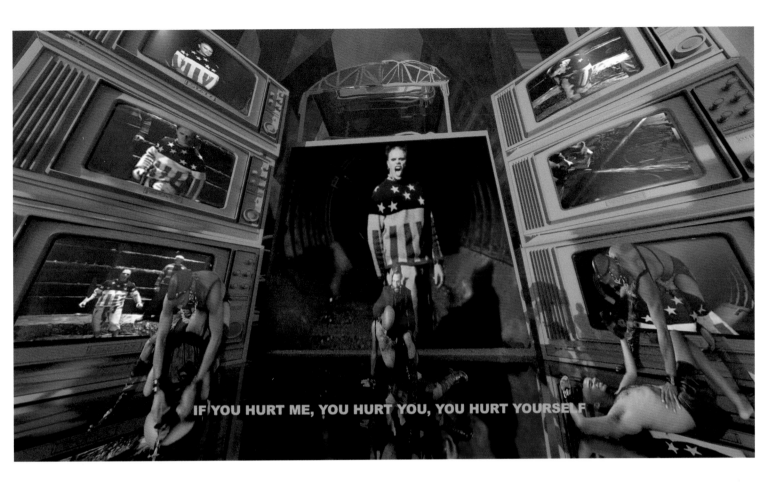

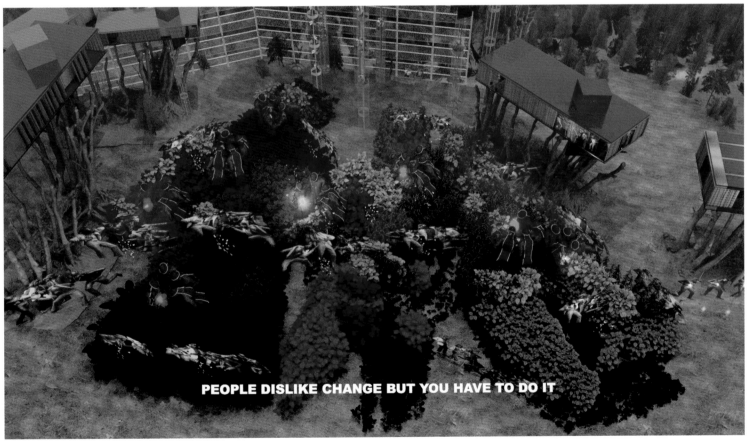

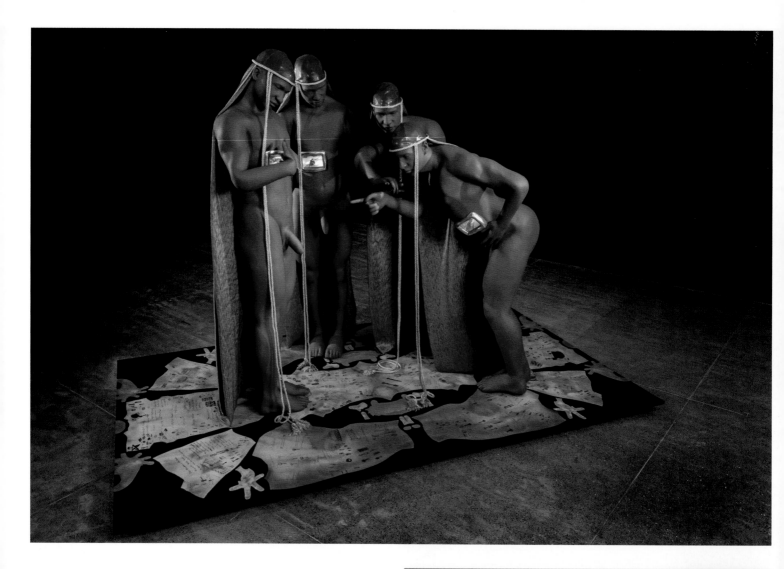

Installation view of sculpture derived from *Reifying Desire 3* and *Shrines*.
Jacolby Satterwhite, in collaboration with The Fabric Workshop and
Museum, Philadelphia. *Room for Doubt*, 2019. Five-channel HD color
video, insulation foam, expanding glue, resin, fairing filler, plywood, faux-
leather vinyl, double-faced chiffon, polyester rope, thread, automotive
paint and inkjet print on synthetic cotton. 93 × 96 × 96 inches (236.2
× 243.8 × 243.8 cm). Installation view of *Room for Living* at The Fabric
Workshop and Museum, Philadelphia, 2019. Courtesy of the artist and
The Fabric Workshop and Museum, Philadelphia. Photo: Carlos Avendaño.

Stills from video embedded in *Room for Doubt*.
Robin vs. The Worm, 2009. Performance, University of Pennsylvania,
Philadelphia.

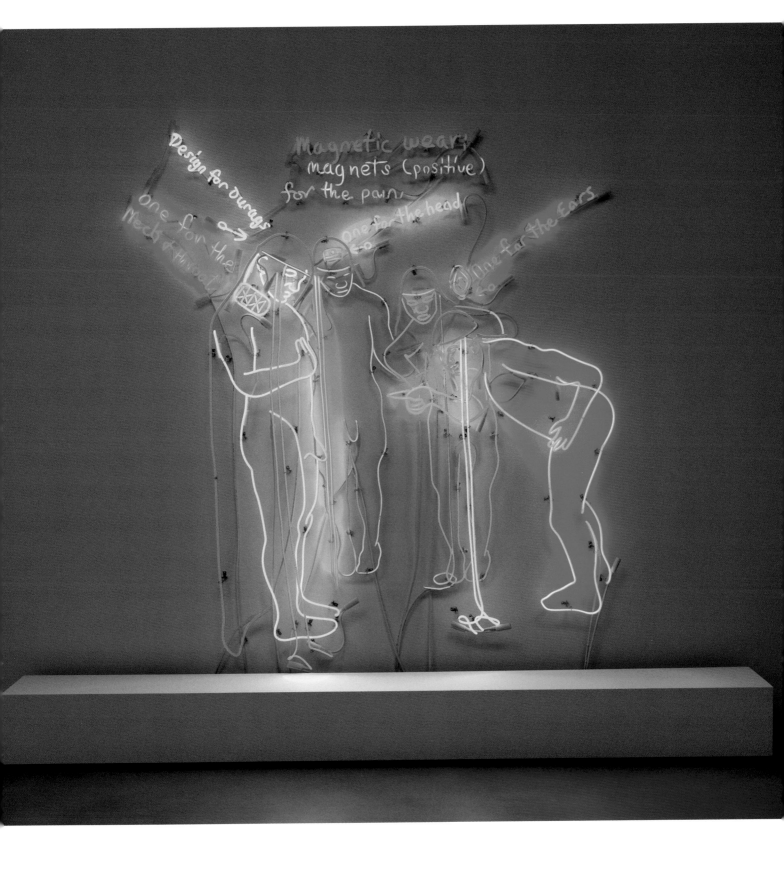

Doubt, 2020. Neon. 73 × 70 inches (185.4 × 177.8 cm). Courtesy of the artist and
Mitchell-Innes & Nash, New York. Photo: Dan Bradica.

Interview with Jacolby

KIMBERLY DREW

KIMBERLY DREW: I want to ask you about what your exhibition at the Miller ICA at Carnegie Mellon University—the basis for this book—means to you?

JACOLBY SATTERWHITE: Since I was nineteen years old, when I first entered the art world, I've always felt misunderstood, even though my process and research were initially rooted in an academic practice. As with any young artist, I thought, if you're not copying someone, you're not going to make sense. And I've been waiting for this moment where the linear narrative arc of my research and practice, the things I've been constructing, ultimately inform each other. This show will give me a level of self-comprehension, I think, and I can't wait to see my ideas from 2008 finally get resolved in the present. It should tie a bow around my entire body of work—from when I was a kid to now—and hopefully send me off in further directions.

KD: Do you feel like you're craving a linearity in the way people understand the work that you're doing?

JS: I've spent most of my life feeling like an eccentric—an eccentric gay Black artist working in an art world dominated by heterosexual white and Black men. Their intellectual and artistic hegemony always made me feel like an outsider because my concern was wellness as a conceptual project, and that just didn't make sense to them. If you look at my *Art21* (2020), I talk about my cancer, mortality, and the body as a landscape—things I have always explored. There is a specific linearity to what I am thinking about conceptually in all my films, and I want to build that up.

KD: I rewatched the 2010 video you did with Jayson Musson, *HOW TO HIP-HOP: No Homo* (from *Art Thoughtz*). The way he asks you questions is a good example of how people have tried to understand what you're doing. I have always looked at your practice as one that demands vulnerability, generosity, and slowness. So, it's interesting to hear you talk about *legibility* alongside linearity.

JS: Black people shouldn't have to be legible all the time. Politically speaking, obscurity is a strong act in itself. When I collaborated with Solange [Knowles] on her album and video *When I Get Home* (2019), we shared the need to abstract Blackness, and that is what my work does: it abstracts Blackness, pain, death.

KD: In your early days, you worked in collaboration with your mom. I wonder if there was ever a moment where you realized you might make a life for yourself as an artist?

JS: When I went to church, as a child, we used to draw Jesus, and I could draw him better than anyone. Early on, I liked to draw because it complimented my mom's own developing practice, which she started after we lost our grocery store, when we went from the upper-middle class to "low down there," or whatever you might call it. After that, my mom entered a feverish dream state, staying up all night to watch infomercials. She was convinced she could invent our way out of poverty, so she would prayerfully send schematic drawings and manuals to programs that promised to have your ideas patented and produced. She thought creativity could save us. I chose to help her by learning how to draw. Later, I realized that she was a schizophrenic, and I stopped. I started making paintings in my bedroom while playing video games.

Another formative incident involved a cute boy whom I lent my first portfolio. He was failing high school and needed a good grade in art class. The problem for him was that I had written my name on the back of all of the paintings. After he won first place in an art competition, passed his class, and the art teacher discovered who made the paintings, we were supposed to get in serious trouble. But my art teacher offered me the option of applying to the South Carolina Governor's School for the Arts and Humanities as an option. Thankfully, I ended up at a prestigious art school in upstate South Carolina, a few hours from where I grew up. There were many talented Black kids in my class: Teyonah Parris from *Mad Men* (2007–15) and *Chi-Raq* (2015), and Nicole Beharie. Later, I got into Maryland Institute College of Art and the University of Pennsylvania on a full scholarship for painting. Eventually, I quit painting because the discourse didn't speak to the way I wanted to express myself as a gay Black man. That's the story—a lot of serendipity and chance.

KD: After studying painting, it's interesting to find you working in the animating program Maya. In some of the earlier films, it seemed you enjoyed the DIY quality of it, but now it's much more polished.

JS: I've been working in Maya for twelve years and I've gotten so much more confident with its language—from lighting to caustics. It's very rigorous. At commercial studios, animators are hired to do *only* the lighting. Another team might deal in polygonal modelling, another with movement. I do it all by myself. I do three times as much as most new media artists, who often hire animation studios for their work, because I need the program to sing for me.

KD: **Is it that you have to guide the creation of the exact image you want?**

JS: I'm still a painter at heart. I change my mind every five seconds. I think, that should be a burnt umber skyline; it should have a specific depth of field, a specific skin map. I'm specific about how the palette registers when it's actually projected or experienced in virtual reality. Every decision, every color, every way I sculpt—it's all me. I only started working with my new gallery a couple years ago, and we are supposed to do our first solo show in fall 2020. In the meantime, I've always had to hustle; I had no choice but to make it by myself. And at this point, if I paid a studio, it would just look ugly.

KD: **I want to ask about your performance practice, particularly on that note about access to resources and materials. In her essay "Performance Practice as a Site of Opposition" (1995), bell hooks writes: "Throughout African-American history, performance has been crucial in the struggle for liberation, precisely because it has not required the material resources demanded by other artforms."[1] I wonder if we could talk about the work that you were doing in public spaces, especially in the mid-2000s to early-2010s. Where did the decision to go into the streets come from, and what surprised you, at that time, about the way people interacted with you?**

JS: My generation's perspective on performance was heavily influenced by Pope.L, Adrian Piper, Bruce Nauman, Chris Burden, especially the element of chance and transgression and the politicization of the artist's body. Being aware of how the body is ultimately a sculptural material was *huge*. When I would perform

1 bell hooks, "Performance Practice as a Site of Opposition," from *Let's Get It On: The Politics of Black Performance*, ed. Catherine Ugwu (Seattle: Bay View Press, 1995): 210–19.

in public, I wore a body suit, with appendages and video screens, as a way to emblemize myself. In a way, I was building a character by using capitalist merchandising strategies as a sort of critique. I thought it would be interesting to take fine art and combine it with the aesthetics of gaming or comics.

So, the suits were almost like mythological characters who referred to personal allegories. They were one way to archive a performance and figure it out later, too. Sometimes I work like that—I take a chance with what my body means in a space. I'll look at the footage the performance produces for a long time because you don't know what kind of intervention you're making in a space until after the fact.

KD: **You were doing that work in New York, almost guerilla-style. Were there other places where you performed?**

JS: China, Mallorca, San Francisco, New York, Miami, San Antonio. All over the country, all over the world. Most of these performances weren't known as an "art moment," and some appear in my work only years later. For one performance, I had fourteen people of all races clean me while wearing Tyvek suits with gloves and masks. When you watch it now, you can't tell if it's a futuristic or dystopian African ritual, or even a riff on a Jim Crow narrative, with all of these Klansmen. It challenges the viewer to see how biased they are in their localized histories.

KD: **This is the one where you are hanging upside down, right?**

JS: Yes. I wanted to celebrate disembodiment without embarrassment. And I wanted that idea to permeate the language of my movement and the characters in the videos for the next twelve years. There was something about the faggotry and the sci-fi aspect of it that was really interesting at the time.

KD: **You've talked about the influences of the ball scene on your work. Do you still look to that community for inspiration?**

JS: I grew up with kids who were part of it. Many of them were traumatized, abandoned, hurt kids who turned to sex work as a means of survival. They found solace in tribes, which helped them develop a talent, a wellness, a self-love. This reminds me of my own relationship to my mother's house, her design house,

her artmaking tribe. I learned how to be the daughter who draws, wears the costumes made from the drawings, and who performs. Basically, the ballroom model was one I could use as an artist, in terms of how I thought about my relationship to my mother. But right now, I'm thinking about my mother less in the work, even though making *Love Will Find A Way Home* (2019) [Satterwhite's collaborative album with his mother] was huge. To answer your question more directly, I don't think about the ball scene so much as I do modernist dance in general: Anne Teresa de Keersmaeker, Pina Bausch, William Forsythe, Merce Cunningham, Gary Allen.

KD: **Your work mills so many different phases of your life and brings them into new contexts. How does that process begin?**

JS: I pick a theme—medicine, the media, athleisure, to name a few. This follows my mother's method. She made drawings of jewelry, sex toys, houseware, and cutlery. So, when I work, I choose something broad; if I stick to a thing capable of embodying many different ideas, if I have my performers from, say, Fire Island pretend they're using a lever and a hammer and a pulley, and then I look up architecture blueprints to model in the software, then I can metastasize a theme until the structure builds itself. When I see how it reinterprets itself through performance, music, the drawings, the landscapes, I find the theme tends to speak to a broader politics. That's how I weave my ideas together. It's why the archive is so important. My mother crystallized a certain banality her whole life by drawing hammers, jewelry, napkins, but those crystals contained dark memories she was trying to resolve.

KD: **It's beautiful to hear about these particular parameters that you work within. In many ways, it sounds like they were inherited from your mom.**

JS: Exactly! When I would ask her about her drawings, I'd say: "Are you drawing a teacup?" She'd reply, "Yeah. Don't you see Diane's face in it?" Diane was her sister. She'd insist that there were figurative elements transcribed in the design of the cups, but I couldn't see it. In her schizophrenic condition, she would talk to herself for twelve hours a day while drawing. She would reminisce about real events, which she thought the objects contained. A time Diane betrayed her—perhaps something she found out over tea. The drawings stopped being

about patents, which she only did for a year; they became an autonomous space for self-healing and the consolidation of her dark and positive memories. It was surreal to grow up with.

KD: **Are there things you wish people would ask about her, her practice, or your relationship?**

JS: I've said as much as I can about what I want people to understand. She's one dot on the constellation board of all the things that are at the forefront of my practice. Other people who've performed for me are just as strong, even if they seem a blip on the surface. A few performers and dancers I've spent a lot of time with in the studio—recording them or rotoscoping their bodies digitally—and sometimes those performances really influence the rest of the film. My mother is the most provocative collaborative element, but with regard to constructing these worlds, twenty amazing images from Tumblr might affect me more. So, in a way I'm just a hoarder of data. I work with 40-terabyte hard drives. I scavenge, select, construct; I'm an architect, and that's how architects think.

KD: **How do you determine who to invite to the party?**

JS: Sometimes it's specific, when the person is inspiring to me, and sometimes it's by chance. If I'm on vacation, I'll set up a green screen in my hotel room and have fun. It depends on how I feel. I don't usually have restrictions, but at the moment, I'm curating more carefully. Before, I was interested in the community depicted in the work, but now I'm more focused on individual subjects and portraits—digital art as a form of portraiture. There are many Black men who are so beautifully weird. I'm good with weird people.

Collaboration requires so much humility and negotiation and vulnerability. Building portraiture, especially in the way *yo ass* is building portraiture, means that you're spending hours looking at someone, looking at the way they move.

That is why I used myself so much for the first six or seven years—I didn't want to compromise someone's self-expression through my own experiments. That way, I wouldn't hurt them. When I finally trusted my language enough to celebrate

others, I started to invite people. [The porn star] Antonio Biaggi and [the rapper] Trina were the first, actually.

KD: **Can you talk more about that collaboration?**

JS: The *Reifying Desire* series was about gestation cycles. When you first study animation, you learn how to make a flower grow. I thought I'd be very literal about that process. At the end of the series, when I wanted to go out with a bang, I asked Biaggi—who was notorious for having unprotected sex—to simulate a gestational period between two gay men. At the time, Biaggi was very controversial—this was just as PrEP [a drug for the prevention of HIV] was becoming widely available—and he made me think of Marilyn Monroe and Bettie Page. It felt timely to do my final gestation cycle with a bareback porn star, an alternative icon.

Afterward, I was still feeling feisty and I wanted to work with Trina, who meant a lot to me. Whenever I had felt I was being abused by my community, in a way that denigrated my gay Black self, especially in urban neighborhoods, I would go home with my friends and listen to Trina. We would recite lyrics to each other and imitate her coping mechanisms. She was important for gay Black men surviving in the hood. I wanted to celebrate that.

KD: **It's almost like you had your Trina moment with Antonio Biaggi because you thought, *fuck that! Ima do me.***

JS: I thought of myself as a Black female rapper. Lil' Kim first emerged in a way that wasn't palatable, but *she* understood herself and it makes complete sense now. When Solange came along, our conversation was one of the most important conversations I've had because I just never felt as conceptually aligned with someone else. She and I are both the same age. We've dealt with a specific escapism. I opened up in that collaboration; we had a genuine heart-to-heart conversation about every thread that led us respectively to where we are now. That honesty led to a much more poignant and resolved project from her and me. I realize that's what I want every time I work with someone. Before, I was somewhat selfish in projecting my own ideas onto other people's bodies—or maybe not. But with Solange, we met at a more mutually respectful space. I want to celebrate more heartfelt conversations.

KD: What are some of the challenges that have arisen as you've prepared for this project, this moment in your career?

JS: I'm still working through the kinks; I'm deep in the middle of building, so I don't yet know if I've seen the worst part of it. But I'll say I have triumphed because I feel brave enough to expand the medium—and my practice—more than I ever have before. I'm introducing augmented reality, and more substantial, interactive virtual experiences. Painting is back in the process. I'm working with C-prints in a dynamic way. And sculpture, too. The thing about this show at Carnegie Mellon is that I feel like I'm triumphing *over* the medium. I'm more fearless. That doesn't mean it's not going to be hard.

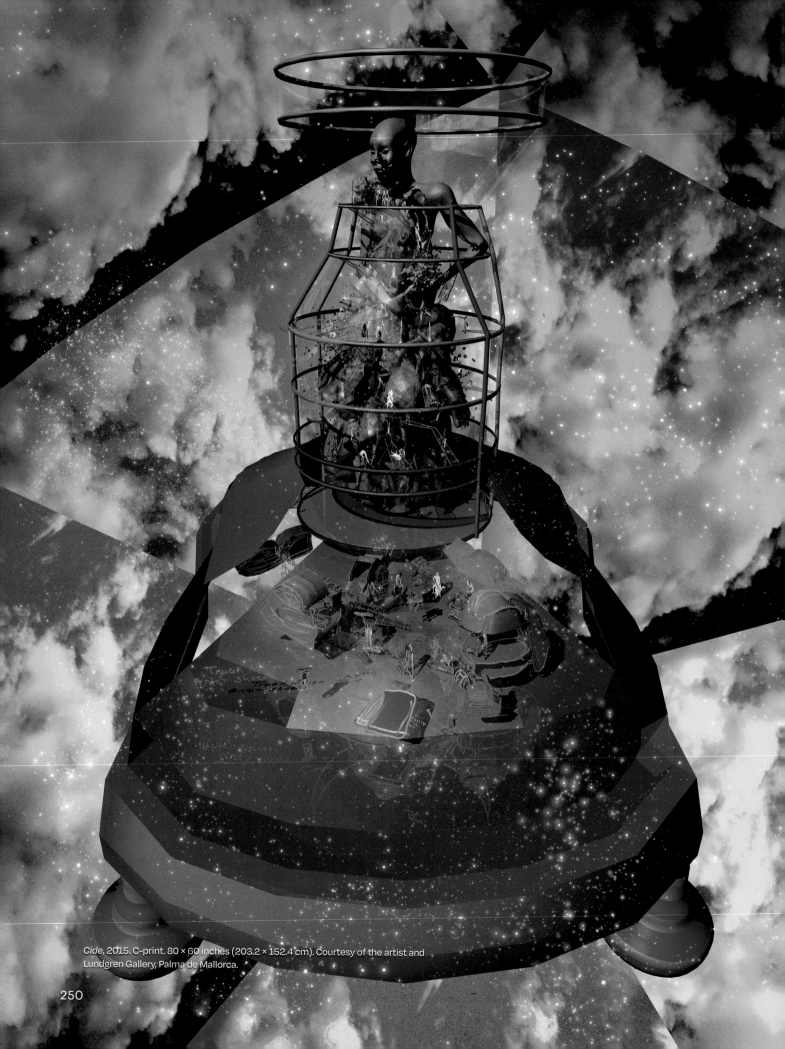

Cide, 2015. C-print. 80 × 60 inches (203.2 × 152.4 cm). Courtesy of the artist and Lundgren Gallery, Palma de Mallorca.

BIOGRAPHY

Jacolby Satterwhite

b. 1986, Columbia, SC
Lives and works in Brooklyn, NY

Jacolby Satterwhite is celebrated for a conceptual practice addressing crucial themes of labor, consumption, carnality and fantasy through immersive installation, virtual reality, and digital media. He uses a range of software to produce intricately detailed animations and live action film of real and imagined worlds populated by the avatars of artists and friends. These animations serve as the stage on which the artist synthesizes the multiple disciplines that encompass his practice, namely illustration, performance, painting, sculpture, photography and writing. Satterwhite draws from an extensive set of references, guided by queer theory, modernism and video game language to challenge conventions of Western art through a personal and political lens. An equally significant influence is that of his late mother, Patricia Satterwhite, whose ethereal vocals and diagrams for visionary household products serve as the source material within a decidedly complex structure of memory and mythology.

Jacolby Satterwhite was born in 1986 in Columbia, South Carolina. He received his BFA from the Maryland Institute College of Arts, Baltimore and his MFA from the University of Pennsylvania, Philadelphia. Satterwhite's work has been presented in numerous exhibitions and festivals internationally, including most recently at the Cleveland Museum of Art (2021); the Athens Biennale (2021); Miller Institute for Contemporary Art at Carnegie Mellon University (2021); Haus der Kunst, Munich (2021); the Gwangju Biennale, Gwangju (2021); the Wexner Center for the Arts, Columbus, OH (2021); The Fabric Workshop & Museum, Philadelphia (2019); Pioneer Works, New York (2019); the Whitechapel Gallery, London (2019); the Museum of Modern Art, New York (2019); the Minneapolis Institute of Art (2019); the Museum of Contemporary Art, Chicago (2018); La Fondation Louis Vuitton, Paris (2018); the New Museum, New York (2017); the Public Art Fund, New York (2017); the San Francisco Museum of Art (2017); and the Institute of Contemporary Art, Philadelphia (2017). He was awarded the United States Artist Francie Bishop Good & David Horvitz Fellowship in 2016. His work is included in the collections of the Museum of Contemporary Art Kiasma, Helsinki; The Museum of Modern Art, New York; the Studio Museum in Harlem, New York; and the Whitney Museum of American Art, New York, among others. In 2019, Satterwhite collaborated with Solange Knowles on her visual album, *When I Get Home*.

ACKNOWLEDGMENTS

 Carnegie Mellon University

Miller ICA is Carnegie Mellon University's contemporary art institute providing transformative experiences with contemporary art through exhibitions, conversation, and exchange in a free and open public space.

Jacolby Satterwhite: Spirits Roaming on the Earth exhibition and accompanying publication was made possible with support from The National Endowment for the Arts, The Frank Ratchye Studio for Creative Inquiry, Center for Arts and Society, Mitchell-Innes & Nash, and with major support from The Andy Warhol Foundation, the College of Fine Arts, Regina and Marlin Miller, and other individual donors.

The Andy Warhol Foundation for the Visual Arts

NATIONAL ENDOWMENT for the ARTS — arts.gov

The Frank-Ratchye STUDIO for Creative Inquiry

SPECIAL THANKS FROM JACOLBY

With much gratitude to all the wonderful people in my life who've shaped my passion, drive, and commitment to my artistic journey. I would like to thank Patricia Satterwhite, Henry Satterwhite Jr., Parthenia Satterwhite, Henry Satterwhite III, Jablonski Satterwhite, Janice B. Johnson, Derrick Adams, Cedric Antonio, Terry Atkins, Davyon Augustus, Firelei Baez, Adam Bainbridge, Patrick Belaga, Brody Blomqvist, Bernard Lumpkin and Carmine Boccuzzi, Alissa Brianna, Gavin Brown, David Casavant, Elizabeth Chodos, Stuart Comer, Lauren Cornell, Kimberly Drew, Andrew Durbin, Nia Evans, Gabriel Florenz, Malik Gaines, Luis Gispert, Thelma Golden, Alejandro Guzman, Ed Halter, Jane Ursula Harris, Heather Hart, Kenyatta AC Hinkle, Isabelle E. Hogenkamp, Tomashi Jackson, Solange Knowles, Lafawndah, Anthony Lawson, Thomas T. Jean Lax, Malcolm Lomax, Parnilla Lundgren, Stefan Lundgren, Eric N. Mack, Lucy Mitchell-Innes and David Nash, Al Morán, Mills Morán, Sophie Morner, Josephine Nash, Andy Robert, Monya Rowe, Lydia Ruby, Legacy Russell,Tony Shore, Frank Smiegel, Mason Soto, Tamara Suber, Taylor Trabulus, Stewart Uoo, Sam Waxman, Nick Weiss, Courtney Willis Blair, Tedra Wilson, Dustin Yellin, and Sonia Yoon. I would also like to thank Art21, The Fabric Workshop and Museum, the Fine Arts Work Center, Haus Der Kunst, the Lower Manhattan Cultural Council, Make-A-Wish Foundation, The Museum of Modern Art, New Museum, Pioneer Works, the San Francisco Museum of Modern Art, Skowhegan School for Painting & Sculpture, South Carolina Governor's School for the Arts and Humanities, The Studio Museum in Harlem, and The Whitney Museum of American Art.

COLOPHON

This publication has been prepared in conjunction with
Jacolby Satterwhite: Spirits Roaming on the Earth curated
by Elizabeth Chodos, Miller ICA Director.
(August 14–December 5, 2021)

PUBLISHED BY:
Miller ICA at Carnegie Mellon University
Purnell Center for the Arts
5000 Forbes Ave.
Pittsburgh, PA 15213
www.miller-ica.cmu.edu

PRODUCED BY:
Elizabeth Chodos, Director, Curator, Editor
Sonia Yoon, Designer & Producer
Andrew Durbin, Essays Editor
Julie Azzam, Copy Editor

ASSISTANCE BY:
Lauren Basing
Courtney Willis Blair
Margaret Cox
Isabelle E. Hogenkamp

ISBN: 978-1-7335378-2-7

Printed in Italy.

PHOTO CREDITS
Cover and Inside Front Cover:
Photography © Henry Leutwyler 2021

Front Endpages:
Jacolby Satterwhite, *How lovly is me being as I am*, 2014. Neon.
25 × 96 inches (63.5 × 243.84 cm). Courtesy of the artist and
Morán Morán, Los Angeles.

Patricia Satterwhite. *How lovly is me being as I am*, 1998–2008.
Graphite on paper. 11 × 8 1/2 inches (27.9 × 21.6 cm). Courtesy of the
artist and Mitchell-Innes & Nash, New York.

p 10: Photograph of Patricia Satterwhite, c. 1988. From the archive
of Jacolby Satterwhite; p 11: Photograph of Jacolby Satterwhite, c.
1988. From the archive of Jacolby Satterwhite; p 12: Photograph of
Patricia Satterwhite, c. 1988. From the archive of Jacolby Satterwhite;
p 13: *En Plein Air: Music of Objective Romance*, 2017. Performance
commissioned by the San Francisco Museum of Modern Art as part
of Performance in Progress, 2017. Courtesy of the artist and San
Francisco Museum of Modern Art, San Francisco. Photo: Charles
Villyard.

Gatefolds, p 16–30:
Stills of *Matriarch's Rhapsody Codex*, 2012. 3-D animation and video.
43:47 minutes. Courtesy of the artist; Lundgren Gallery, Palma de
Mallorca, Spain; Mitchell-Innes & Nash, New York and Morán Morán,
Los Angeles.

Cock's house, 2018. Neon. 86 3/5 × 51 1/5 × 2 inches (220 × 130 × 5
cm). Courtesy of the artist and Lundgren Gallery, Palma de Mallorca.

Money, money paper money for the queen me!!, 2018. Neon. 94 1/2 ×
67 × 2 inches (240 × 170 × 5 cm). Courtesy of the artist and Lundgren
Gallery, Palma de Mallorca.

For Fuel, 2018. Neon. 83 3/5 × 47 1/5 × 2 inches (220 × 120 × 5 cm).
Courtesy of the artist and Lundgren Gallery, Palma de Mallorca.

Back Endpages:
I Will Never Go Back, 2020. Neon. 10 1/2 × 70 × 2 1/4 inches.
(26.7 × 177.8 × 5.7 cm). Courtesy of the artist and Miller Institute for
Contemporary Art, Pittsburgh. Photo: Margaret Cox.